W9-AZH-496

MANGA MANIA
MAGICAL GIRLS AND
FRIENDS

CHRISTOPHER
HART

Manga Mania Bishoujo copyright © 2005
by Christopher Hart
Manga Mania Magical Girls and Friends copyright
© 2006 by Christopher Hart

All rights reserved.
Published in the United States by Watson-Guptill
Publications, an imprint of the Crown Publishing Group,
a division of Penguin Random House LLC, New York.
www.crownpublishing.com
www.watsonguptill.com

WATSON-GUPTILL and the WG and Horse designs are
registered trademarks of Penguin Random House LLC.

This work is comprised of two volumes originally
published separately as *Manga Mania Bishoujo* and
Manga Mania Magical Girls and Friends by Watson-Guptill
Publications, an imprint of the Crown Publishing Group, a
division of Penguin Random House LLC, New York, in 2005
and 2006 respectively.

CIP information available upon request.

ISBN 978-0-385-36531-4

Printed in China

Sterling Proprietary Edition

Cover design by Jeff Kenyon

9 8 7 6 5 4 3 2 1

CONTRIBUTING ARTISTS TO *MANGA MANIA BISHOUJO*:
Diana F. Devora: 8, 50–59, 60–65, 70–75, 88–91, 98, 99, 118
Vanessa Duran: 4, 22, 23, 68,69, 126, 127
Christopher Hart: 6, 24–37, 66, 67
Atsuko Ishida: 100–113
Roberta Pares Massensini: 128–143
Maki Michaux: 114–117
Romy: 49, 92–97
Aurora G. Tejado: cover, 2, 3, 9–21, 38, 39, 40–48, 119–125
Cindy Yamuchi: 76–87

Color by MADA Design, Inc., with the exception of pages
 76, 79, 81, 83, 85, 87, 92, 93, 100, 101, 103–113 by the
 artists

**CONTRIBUTING ARTISTS TO *MANGA MANIA MAGICAL
GIRLS AND FRIENDS*:**
Denise Akemi: 90–95, 104–109
Azu: 12, 13, 47–49, 64–73
Diana Fernandez Devora: 18, 28–31, 122, 123
Vanessa Duran: 32, 33, 39–41, 50, 51, 54, 55, 76–89
Christopher Hart: 23–27
Makiko Kanada: 96–99, 124–129
Chihiro Milley: 44–46, 56–63
Roberta Pares: 1, 4, 6, 38, 52, 53, 130, 134–143
PH: 8, 14, 15, 42, 43, 74, 75, 100, 110–115
Aurora Garcia Tejado: 16, 17, 101–103
Nao Yazawa: 2, 3, 9–11, 19–22, 34–37, 116–121, 131–133

Color by MADA Design, Inc., except for pages 44–46, 71,
 73 by Anzu and 47–49, 56–63 by Chihiro Milley

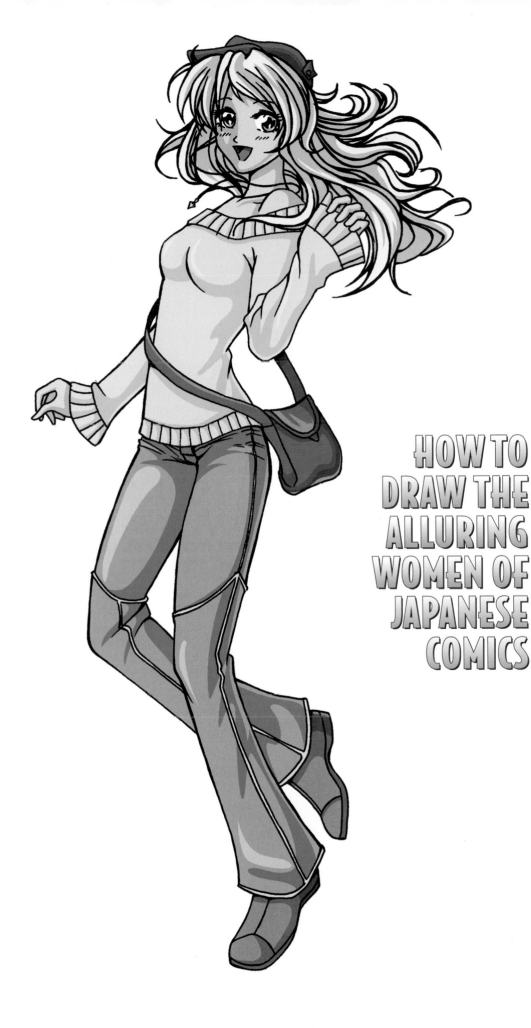

MANGA
MANIA

BISHOUJO

HOW TO
DRAW THE
ALLURING
WOMEN OF
JAPANESE
COMICS

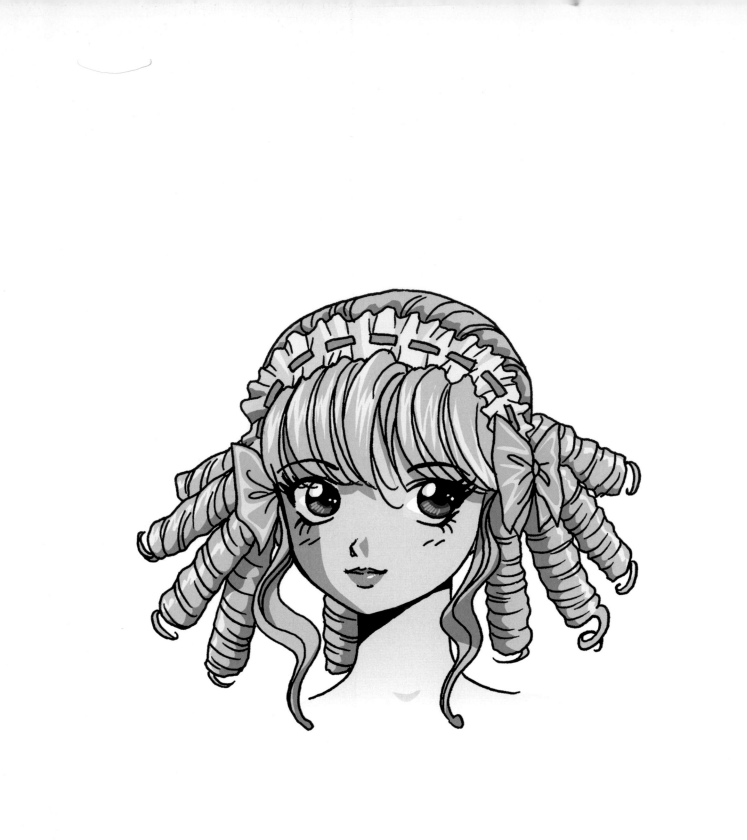

CONTENTS

INTRODUCTION

I'm very excited to introduce you to what I believe is, by far, the most comprehensive, authentic and eye-catching book on *bishoujo*—an incredibly popular genre of manga. *Bishoujo* is a Japanese term that means *beautiful women*. Knowing how to draw beautiful women is an essential skill for every aspiring *mangaka* (*manga artist*). The bishoujo genre encompasses a wide range of character types and subgenres, from uniformed schoolgirls to the immensely popular Magical Girl subgenre, and from heroic fighter pilots of the Sci-Fi genre to fairies, martial arts masters, undercover agents, the Urban Chic subgenre, and much, much more.

Have you ever had difficulty drawing dazzling women? Most artists have. Drawing the beautiful eyes, the gentle contours of the face and figure, the hair, the lips, all of it can either make or break a drawing. This book is the definitive resource on how to draw beautiful women. As you flip through the pages, you'll see the widest possible assortment of bishoujo characters in a variety of styles. As an aspiring artist, you should have exposure to the entire spectrum of styles so that your work remains exciting and current.

This book is comprehensive like no other. To start, it breaks down—into clear and easy-to-follow instructions—exactly how to draw the eyes so that they glisten and beam with expression. Eyelashes, eyebrows, pupils, and irises are all explained and illustrated in such detail that nothing will remain a mystery to you. Then follows the section devoted to drawing the mouth in various positions and expressions. Moving on, you'll learn how to draw the attractive female head in every conceivable angle, which will give you confidence as an artist and allow you to create your own characters in any position, in any scene. All of the latest and most appealing hairstyles are shown, as are facial expressions, emotions, the body, posture, body language, action poses, character types, costumes, and hands and feet.

Did I leave out anything? I don't think so. But there's more! A section on glamour, which shows you the secret to turning ordinary females into sparkling beauties. You'll learn how to draw two characters together in a scene so that you won't have to draw scenes with only one figure anymore. And as a bonus, there's a fabulous section on the fighting women of the famous Magical Girl subgenre. It's a dazzling section sure to inspire you to put pencil to paper.

Not only will this book show you how to draw manga, but it will also improve your drawing skills in general. You'll be learning the solid art principles used by top professional manga illustrators. So, whether you're a big-time manga fan or you draw American-style comic book art, you'll get valuable drawing instruction.

THE DETAILS OF THE HEAD

The attractive female manga head is made up of three elements: the basic structure and outline, the facial features (including those amazing manga eyes), and a dramatic hairstyle. We'll cover the first two here, and get to the hair in a following chapter.

Enchanting eyes are an essential part of the beautiful women of manga. Eyes are the focus of the face and are more important to the expression than any other feature. They make a stronger statement about the character than even the costume. Who has ever seen a seductive villainess without long elegant eyelashes, or a pretty heroine without large glistening eyes? The eyes create the character. In fact, you could almost say that the character is created around the eyes.

Most beginners use the same shape of eye for every female character they create. But eyes are not "one size fits all." Different character types require different eye shapes. A young girl will have a different eye shape than a twentysomething-year-old woman.

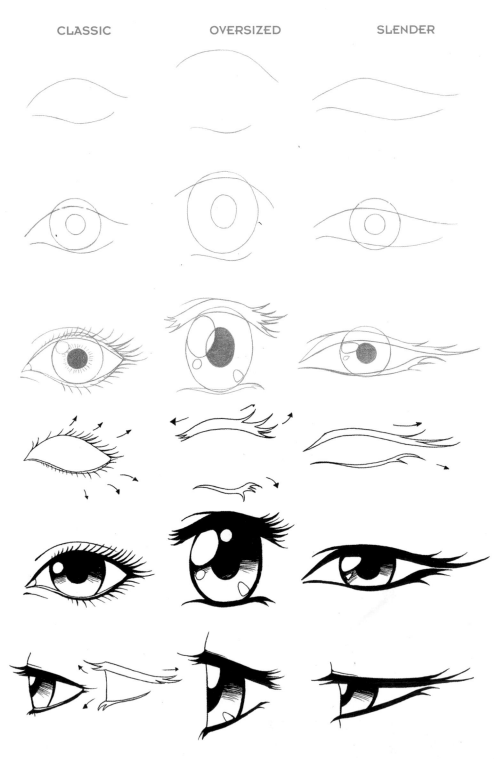

CLASSIC OVERSIZED SLENDER

Although the eyeball may seem like the natural place to start, it's best not to begin there. Instead, draw the shape of the top and bottom eyelids. This will help to frame the eyeball and lock it in place. Note that the upper eyelid is always longer than the lower one and is also the one that makes the most dramatic arc.

Now draw two concentric circles within the eyelids. The outer one indicates the iris, and the inner one is the pupil. The upper eyelid should overlap the iris, covering it a bit. If you were, instead, to place the upper eyelid at the very edge of the iris, the character would always look wide-eyed and surprised.

Once the eyelids are in place, add the eyelashes. You can bunch them together so that they look like a single mass of black, or you can draw them as individual lashes. These are stylistic choices that are fun to experiment with. Either way, the lashes should feather at the ends. The other important elements are the eye shines. Vary the size and placement of them. Feel free to let the shine overlap the pupil. In addition, short lines around the pupil add a nice detail to the iris.

In general, the eyelashes brush outward, toward the ear, with the upper eyelashes brushing upward and the lower eyelashes brushing downward. The oversized eye requires the thickest eyelashes, while the slender eye features long eyelashes that are more horizontal than the other two styles.

SIDE VIEW

The side view of the eye is easy to draw. Partly, this is due to the fact that you don't have to line up two eyes evenly, as is required in the front view. The shape is basically triangular. The lashes feather in front and back.

More Captivating Eyes

Here are a few more popular eye types, divided into two categories. The top row represents the cleaner, simpler look, with bold crisp lines and no sketch marks. The bottom row features sketchier eyelids and lashes, as well as shading on the eyeball itself. The top look is used for younger characters, and the Fantasy and Sci-Fi genres. The bottom row is more for romantic and alluring characters.

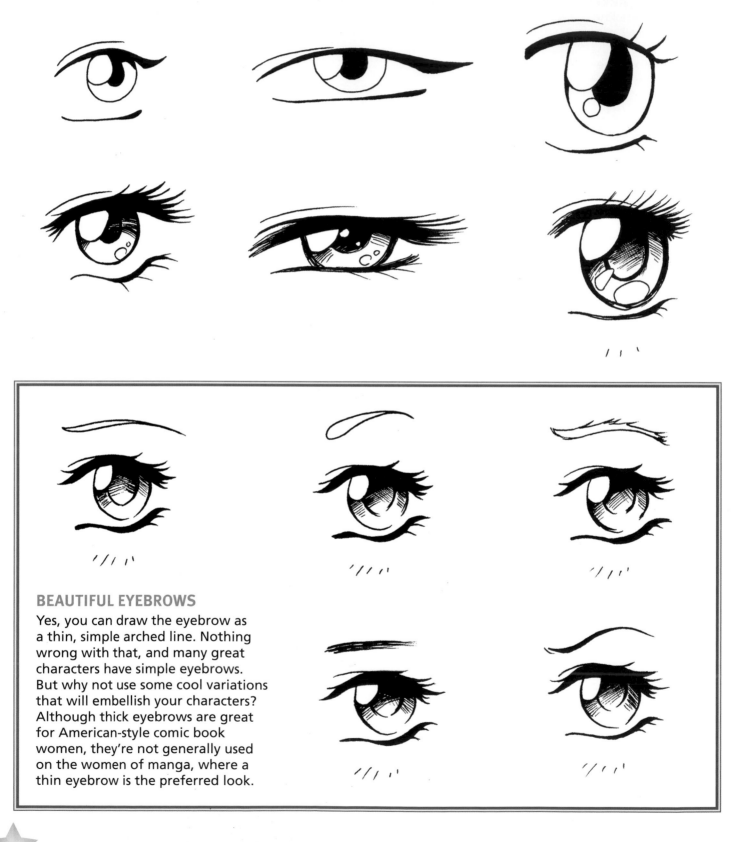

BEAUTIFUL EYEBROWS

Yes, you can draw the eyebrow as a thin, simple arched line. Nothing wrong with that, and many great characters have simple eyebrows. But why not use some cool variations that will embellish your characters? Although thick eyebrows are great for American-style comic book women, they're not generally used on the women of manga, where a thin eyebrow is the preferred look.

Do you draw full lips or a single line? Do you use continuous or broken lines? Only female characters have full lips. And thicker lips are, generally, for more mature characters. Also, the more attractive the character, the thicker the lips should be.

Leaving some lines broken is a cool look, because the eye naturally tends to fill in the gaps in the lines. With the broken-line style, you can place an accent mark just above the central dip in the middle of the upper lip and a small shadow below the bottom lip.

When the mouth is open, the upper teeth tend to show; the bottom ones do not, unless the character is angry. The upper teeth are not indicated with a straight line across the mouth but with an upward-curving one. Or, the lips give form to the teeth, as in the bottom left example. In the side view, the top lip protrudes with an overbite, extending beyond the lower lip.

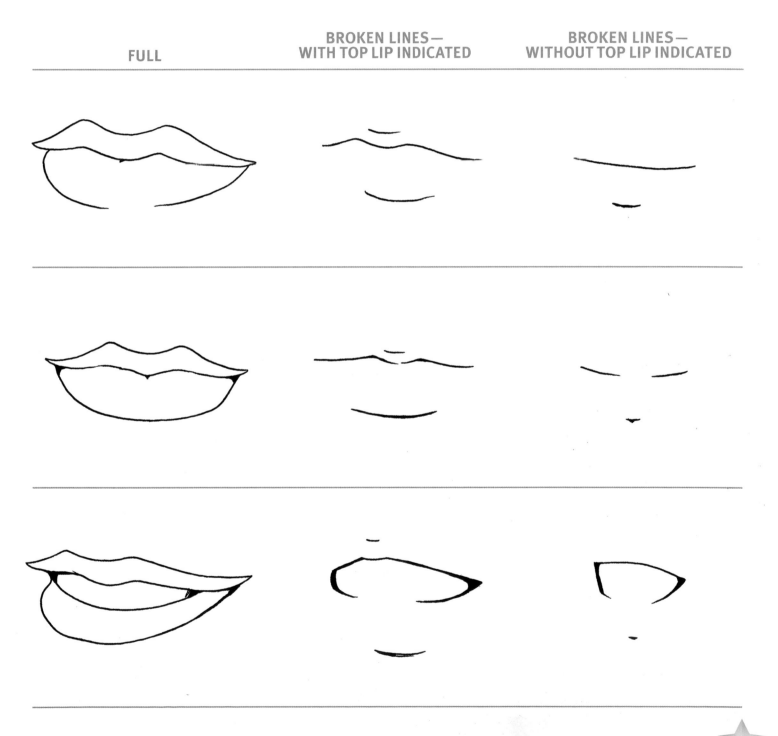

| FULL | BROKEN LINES— WITH TOP LIP INDICATED | BROKEN LINES— WITHOUT TOP LIP INDICATED |

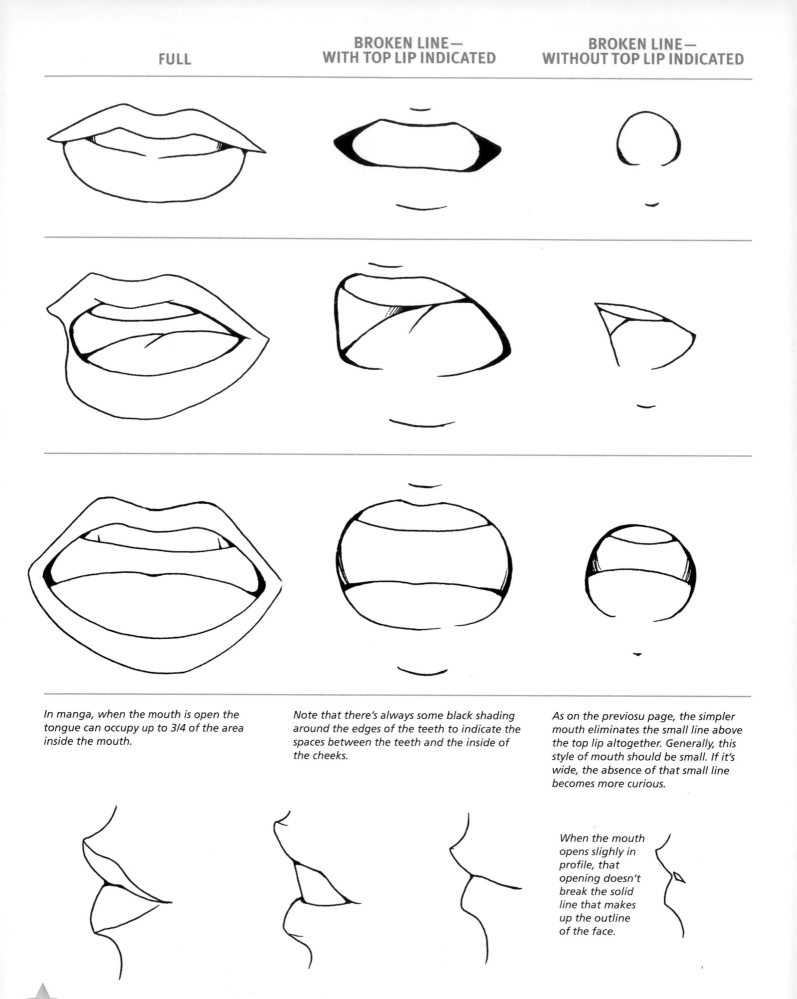

In manga, when the mouth is open the tongue can occupy up to 3/4 of the area inside the mouth.

Note that there's always some black shading around the edges of the teeth to indicate the spaces between the teeth and the inside of the cheeks.

As on the previosu page, the simpler mouth eliminates the small line above the top lip altogether. Generally, this style of mouth should be small. If it's wide, the absence of that small line becomes more curious.

When the mouth opens slighly in profile, that opening doesn't break the solid line that makes up the outline of the face.

Smiles and Other Expressions

Smiles can be drawn in many different ways. Compare the four here:

Simple but effective, with a shine on the bottom lip.

A typical full-lipped smile

Emphasizing strong shadows.

Showing a bit of teeth.

CREATING EXPRESSIONS

Beautiful manga characters have a subdued look that makes them alluring. But when they react, they do so with big emotions. There are no wallflowers in manga!

A character won't lose her femininity when she has a big outburst of emotion, so long as she returns to her softer side once the moment of agitation subsides.

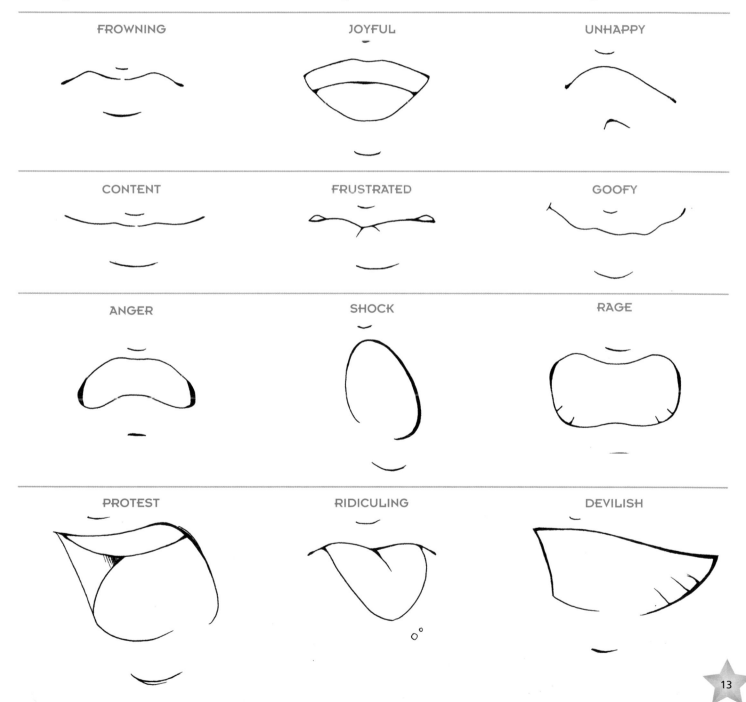

FROWNING

JOYFUL

UNHAPPY

CONTENT

FRUSTRATED

GOOFY

ANGER

SHOCK

RAGE

PROTEST

RIDICULING

DEVILISH

The Head in Four Ridiculously Simple Steps

The outline of the head should be simple and subtle—no hard angles, except for the famous pointed manga chin. Allow the eyes and hair—not the shape of the head—to provide the glamour. And, don't rush; for the best results, approach this in a thoughtful way.

FRONT

This is a typical manga girl who, depending on her costume, could be anywhere from sixteen to twenty years of age. A great deal depends on costuming, as you'll see in later chapters.

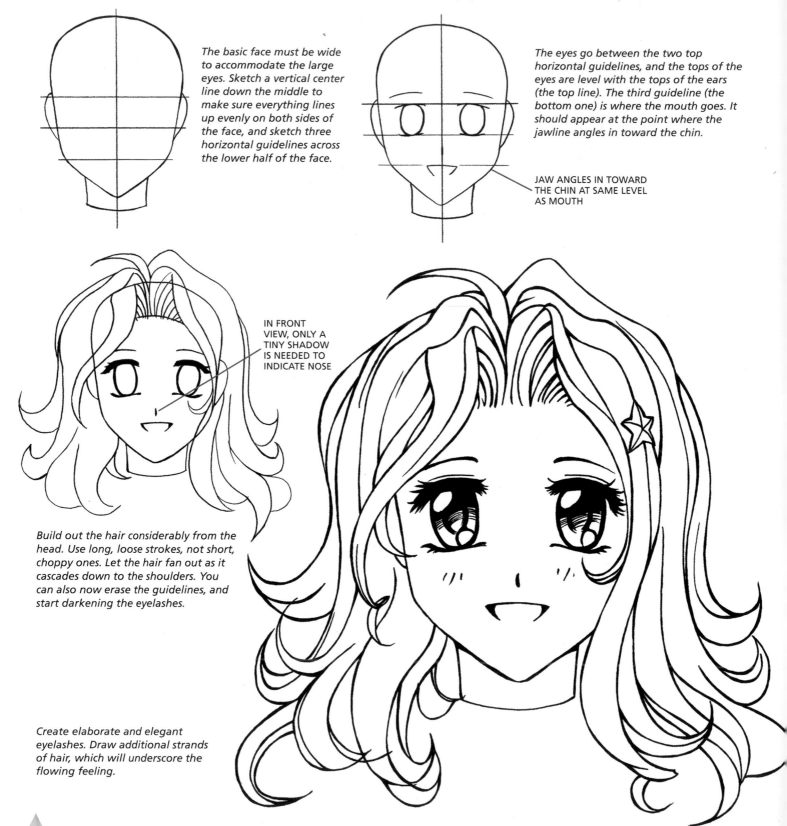

The basic face must be wide to accommodate the large eyes. Sketch a vertical center line down the middle to make sure everything lines up evenly on both sides of the face, and sketch three horizontal guidelines across the lower half of the face.

The eyes go between the two top horizontal guidelines, and the tops of the eyes are level with the tops of the ears (the top line). The third guideline (the bottom one) is where the mouth goes. It should appear at the point where the jawline angles in toward the chin.

JAW ANGLES IN TOWARD THE CHIN AT SAME LEVEL AS MOUTH

IN FRONT VIEW, ONLY A TINY SHADOW IS NEEDED TO INDICATE NOSE

Build out the hair considerably from the head. Use long, loose strokes, not short, choppy ones. Let the hair fan out as it cascades down to the shoulders. You can also now erase the guidelines, and start darkening the eyelashes.

Create elaborate and elegant eyelashes. Draw additional strands of hair, which will underscore the flowing feeling.

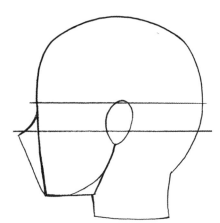

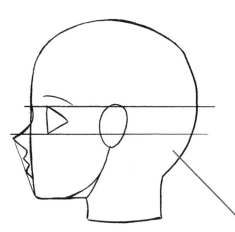

PROFILE

In order to maintain the character's femininity in the side view, it's essential to emphasize the curve of the forehead, and allow it to gently sweep into the bridge of the nose. There should be a considerable amount of head behind the ears. The underside of the jaw should always look soft, never bony, and it should rise up to the ear on a gentle curve.

SIGNIFICANT MASS TO BACK OF HEAD

The front of the face is first drawn as a straight vertical line. Then the bridge of the nose is created, along with a diagonal line from the tip of the nose to the point of the chin.

The tip of the nose, the lips, and the chin all appear along the diagonal line running from the nose to the chin.

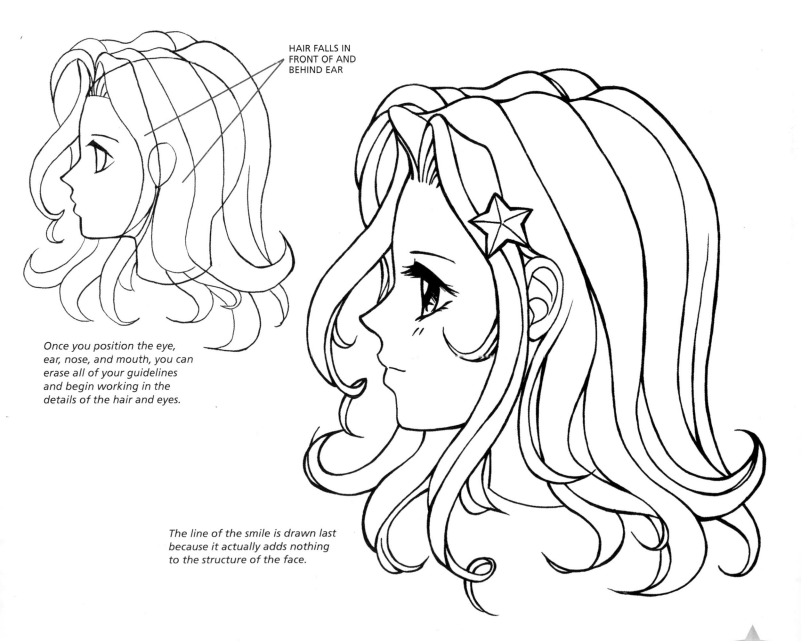

HAIR FALLS IN FRONT OF AND BEHIND EAR

Once you position the eye, ear, nose, and mouth, you can erase all of your guidelines and begin working in the details of the hair and eyes.

The line of the smile is drawn last because it actually adds nothing to the structure of the face.

3/4 VIEW

In this view, very little of the rear mass of the head (behind the ear) is visible. And, we see far more of the surface area of the near side of the face than of the far side.

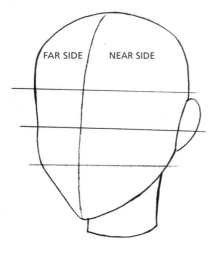

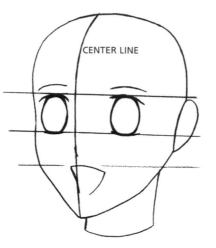

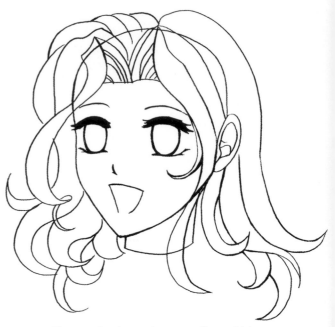

The same three horizontal guidelines that you used in the front view also apply here.

The vertical center line curves over the forehead, indicating the three-dimensionality of the face. The eyes, ears, nose, and mouth all fall in the same places along the horizontal guidelines as they did in the front view.

The part begins at the center line, which is slightly left of center in the 3/4 view.

Once you've got the placement of the features, you can fill in the details.

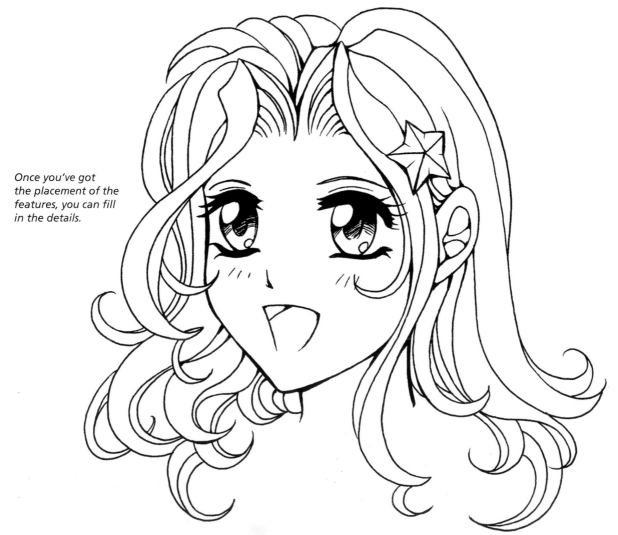

Rear Views

Most people never think about drawing rear views of the head—until they have to! When might you be called on to draw a character in such a pose? When two characters are talking to each other, the viewer looks over the back of the listening character at the face of the speaking character. And in this case, you'd need to draw the back of the listener's head. Of course, any scene in which a character turns and walks or runs away from the reader/viewer also requires a rear view.

REAR

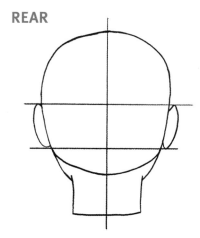
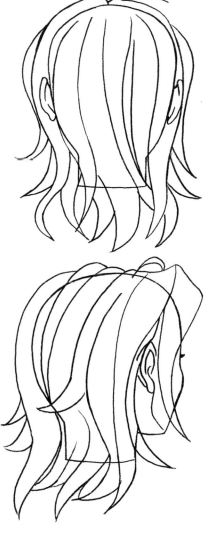
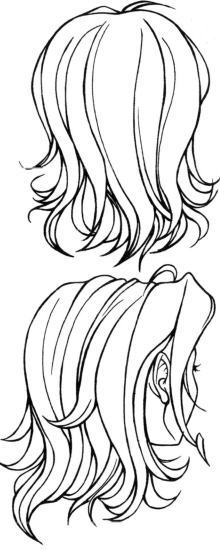

3/4 REAR RIGHT

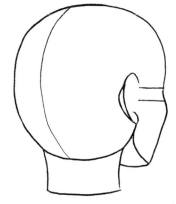

EXTREME (7/8) REAR RIGHT

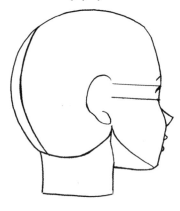
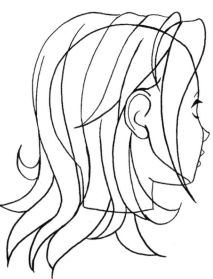
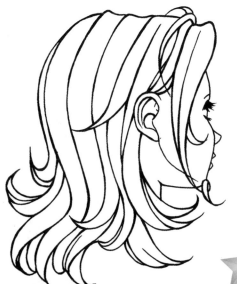

Low Angles

It's the most common question among beginning and intermediate artists: How do I draw a character in different positions and still make her look the same? The answer lies not in how you draw the eyes, the nose, or the mouth, but in your grasp of the overall shape of the head. Characters drawn from below and above look cool. These angles are used often by professional manga artists but almost never by amateurs. You can raise the level of your drawings to new heights by using these "head tilts." Continue to use the center line and the horizontal guidelines to correctly map out the face and help determine where to place the features once you tilt—or change the angle of—the head.

We'll start with low angles and then move on to high and rear views. Low angles are those in which you are below the subject, looking up at it. Low angles exhibit a mild amount of foreshortening. In other words, as the character's head tilts back, the spaces between the features—especially between the eyes and the nose—appear to compress and are drawn closer together than you would normally draw them.

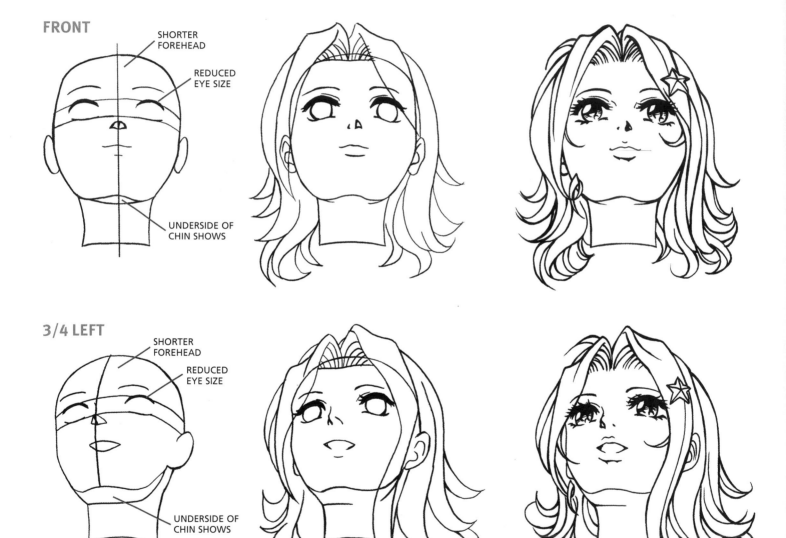

FRONT

SHORTER FOREHEAD

REDUCED EYE SIZE

UNDERSIDE OF CHIN SHOWS

3/4 LEFT

SHORTER FOREHEAD

REDUCED EYE SIZE

UNDERSIDE OF CHIN SHOWS

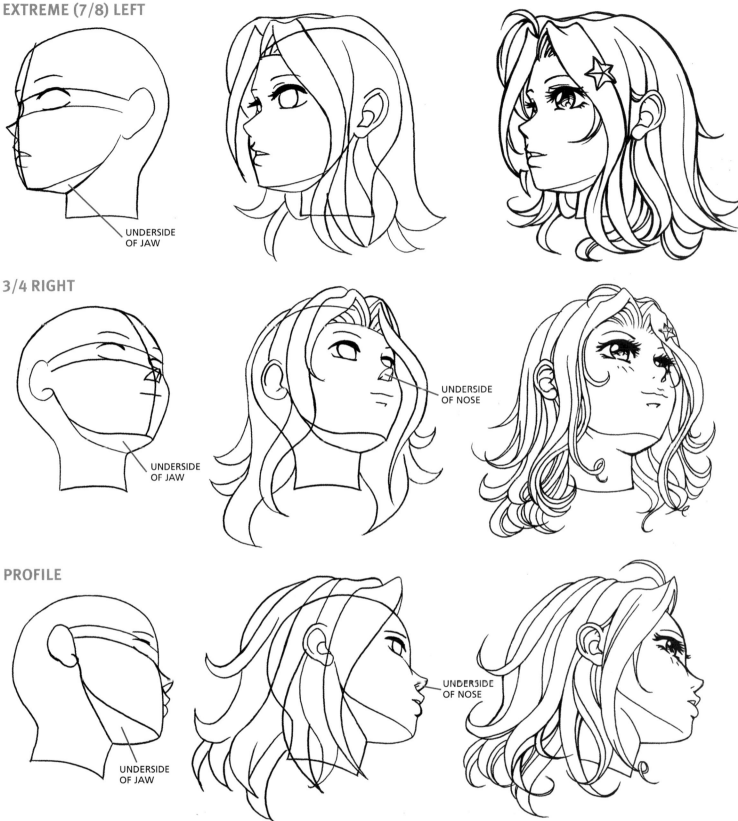

EXTREME (7/8) LEFT

UNDERSIDE OF JAW

3/4 RIGHT

UNDERSIDE OF JAW

UNDERSIDE OF NOSE

PROFILE

UNDERSIDE OF JAW

UNDERSIDE OF NOSE

A NOTE ABOUT ANGLES AND FRACTIONS
You can slice these fractions as small as you like. Simply turn the head a small notch to create a new angle. To help you visualize these positions and draw these angles accurately, you can purchase model busts or full-body wooden mannequins from art supply stores and Web sites.

High Angles

High angles are those in which you are positioned above the subject, looking down at it. As a result of the perspective involved in a high angle, the mouth and nose will look slightly compressed and, therefore, should be drawn closer together than they would appear in a neutral angle (when you are at the same level as your subject). The chin also diminishes in size in the high angle. And, you'll need to show more of the top of the head; as a result, more of the hair's part will be visible.

FRONT

MORE OF FOREHEAD SHOWS

MORE OF PART SHOWS

MOUTH AND NOSE ARE COMPRESSED

3/4 LEFT

EXTREME (7/8) LEFT, SLIGHTLY LOWER HIGH ANGLE

FAR SIDE OF CHEEK SHOWS

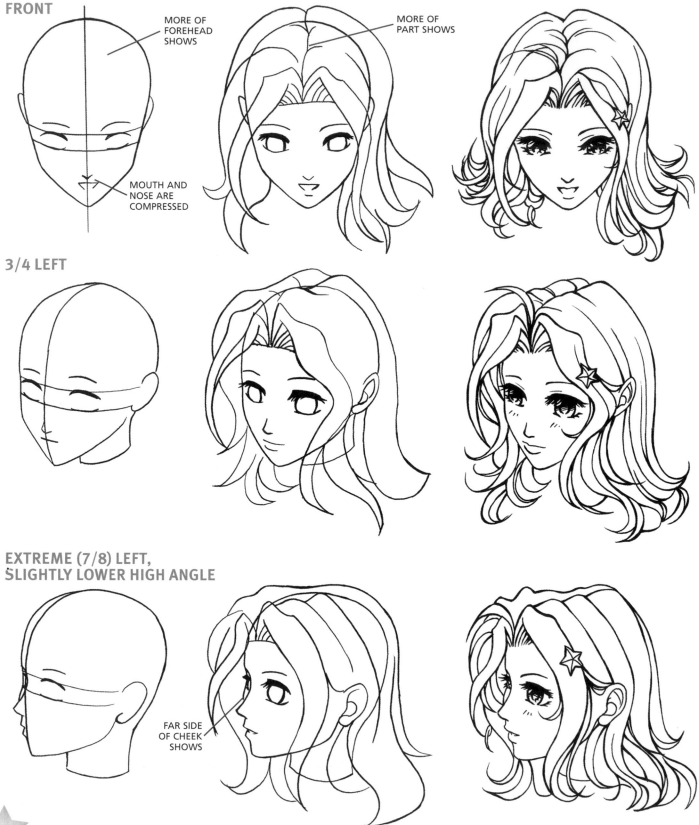

EXTREME 3/4 RIGHT

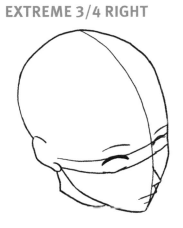

PROFILE (EXTREME HIGH ANGLE)

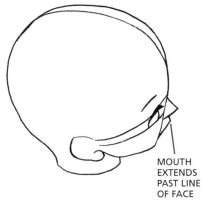 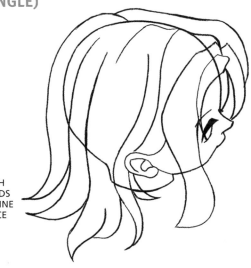

MOUTH
EXTENDS
PAST LINE
OF FACE

2/3 RIGHT

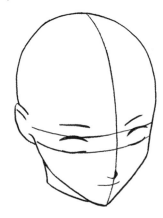 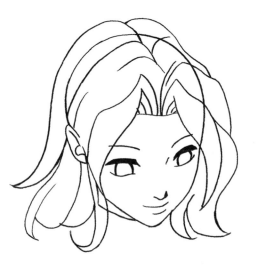

Expressions

Bishoujo characters look pretty, and some are even drop-dead gorgeous. But they've still got to have life to them. Their faces can't look like expressionless mannequins or fashion magazine cover models. Manga characters love, laugh, cry, rage, and pout. That's why they're so popular—because behind those pretty eyes, they're real people to whom everyone can relate.

The way to convey this is to create "elasticity of the face." That simply means that the face must be somewhat rubbery. Not a lot, but just enough to allow it to distort slightly for specific attitudes and expressions. For example, when a person is surprised the eyes widen, the mouth opens, and the face stretches slightly. The shape of the eyes also changes with the expression. Happy eyes are large, angry eyes are narrow, and sad eyes tilt downward at the outer corners.

This doesn't mean you should overlook the beauty of the character. A female character should look just as pretty when she's furious as she does when she's happy.

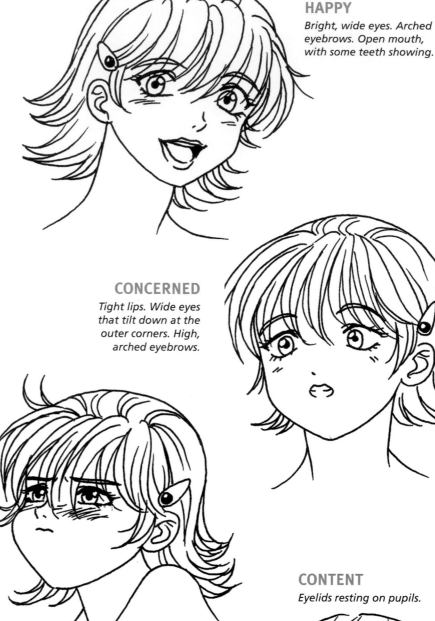

HAPPY

Bright, wide eyes. Arched eyebrows. Open mouth, with some teeth showing.

CONCERNED

Tight lips. Wide eyes that tilt down at the outer corners. High, arched eyebrows.

CONTENT

Eyelids resting on pupils.

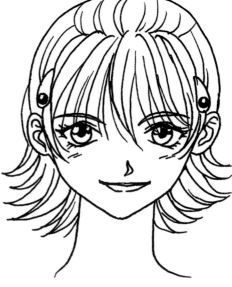

EMBARRASSED

A single line for the mouth. Furrowed eyebrows. Blush lines streaking across the face. (Note how the face is squashed and compressed.)

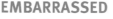

RESENTFUL

Top lip is bitten. Eyes are determined and half cut off by eyelids. Gaze is intense.

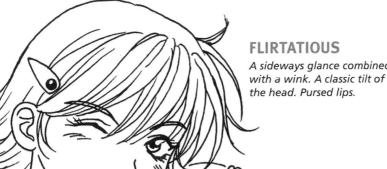

FLIRTATIOUS
A sideways glance combined with a wink. A classic tilt of the head. Pursed lips.

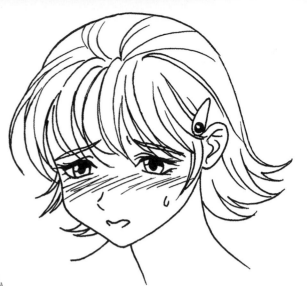

SORROWFUL
More than just unhappy, she's in emotional pain. Eyes and eyebrows tilt down at the outer corners. Blush marks cross the face. Eyes look down, reflectively, as a slight teardrop rolls down the cheek.

SUSPICIOUS
Gaze is directed out of the corner of the eyes, under heavy eyelids. One eyebrow is raised.

HURT
Eyes well up with tears. Eyebrows push together and upward.

PLEASED
Eyes closed. Eyebrows raised. Full-lipped smile.

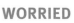

WORRIED
Eyebrows push together and upward. She bites her lower lip.

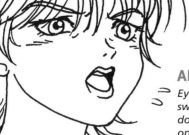

ANGRY
Eyebrows make a dramatic sweep downward and press down on the eyeballs. Mouth opens wide to voice protest. A few sweat drops around the head indicate stress.

Now that you've got some of the basics down, it's time for the fun part: drawing some very cool, very attractive bishoujo character types. These characters are all based on their roles (*fighter pilot* or *student*, for example) and on personality types. The process of deciding these aspects is called "character design," and it's one of the most satisfying creative areas in comics and anime. Even though this section still concentrates mostly on head shots (the body will come later), there will be an indication of the costumes, which also helps to define a character's occupation.

The schoolgirl is a *very* popular character type in manga. Schoolgirl types are ordinarily from twelve to seventeen years old. They're pretty, energetic, and stylish. They should have bright eyes and a squeaky-clean look, with bubbly personalities. Long hair isn't a requirement for the manga school girl, but it is one of the better looks for this type of character. Young female characters generally start out with long hair, and as they become women, their hairstyles usually become somewhat shorter.

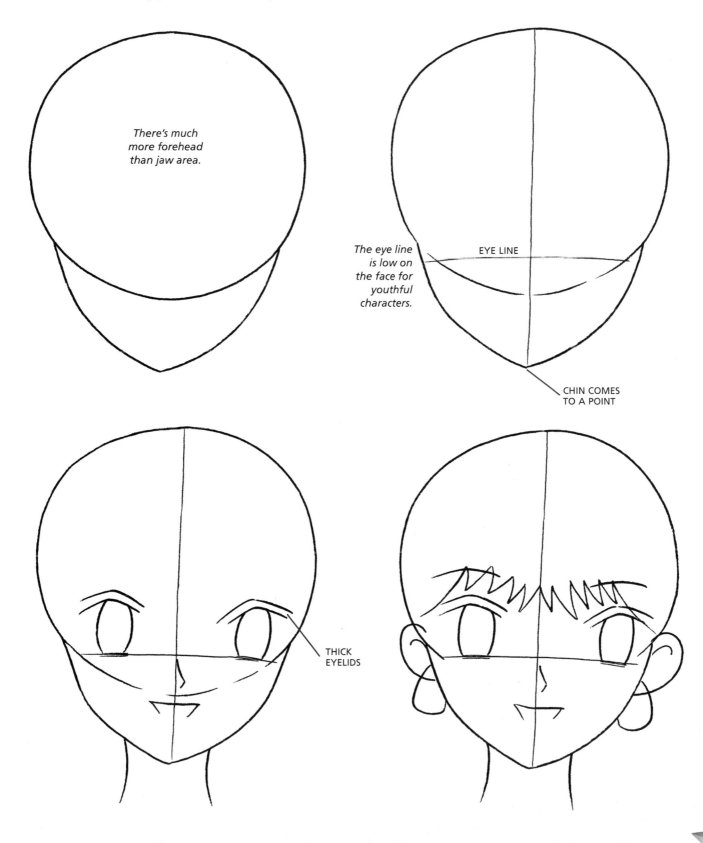

There's much more forehead than jaw area.

The eye line is low on the face for youthful characters.

EYE LINE

CHIN COMES TO A POINT

THICK EYELIDS

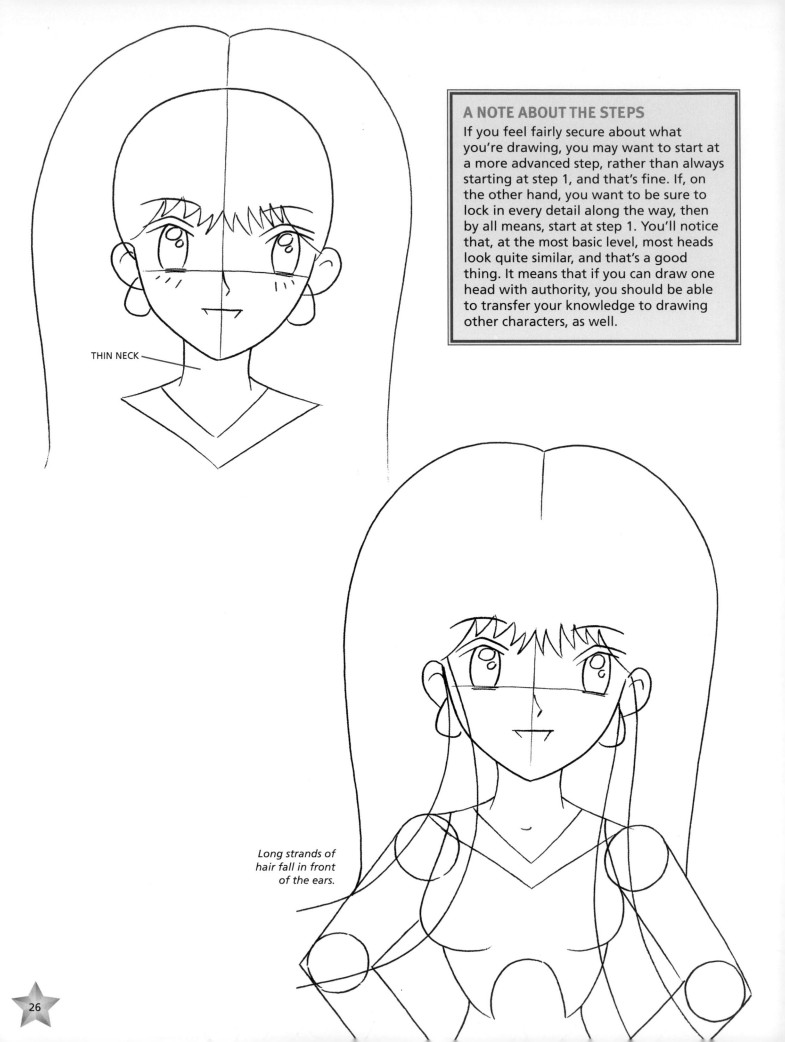

THIN NECK

A NOTE ABOUT THE STEPS
If you feel fairly secure about what you're drawing, you may want to start at a more advanced step, rather than always starting at step 1, and that's fine. If, on the other hand, you want to be sure to lock in every detail along the way, then by all means, start at step 1. You'll notice that, at the most basic level, most heads look quite similar, and that's a good thing. It means that if you can draw one head with authority, you should be able to transfer your knowledge to drawing other characters, as well.

Long strands of hair fall in front of the ears.

COLOR SUGGESTIONS

Basic Teen or Tween

Here's a simple but appealing profile you should try out. In other art styles, including American-style comics, eyeballs shown in profile always curve outward. But in manga, they curve inward. This gives them a sharp graphic look, which is desirable and has an authentic Japanese flair. The eyes are quite large on manga teens and tweenagers. If she were, say, twenty-five years old, I would make the eyes about two thirds as tall as they are here and more horizontal in shape. Although the pupil is quite slender in profile, there's still ample room to add the eye shines, which are a necessity. The long, flowing bands of hair that fall in front of the ears are an extremely popular look. Draw a few far bands of hair on the far side of the face, as this will prevent the character from appearing flat.

The hair on the far side of the face prevents the image from appearing flat.

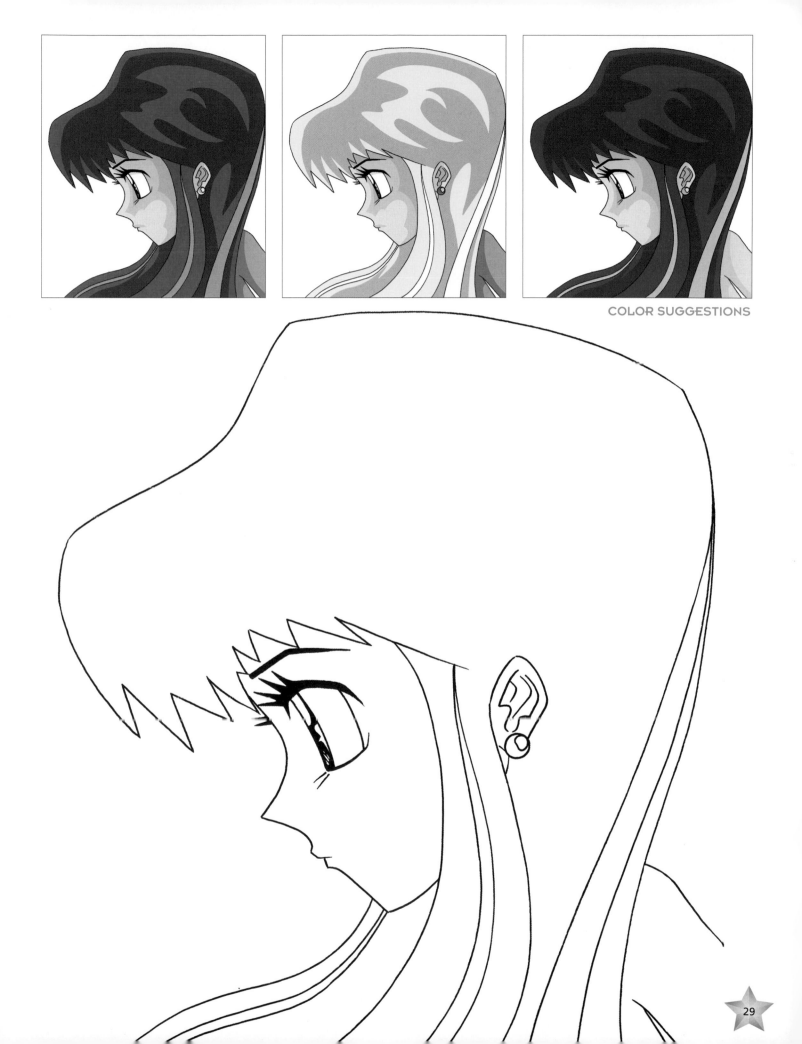

Space Ranger

Characters like this—spaceship and fighter pilots and the like—are the scene-stealers in Sci-Fi comics and most anime. In the profile, note how far out in front of her face her upper eyelashes extend. That creates added glamour, as does the high, angled eyebrow. The eyebrows should also be thin, to stress the femininity of the character. Remember, you've got to do all you can to bring out her feminine qualities when she's in such a tough-as-nails uniform. The mouth should be small but delicate, with full but petite lips. Strands of hair should fall over the eyes. And perhaps most importantly, she needs a high, nicely rounded jawline that gives her a soft look—not hard or angular.

In addition, remember the profile on the previous page? I noted that her large eyes were typical for a teenager but that an older character would have eyes that were more horizontal. Well, now you're looking at that older version. In fact, all I'd have to do to turn this character into a teenager would be to give her the same eyes as on the previous profile. So, it's important that the features you use match the age of the character you're drawing.

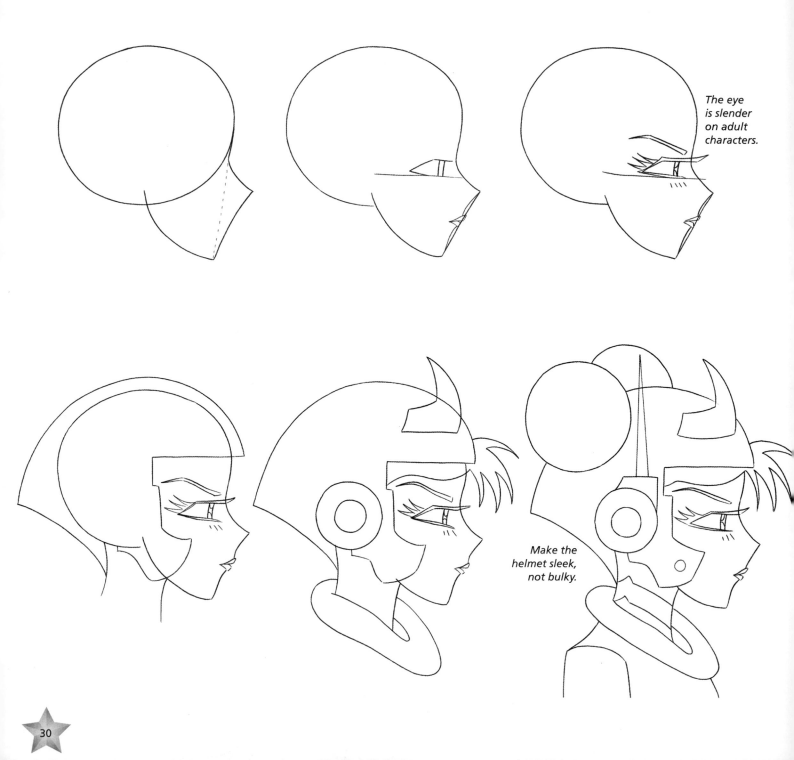

The eye is slender on adult characters.

Make the helmet sleek, not bulky.

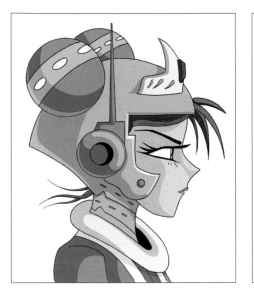
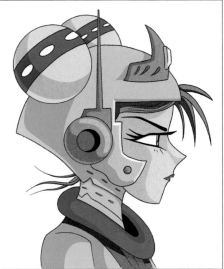
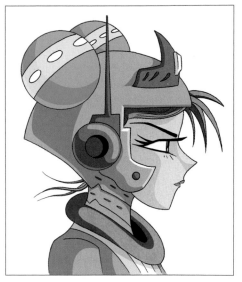

COLOR SUGGESTIONS

A NOTE ABOUT PROFILES

Logically, one would assume that if you can draw a left profile (page 29), you can draw a right profile without any trouble. You would think. But artists often find, to their dismay, that they naturally tend to favor certain angles over others, and so it's important to practice drawing both left and right profiles.

Perhaps the most important thing to notice about attractive manga profiles is that there's very little change of angle from the bottom of the nose to the top of the upper lip. It's all one diagonal line. Also, the chin always recedes. Keep these things in mind, and you won't go wrong!

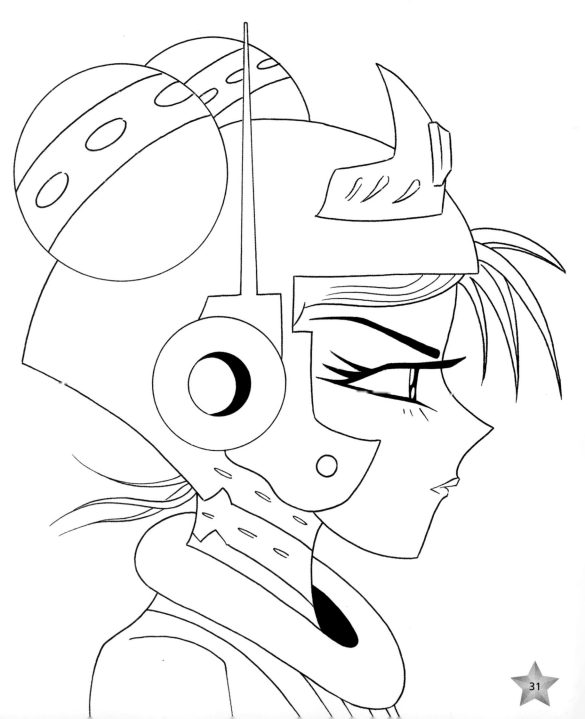

31

Trendy Girl

Here's a nice example of a short haircut. The current trend is to bunch the strands of hair into thick bands that taper to a point and drift in front of the face. Note that most of the important parts of the hairstyle occur just above the forehead. That's true of most characters, regardless of hair length. Short hair makes for a trendier, sharper character. The more traditional and Fantasy-style characters have long hair. (See pages 40–49 for more on drawing flashy hairstyles.) Again, notice how effective it is to draw petite lips. This leaves the face uncluttered. Also, the outward bend of the neck is distinctly feminine. A few pieces of jewelry and Asian-style hair accessories add a nice accent.

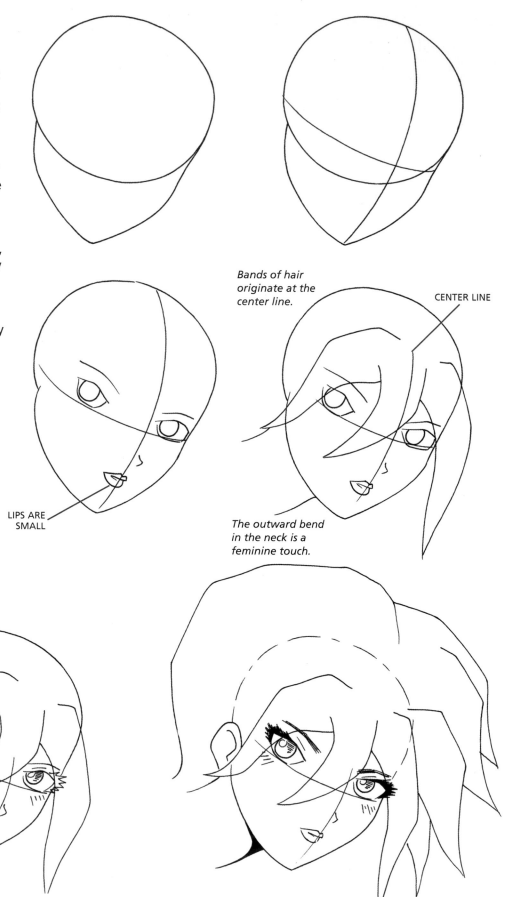

Bands of hair originate at the center line.

CENTER LINE

LIPS ARE SMALL

The outward bend in the neck is a feminine touch.

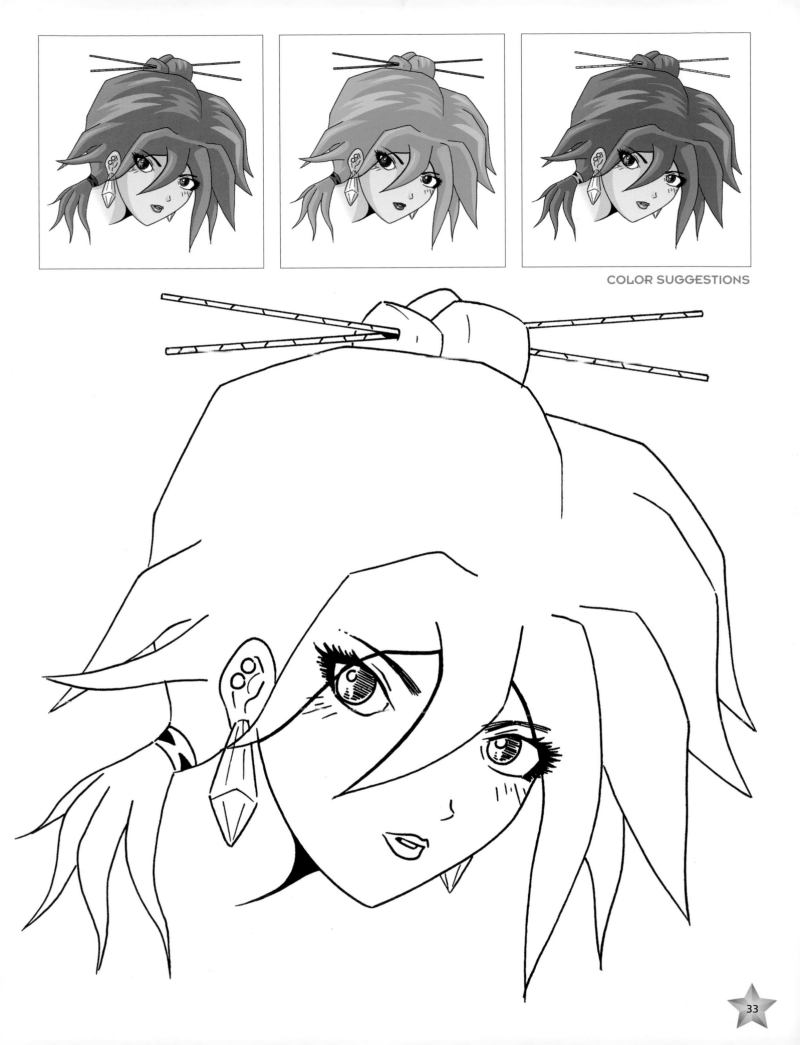

COLOR SUGGESTIONS

Dangerous Woman

A cold heart and a beautiful face make a thrilling combination in Action manga. Her eyes are as sharp as stilettos. The lashes, too. To create a dangerous look, draw the eyeballs peering up from under the eyelids. In other words, cut off the tops of the eyes with the eyelids. It adds a feeling of intensity. On good-natured characters, the eyebrows arch high above the eyes. The mouth should be small and taut, the lips almost pursed—as if she's not sure if she wants to kiss you or kill you. Cover parts of the face with wisps of hair to give her a mysterious look.

Hair falls over the eyes.

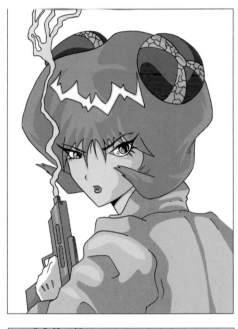

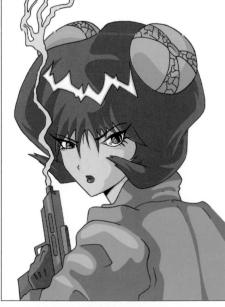

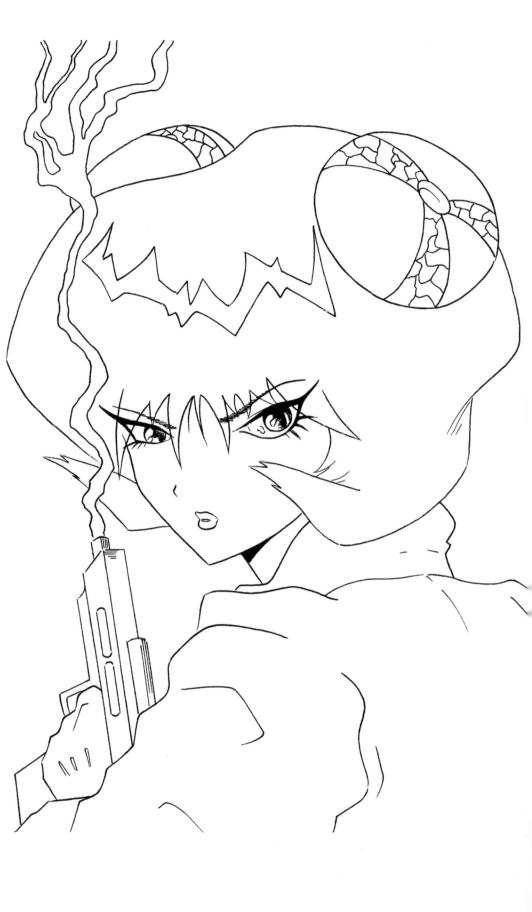

COLOR SUGGESTIONS

Fantasy Princess

The beautiful, alluring, and somewhat mysterious princess from another world is a very popular bishoujo character. You'll see this type across many different genres of manga, from shoujo (girls' comics) to Fantasy, Sci-Fi, and even some Occult and Horror. The fantasy princess should have an open, appealing face with big, wide eyes and a pleasant expression. Note the big pools of reflected light in the eyes; this is an important element in designing "good" characters (as opposed to "bad girls"). If you want to give her a tiara, keep it small, and be sure that you don't invent something that looks like a crown from the Middle Ages. That's corny. Her hair should have buns combined with flowing locks. That's the quintessential look for this character type.

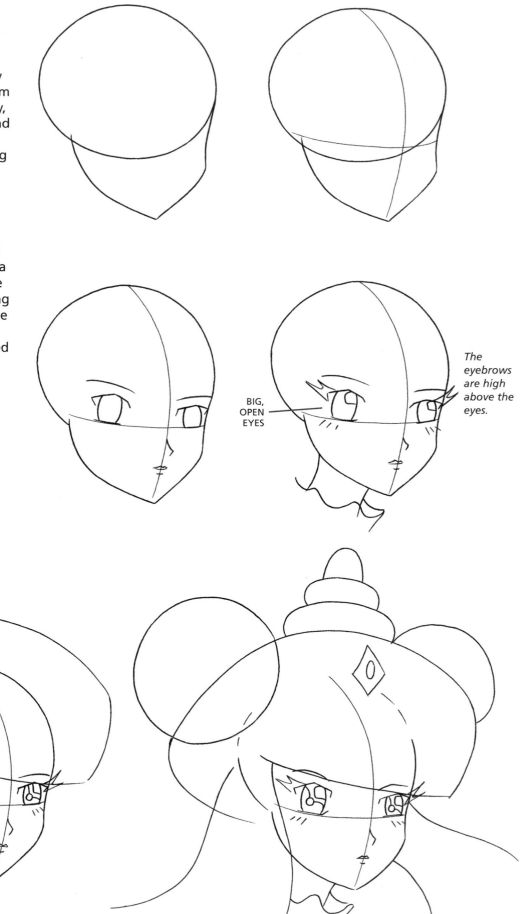

BIG, OPEN EYES

The eyebrows are high above the eyes.

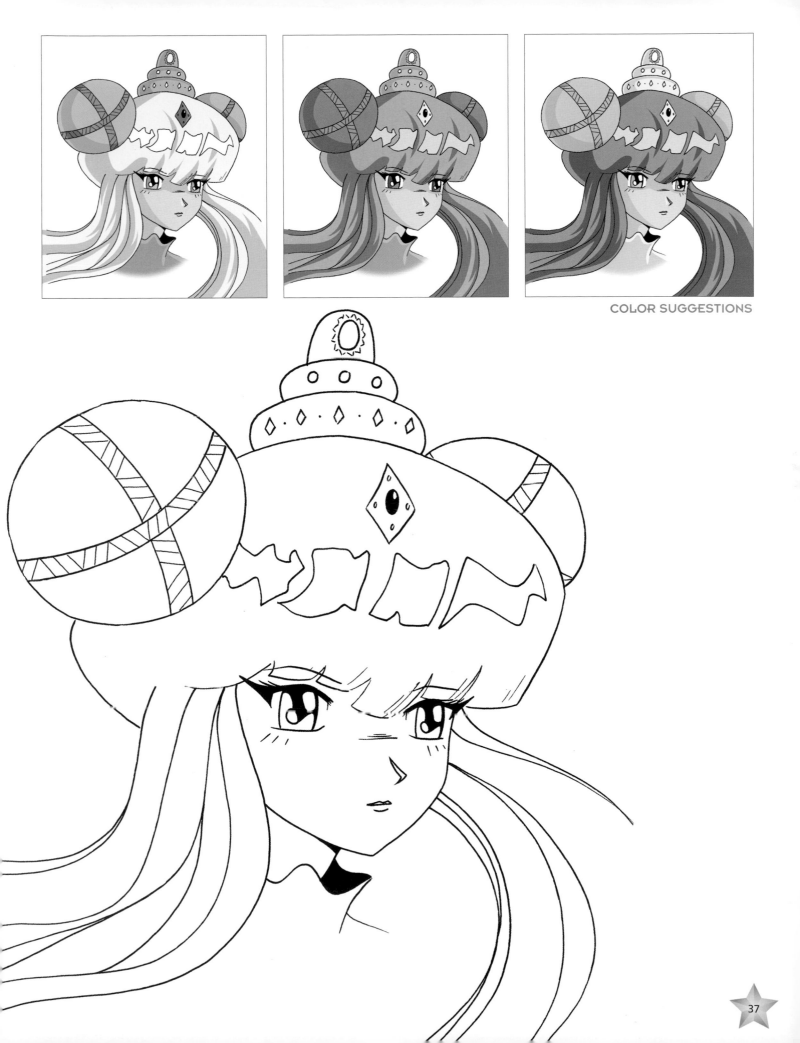

The Cheat

The *cheat* is not a character type; it's an important drawing technique, so I want to mention it here before we proceed. *Cheating* is drawing aspects of a figure or scene that, strictly speaking, wouldn't really be seen in that view from that angle. Even though this character is in a front view, she's angled slightly to the viewer's left and you're looking at her from an angle that's just slightly above her. These shifts are *cheats*, and they are so slight that they are almost imperceptible—but what they do for the drawing is considerable. Drawing the character subtly to one side allows the artist to draw the nose slightly to one side with a delicate cast shadow, which is more attractive than showing both nostrils flat on in a true frontal angle. And, even more importantly, turning the head slightly to one side results in a sleek jawline on one side of the face and a soft cheek area on the other, which brings out the character's femininity and keeps the image from being completely symmetrical (hence, less interesting).

SOFT CHEEK AREA

SLEEK JAWLINE

NOSE "CHEATS" LEFT

Pretty Girl

This is your basic pretty bishoujo character. The attractive manga woman has an elongated chin that comes to a point. But the rest of the head is rounded and soft so that the character doesn't come off as angular and hard.

When drawing a 3/4 view, always sketch in a vertical center line on the head, as in the first step here. Use this as a guide to help you determine the correct placement of the features. Note how, in this angle, the far eye is close to the center line, while the near eye is far from it. That eye placement it essential in a 3/4 pose, and the center line helps you get it down.

CHIN RECEDES

CENTER LINE

BISHOUJO
HAIR

Welcome to the Bishoujo Spa. Come in, our stylist will be with you shortly. We'll bypass the facials and foot scrubs, and go right to the pertinent stuff: drawing the flashy, trendy hairstyles that create the most mesmerizing bishoujo characters on Earth. Manga characters all have big hair. It's a hugely important element in every character's design—in fact, it will, when properly drawn, add glamour and brilliance to your character. It can be graceful or cutting edge. Either way, use it to make a statement.

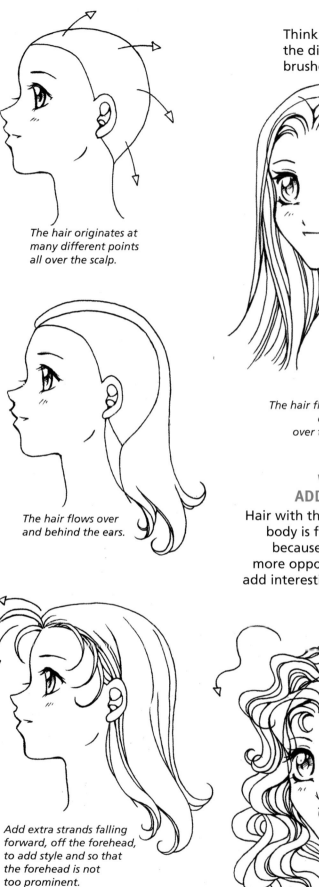

The hair originates at many different points all over the scalp.

The hair flows over and behind the ears.

Add extra strands falling forward, off the forehead, to add style and so that the forehead is not too prominent.

Think in terms of the direction the hair travels when combed and the direction it falls when loose. Start off with a simple hairstyle: brushed back, which is typical for younger teens and girls.

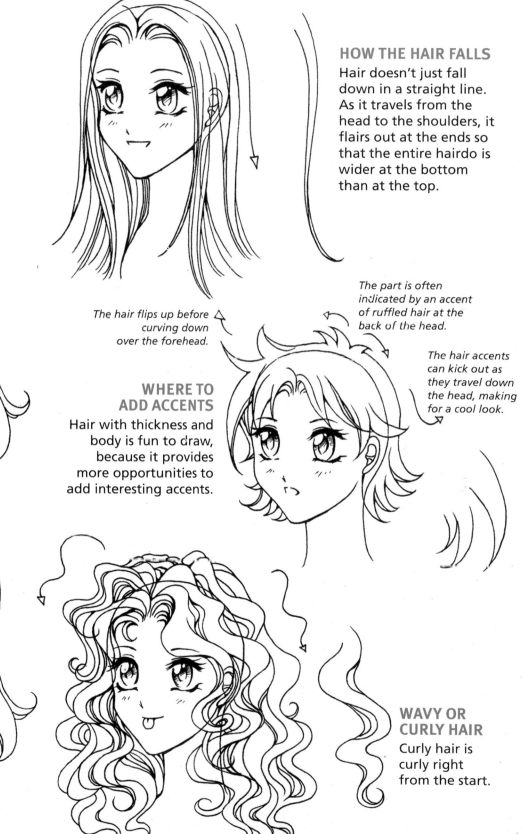

HOW THE HAIR FALLS

Hair doesn't just fall down in a straight line. As it travels from the head to the shoulders, it flairs out at the ends so that the entire hairdo is wider at the bottom than at the top.

The hair flips up before curving down over the forehead.

The part is often indicated by an accent of ruffled hair at the back of the head.

The hair accents can kick out as they travel down the head, making for a cool look.

WHERE TO ADD ACCENTS

Hair with thickness and body is fun to draw, because it provides more opportunities to add interesting accents.

WAVY OR CURLY HAIR

Curly hair is curly right from the start.

Windswept Hair

The most graceful and attractive hair is of the windswept variety. It also increases the effectiveness of Fantasy characters. Plus, it's exceedingly popular in the Magical Girl manga genre, in which school-age girls have magical powers. You should definitely add it to your repertoire. Here are the four basic windswept styles and drawing techniques.

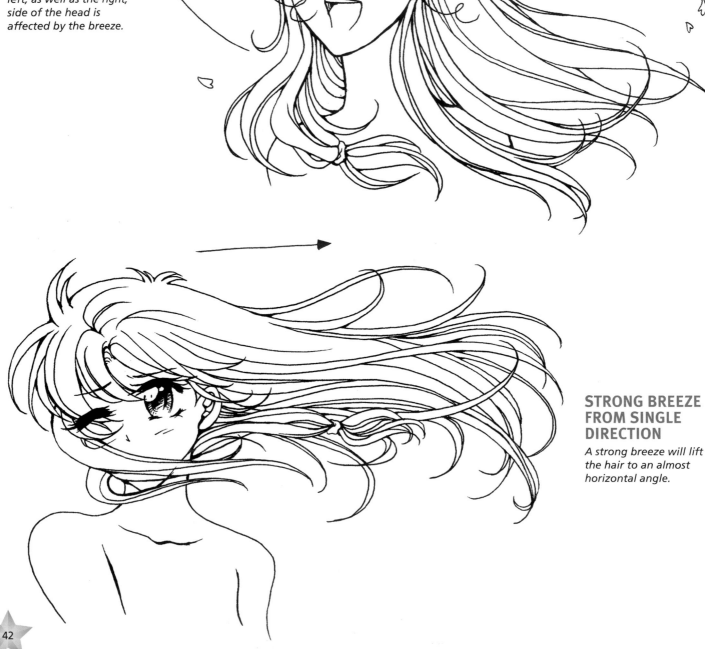

SOFT BREEZE FROM SINGLE DIRECTION

A soft breeze will cause the hair to blow at a diagonal. Most of the action occurs at the bottom of the hairstyle, where the hair gathers. Note that the hair on the left, as well as the right, side of the head is affected by the breeze.

STRONG BREEZE FROM SINGLE DIRECTION

A strong breeze will lift the hair to an almost horizontal angle.

NONDIRECTIONAL BREEZE

This is a breeze that doesn't come from a clear direction. This windswept approach is good to use to reflect the character's emotional state. For example, if she's bewildered, then having the wind upset her hairstyle reinforces what she's feeling.

FANTASY WINDSWEPT HAIR

In this very popular style, there's no breeze at all; rather, the hair seems to float by itself in graceful, swirling patterns. This is a very appealing technique, especially for characters with special powers.

Braids, Ponytails, and More

You can combine one, two, or more of these ponytails and other elements on a character to create elaborate, fanciful hairstyles. The more elaborate hairdos suit Fantasy and Magical Girl characters best.

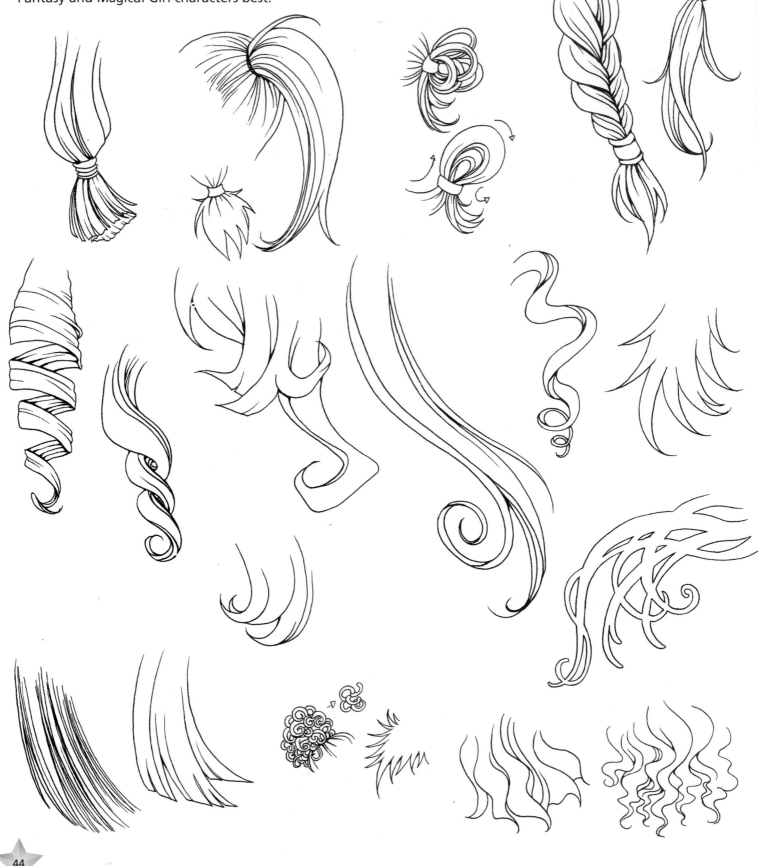

Short and Trendy Hair

Short hair can be very attractive, very sharp looking. It's a great match for hip, cosmopolitan characters. Their clothes will also have to match their hairstyles; in other words, no flowing robes or fantasy gowns for short-haired bishoujo characters. They get short skirts, tight jeans, or Sci-Fi body-hugging space suits.

Long Hair

On real people, long hair means shoulder length, more or less. On bishoujo characters, however, it can mean as long as the entire figure! But remember, the longer the hair, the more swirls you must add to it to keep it looking graceful. In addition to bringing out the supergraceful qualities of female characters, long hair is also the best approach for drawing enchanted beings, such as faeries, elves, and any type of princess.

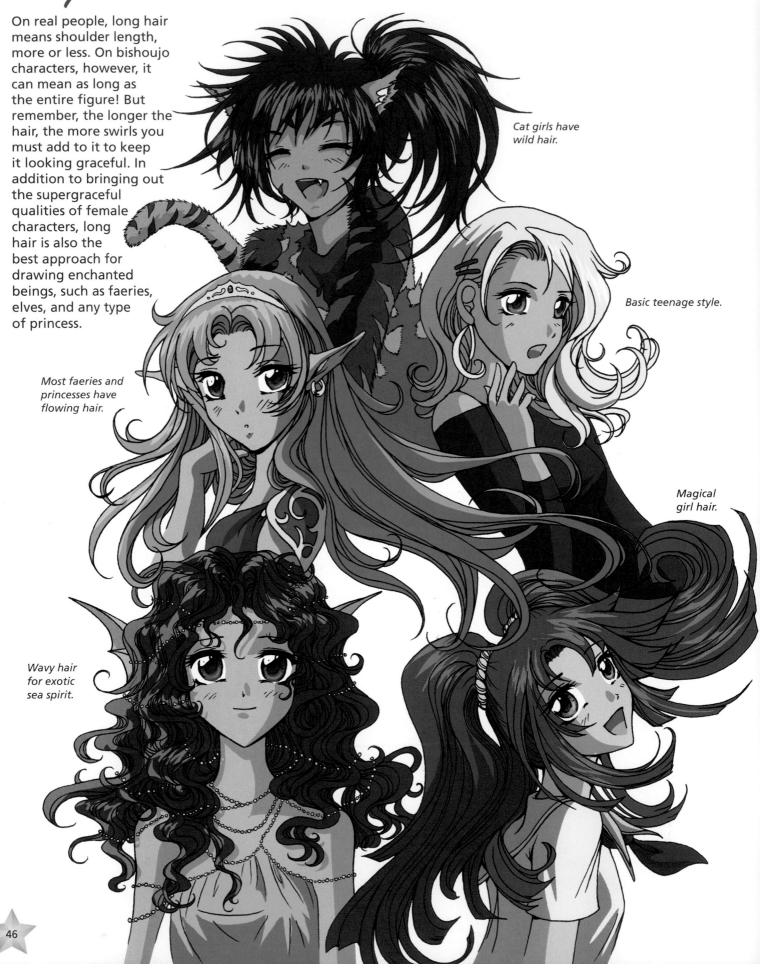

Cat girls have wild hair.

Basic teenage style.

Most faeries and princesses have flowing hair.

Magical girl hair.

Wavy hair for exotic sea spirit.

Medium Length Hair

You can also split the difference between short and long to create hairstyles with a medium length. This is the most common style for the sweet, girl-next-door type, but you can also use it on many other characters, too. Bangs, scarves, flower accessories, clips—you can use the whole shebang to spruce up your character.

Basic medium length, with barrettes.

Basic medium length with bandanna.

Headband of flowers and twigs for faeries.

Basic meduim length, without barrettes.

Straight bangs for villainous characters.

The Wild Side of Hairstyles

You can go as far out as you like with the hair, provided that it's consistent with your vision for the character and her costume. Aren't these cool?

A NOTE ABOUT HAIRSTYLES AND CHARACTER DESIGN

Keep in mind that the hairstyle reflects the personality of the character. For example, a wicked queen will have an extreme and sharp hairdo, while a pretty tomboy will have a scruffy hairstyle.

Change a Hairstyle, Change a Character

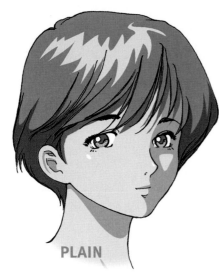

PLAIN

TRENDY

While you cannot create an entirely new character simply by changing the hairstyle, the hairstyle is, perhaps, the single most significant element in carving out a character's visual identity. By altering the cut, shape, and length of the hair, you'll go a long way toward inventing a new character. Most of the time, new characters aren't so much created from scratch as they are reinvented from the old. By making a costume change and a few adjustments to the eyes, you'll add a new player to your cast.

FUN-LOVING

PRINCESS

INTELLIGENT

WEIRDO WITCH

THE BISHOUJO BODY

In addition to facial expression, the figure is an important tool for communicating feelings to the reader; using it will make your manga more successful. The common problems beginners have are getting the proportions and shapes of the major body parts correct. The legs and neck end up way too long, for example, or the hips and chest are much too skinny. But by starting with a basic construction of the female figure, you can easily avoid these problems. Once you get this down, you can move on to the more advanced poses and costumes that help your characters convey the emotion of the story.

ARMS DOWN

In the construction drawing, the chest and hip areas are sketched as ovals, with the chest being the larger of the two. Drawing these ovals first, and the frame of the body around them second, establishes the correct proportions at the outset. The horizontal line at the top of the chest (the collarbone) creates a strong visual plane. It's often drawn at an angle, which makes the pose more dramatic. The line of the hips tilts in the opposite direction than the collarbone.

When down, the relaxed arm will hang at mid-thigh level. The legs are approximately 25 percent longer than the arms.

LINE OF THE SHOULDERS

LINE OF THE HIPS

ARMS UP

When the arms are raised above the head, the collarbones bend at the pit of the neck, forming a wide V. The breasts lift and flatten. The outer breast tissue wraps around the deltoid (the shoulder muscle), as indicated on the detail.

To make sure the weight is distributed correctly, you need to find the center of balance. To do this, draw a straight line from the pit of the neck to the ground. In this case, *her* right heel is the center of balance. And since more of her body mass appears to the left of the equilibrium line, she must lean slightly back to the right to maintain balance.

The outer upper breast area wraps around the inner deltoid (shoulder muscle).

CENTER OF BALANCE

3/4 View

When you turn the body in a 3/4 view (halfway between a front and a side view), the center line becomes all-important. Serving the same function as it does when you draw the head, the center line runs vertically through the center of the body. It's not used to indicate balance but is a guideline to divide the body equally in half. When the body is turned 3/4 of the way around, the halfway point (and, therefore, the center line) will appear to be 3/4 of the way over. In addition to aiding the artist in visualizing the body correctly, the center line helps the artist draw the costume in the correct proportions. Belt buckles, zippers, and buttons often appear down the middle of the body, so they naturally fall on the center line.

In addition, artists use circles—spheres, really (because they're envisioned as three-dimensional)—to represent the various joints of the body. This serves as a reminder that the joints have mass. Many beginners draw joints that are far too thin, so this is a good technique to use.

The neck is wedged down into the chest area and not simply pasted on top of it.

CENTER LINE

Although the center line appears to travel through the near breast in this angle, it doesn't; rather, everything has just been drawn see-through to show the construction, and in this pose, the near breast overlaps the center line. It's really in front of it.

FEET ON DIFFERENT LEVELS

When the body is turned, perspective comes into play. The near leg will, therefore, appear longer than the far one.

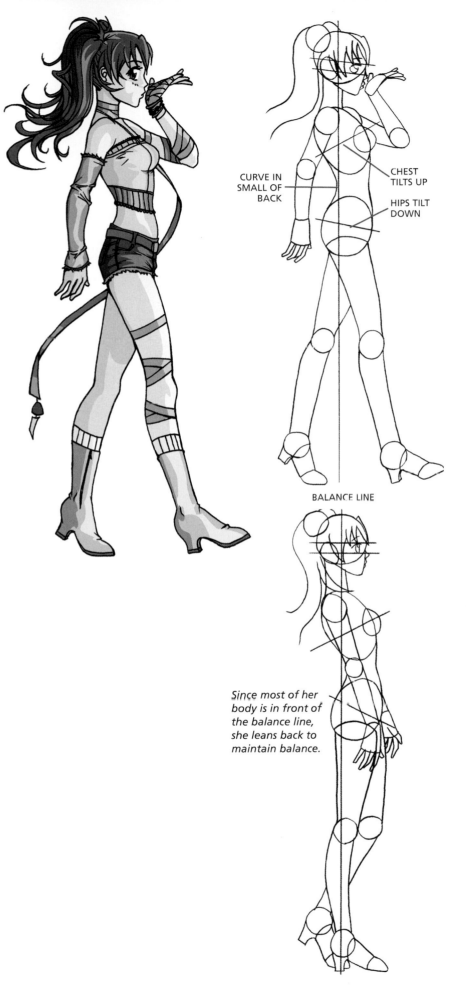

Side View

In the side view, the chest tilts up slightly while the hips tilt down slightly, as indicated by the horizontal guidelines. These two forces combine to create an attractive curve in the small of her back. Also observe the shoulder socket: it should fall within the oval of the chest area. And here's one more item to keep in mind: even though it's only slightly noticeable, the far foot must be placed a tiny bit higher than the near foot, due to the effects of perspective (when things that are farther away from us appear smaller than things that are closer to us).

CURVE IN SMALL OF BACK

CHEST TILTS UP

HIPS TILT DOWN

BALANCE LINE

Since most of her body is in front of the balance line, she leans back to maintain balance.

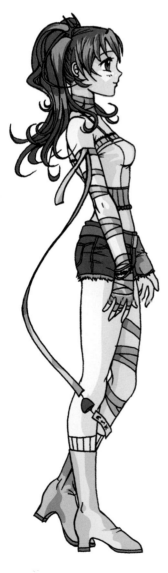

Back View

A pose tends to look more natural if the weight of the figure is distributed unevenly. The leg that carries most of the weight is the straight one. The relaxed leg shifts away from the body, with the knee slightly bent, sometimes barely touching the ground with the toes. As the relaxed leg moves away from the center of the body, it pulls some of the body in its direction. You can see this by looking at the line of the spine, which pulls away from the central balance line in the direction of the relaxed leg.

BALANCE LINE

TRAPEZIUS MUSCLE

Less of the neck is visible in the back view than in the front view. That's because the trapezius muscle (which rises from the shoulders to the base of the neck) obscures it. In the front view, there is no similar muscle to obscure the neck.

RELAXED LEG IS SLIGHTLY BENT

WEIGHT-BEARING LEG IS STRAIGHT

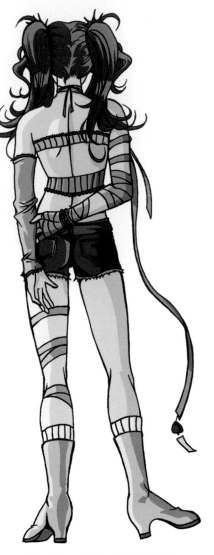

WEIGHT ON LEFT LEG

BALANCE LINE

RELAXED LEG IS SLIGHTLY BENT

WEIGHT-BEARING LEG IS STRAIGHT

WEIGHT ON RIGHT LEG

Drawing Pretty Hands

You can't draw your characters with their hands in their pockets or behind their backs and not expect everyone to realize that you're hiding your inadequacies. Hey, I understand the frustration: you've drawn a good character, and you're afraid you might ruin it if you show the hands. Be brave! You're probably a lot closer to drawing a convincing hand than you realize. Here are some tips that will get you drawing hands like a pro.

FINGERS HAVE THREE JOINTS

THUMB HAS TWO JOINTS

JOINT AT BASE OF THUMB

Pay attention to the joints in the fingers. Each finger has three joints.

Each finger is a different length, but the pinky is a real shrimp.

JOINT AT BASE OF THUMB

The thumb has a moveable joint at its base, which is pronounced. This is what gives the thumb its width.

When having trouble, study your own hand in the pose you are trying to draw. But, if you're a guy, keep in mind that a woman's hand is narrower than yours.

NAIL TIP VARIATIONS

FLAT ROUND POINTED TRIMMED

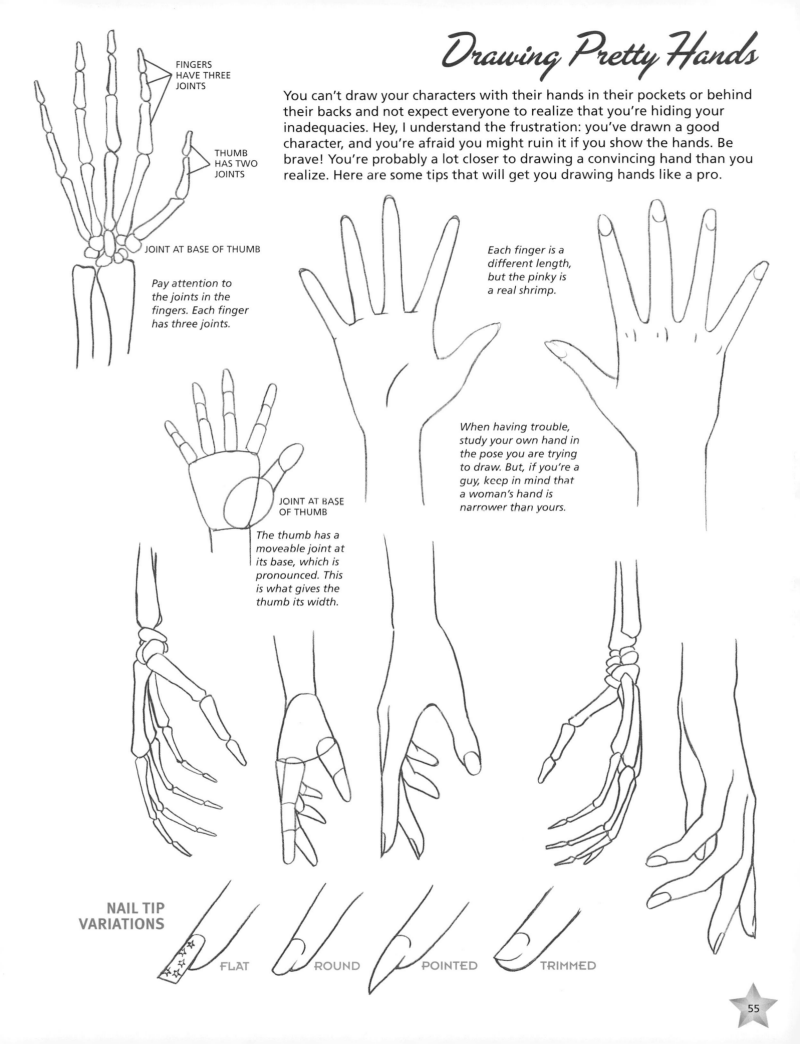

Hand Poses and Accessories

You can draw hands in all sorts of expressive poses, even using extreme foreshortening (bottom right). You can also liven up your hands by adding rings, bracelets, hand guards, gloves, gold chains, and even mysterious tattoos.

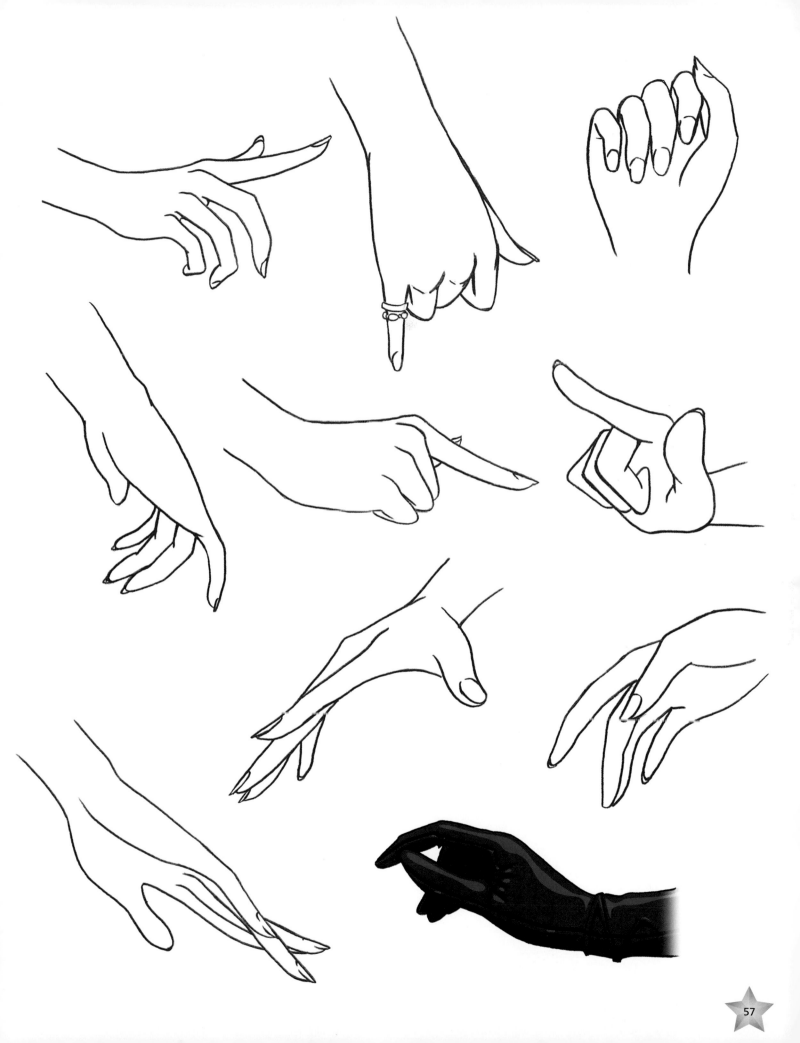

Feet, Shoes, and Boots

A woman's foot will always appear more attractive when the heel is lifted off the ground. This holds true whether your character is wearing stiletto shoes or space-fighter-pilot boots. The elevated heel causes the bridge of the foot to slope downward, elongating the look of the leg and creating a smoothly tapered appearance.

Feet in high heels make the legs look longer.

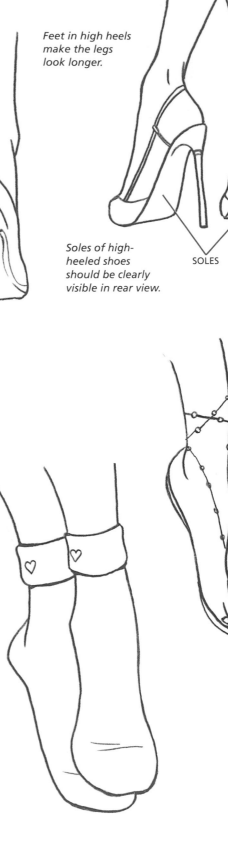

Soles of high-heeled shoes should be clearly visible in rear view.

SOLES

BRIDGE OF FOOT
SLOPES DOWNWARD

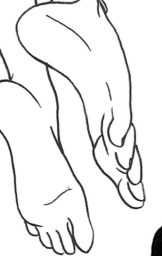

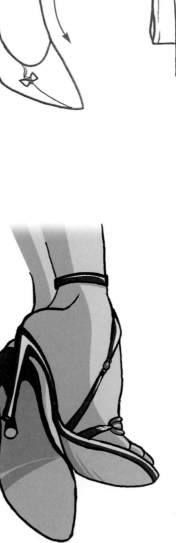

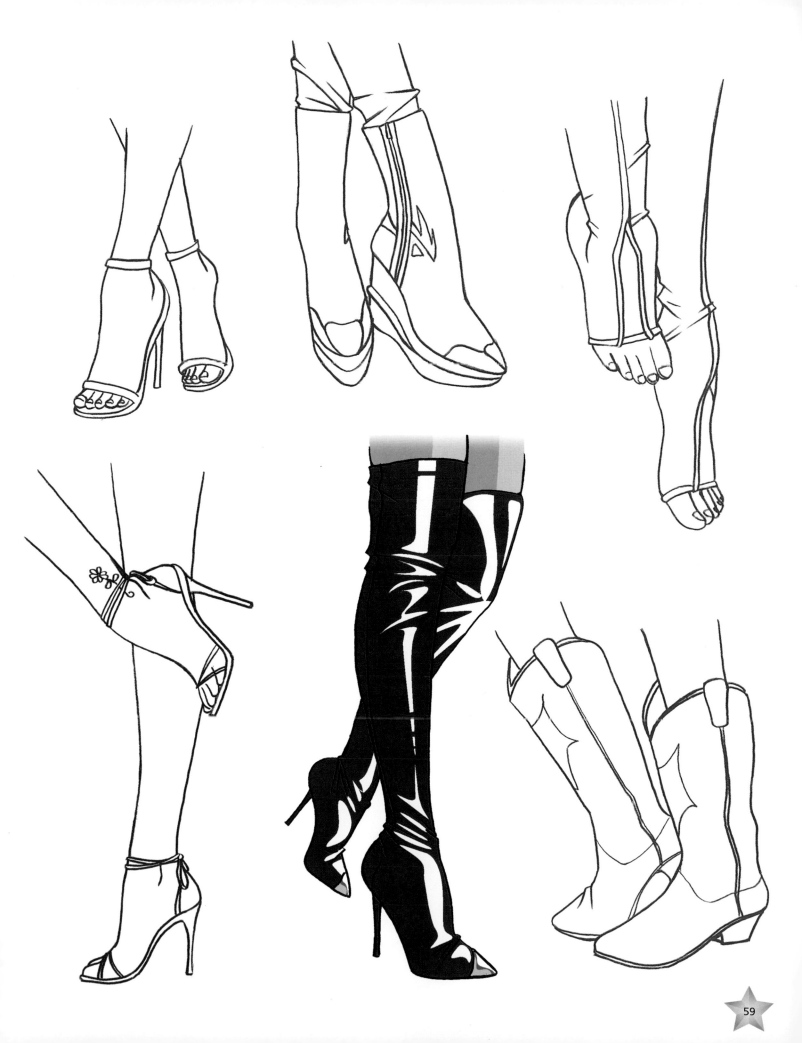

Stylish Figure

Let's put some costumes together with poses so that the personalities of the characters come through. This is a playful pose that works well with this attractive character, who wears stylish, casual clothing. To create a playful look, keep the figure light on her feet, with a bounce to her walk.

 Broken down into its elements, this lively and appealing pose is actually quite easy to draw. It might not seem that way if you only look at the finished drawing, but if you examine the first construction step, you can see how the pose breaks down. That's what you should be fixing your mind on. Most of the important decisions are made in the first construction step. With that locked in, you're actually more than halfway done, and everything else falls into place. By making sure you begin at the first step, you're starting to draw correctly; most people start at the final stage and, consequently, never get it right and have no clue why.

SHOULDER UP FOR A PLAYFUL LOOK

A low-cut sweater is attractive.

Long sleeves are stylish.

Bell bottoms are retro!

This is a 3/4 pose, so look back at the 3/4 figure on page 52 if you feel you need a quick refresher.

To get a figure that conveys that sultry look, draw long arms and legs. Give her a thin, long waist area, and separate the breasts across the chest. Also, widen the shoulders and show a clearly defined collarbone; wide shoulders on thin, sexy women always create an appealing look.

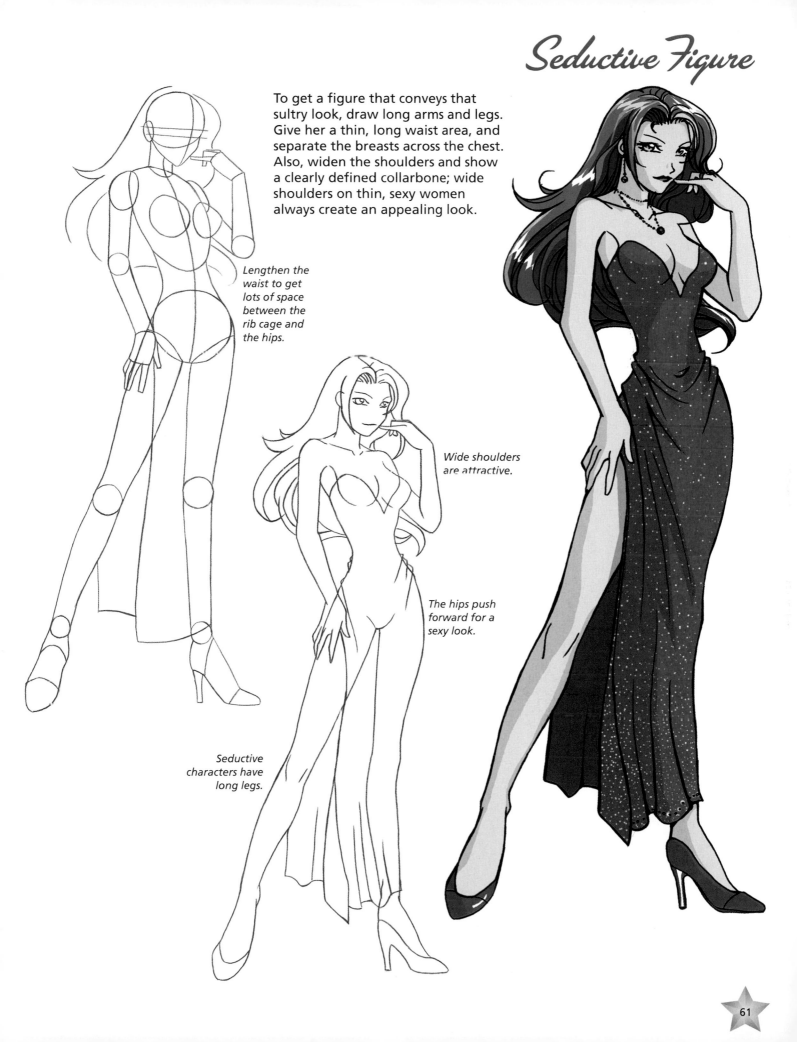

Lengthen the waist to get lots of space between the rib cage and the hips.

Wide shoulders are attractive.

The hips push forward for a sexy look.

Seductive characters have long legs.

Cool Figure

You definitely can't wear this to your next job interview, but for bishoujo characters, it's sensational! Sometimes, the clothes are so dramatic that you should let them do most of the work. For example, this character's pose is subdued to give the viewer a chance to get a good look at her flashy costume. With the long coat and the belt flapping in the wind, the outfit provides all the movement the figure needs.

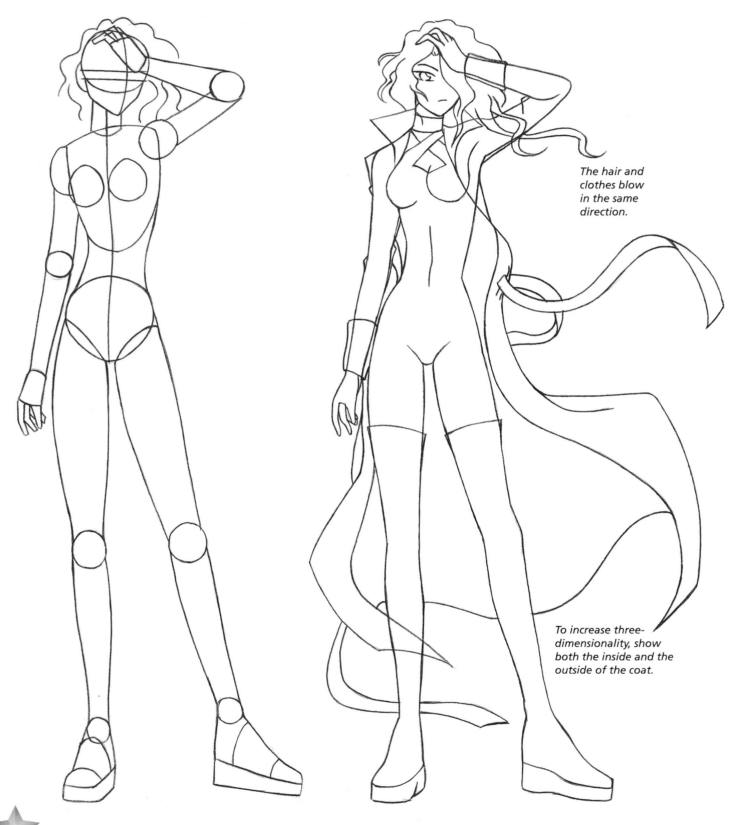

The hair and clothes blow in the same direction.

To increase three-dimensionality, show both the inside and the outside of the coat.

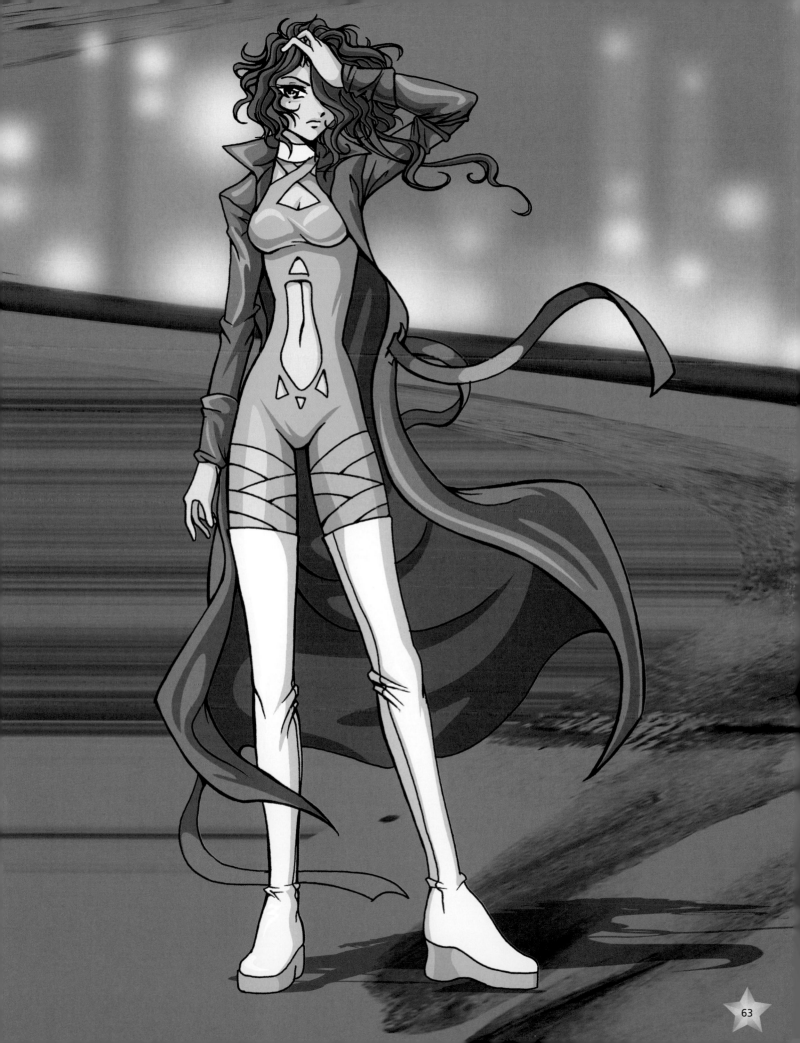

Warrior Figure

In keeping with her character, this figure is more athletic and rugged than the previous examples. She's an expert with the longbow. A wide stance is used to add stability. Archers are an important part of the Fantasy genre. They dress as if they were from the medieval peasant class; in other words, no armor, which was a trapping of the elite classes back then.

Even though she has a warrior's heart, she should still have attractive features, such as dark eyelashes, a petite mouth and nose, and dramatic hair.

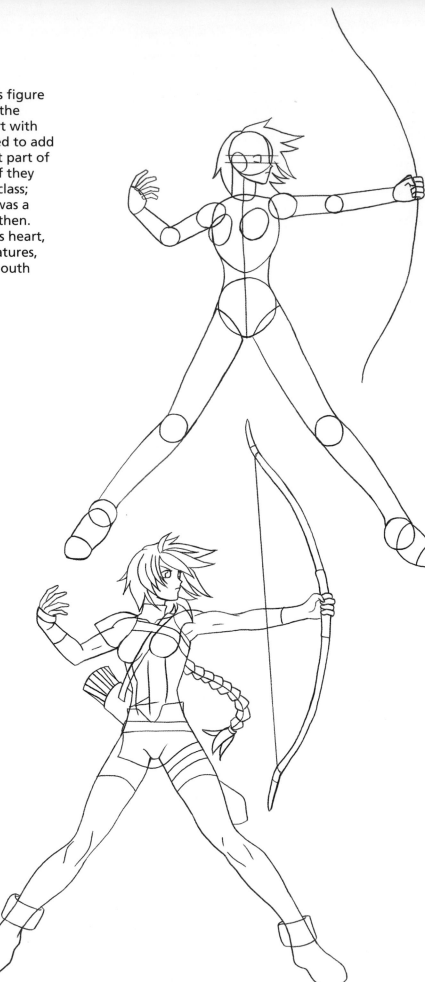

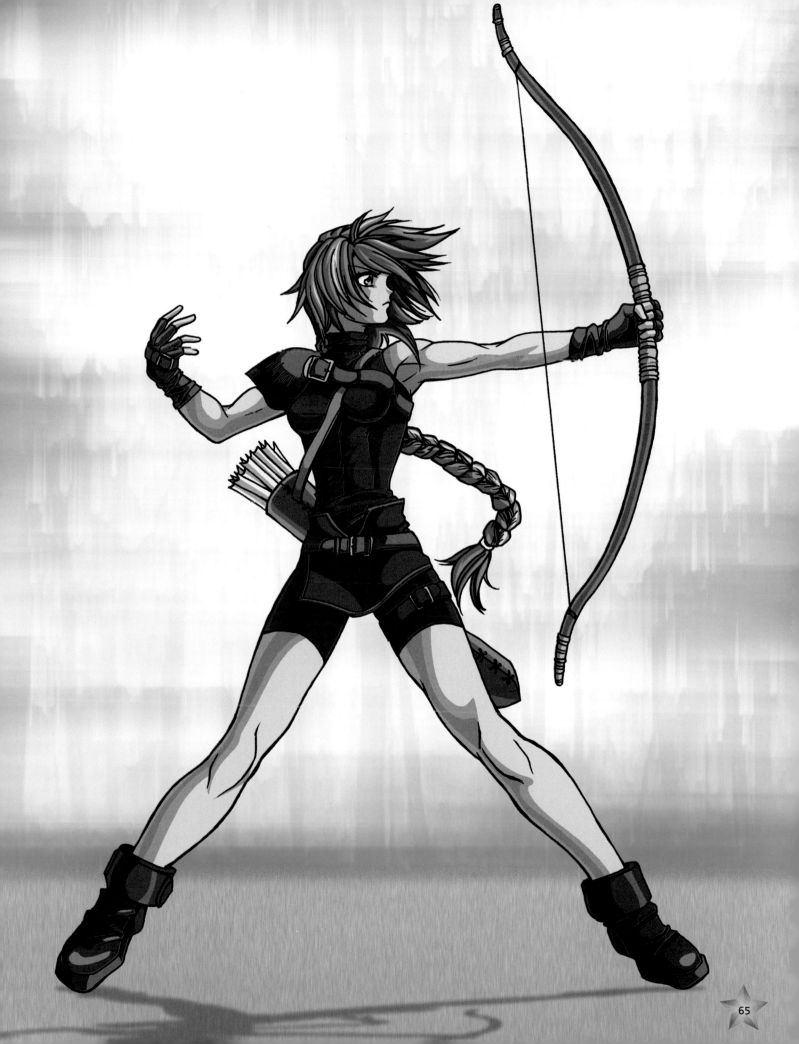

Posture and Emotion

In comics, characters communicate through words in speech balloons. But if words were enough, artists wouldn't need to draw facial expressions. Likewise, if facial expressions alone did the trick, there would be no need for dynamic poses. However the truth is that, we need the whole shebang: the words, facial expressions, and expressive posture.

Posture reflects the inner turmoil of a character. Positive emotions (such as joy), as well as forceful emotions (such as anger), require postures in which the chest is held out. Negative emotions (such as cowardice, sneakiness, and sadness) require postures with a sunken chest. Depending on the emotion, the shoulders tense up or droop, the head is either held high or low, and the spine stiffens or bends. Take a look at some of the ways the body typically conveys mood.

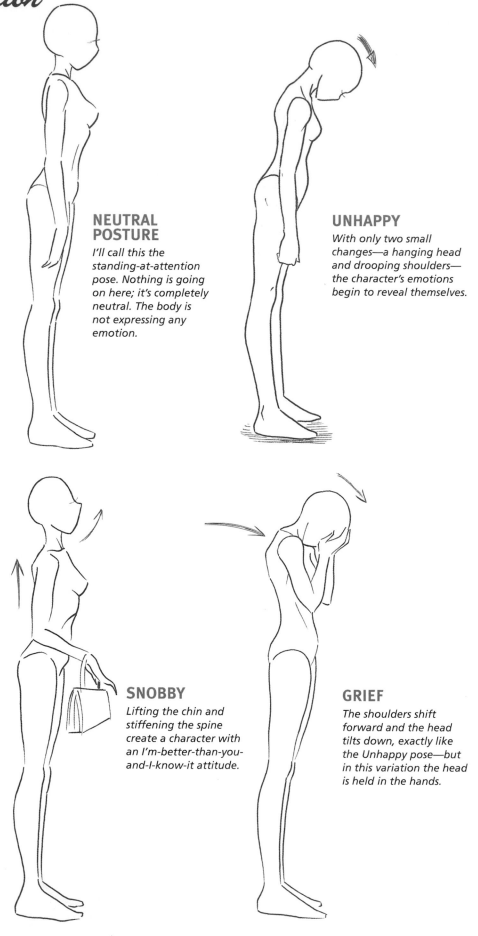

NEUTRAL POSTURE

I'll call this the standing-at-attention pose. Nothing is going on here; it's completely neutral. The body is not expressing any emotion.

UNHAPPY

With only two small changes—a hanging head and drooping shoulders—the character's emotions begin to reveal themselves.

SNOBBY

Lifting the chin and stiffening the spine create a character with an I'm-better-than-you-and-I-know-it attitude.

GRIEF

The shoulders shift forward and the head tilts down, exactly like the Unhappy pose—but in this variation the head is held in the hands.

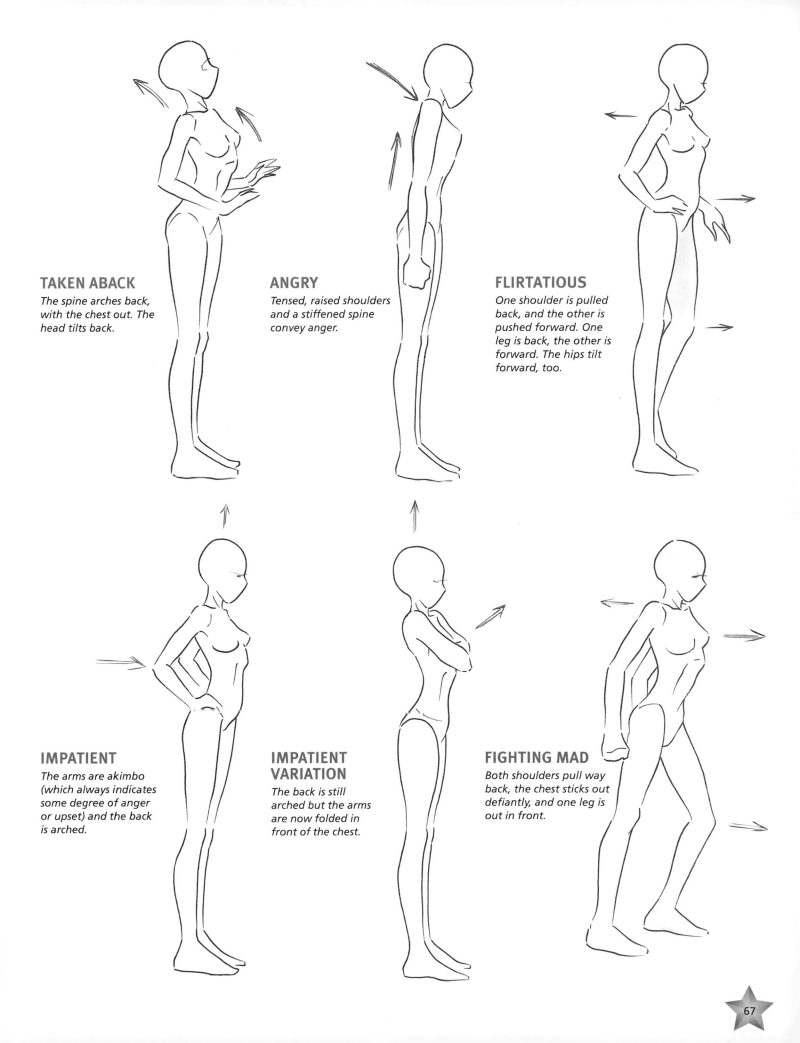

TAKEN ABACK

The spine arches back, with the chest out. The head tilts back.

ANGRY

Tensed, raised shoulders and a stiffened spine convey anger.

FLIRTATIOUS

One shoulder is pulled back, and the other is pushed forward. One leg is back, the other is forward. The hips tilt forward, too.

IMPATIENT

The arms are akimbo (which always indicates some degree of anger or upset) and the back is arched.

IMPATIENT VARIATION

The back is still arched but the arms are now folded in front of the chest.

FIGHTING MAD

Both shoulders pull way back, the chest sticks out defiantly, and one leg is out in front.

Emotions on Finished Figures

Now let's go one step further and vary the angles of the poses on finished figures. You'll see that despite the more elaborate rendering, the attitude reads just as clearly as it did before, because it's based on the body *posture*, not on the smaller details. The facial expressions assist the body language, making a strong statement even stronger.

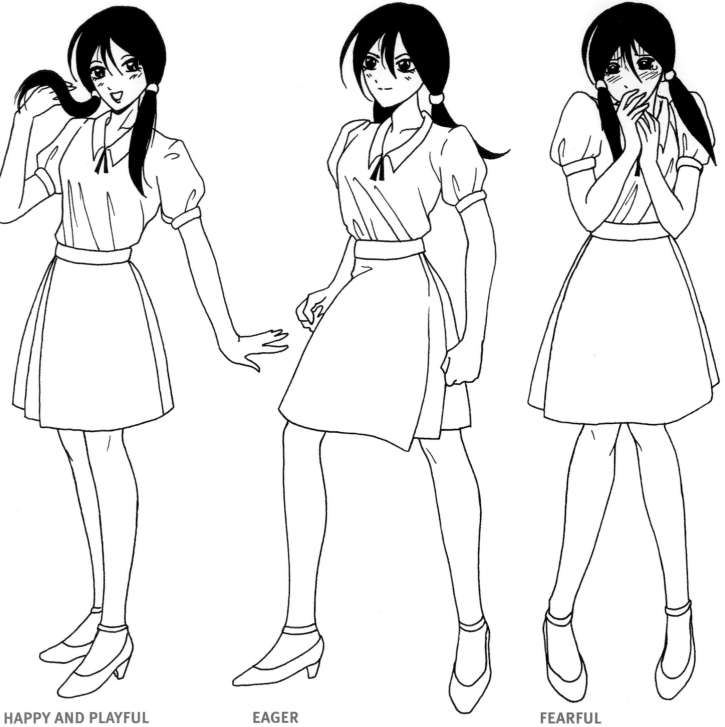

HAPPY AND PLAYFUL

An arched spine combines with a playful twist of one ponytail.

EAGER

This is similar to the Fighting Mad pose on page 67, but less intense.

FEARFUL

The knees knock together in a sign of weakness, the chest is sunken, and the shoulders rise nervously.

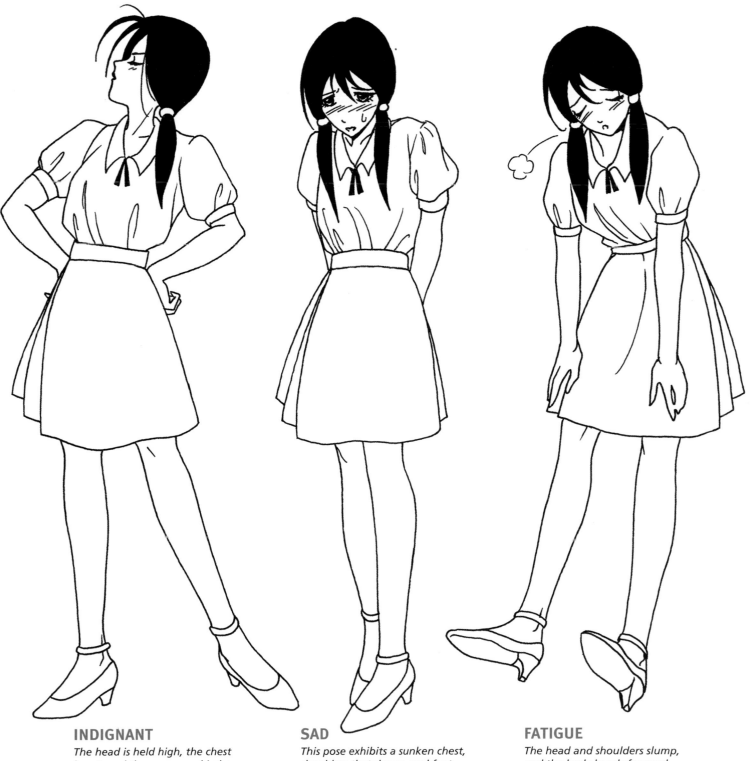

INDIGNANT

The head is held high, the chest is out, and the arms are akimbo.

SAD

This pose exhibits a sunken chest, shoulders that droop, and feet that turn slightly inward (always a sign of weakness).

FATIGUE

The head and shoulders slump, and the body bends forward in a sign of sapped strength.

Advanced Body Language

There are many ways to portray an emotion through body language. But ultimately, the most important tool you have is your own gut instinct. After you rough out a drawing, pause a moment to see whether it conveys the emotion you're trying to portray. If it doesn't, then you've still got work to do. But if you can look at your drawing and say, "Yeah, she looks tired [or happy or in love or whatever emotion you're after]," then you've nailed it and you can proceed. It's your job to be the final arbiter of what works and what doesn't. This section contains a few more advanced poses that you can copy exactly as they are for practice or that you can use as a springboard when developing your own original characters.

FLIRTATIOUS

The head tilts down, nesting in the shoulder. This is classic, flirtatious posture.

IMPATIENT

Sometimes, a simple action will read more clearly than an overly detailed pose. Instead of gritting her teeth and clenching her fists, all this character has to do is check her wristwatch for us to know what's happening.

READY TO GET EVEN

Clenched and half-clenched fists telegraph emotions clearly.

ETHEREAL

Sometimes you'll want to draw an angel, a princess, or a faerie whose mere presence is a harbinger of good things. These characters can appear out of nowhere, like apparitions, to guide characters to safety. The body language is straightforward and open, never cryptic. She's usually portrayed, at least in the establishing shot, in a front view with open arms and a relaxed posture.

STALKING

When your character is tracking down a criminal, for example, how would she go about doing it? Would she hold her gun down by her side or up at the ready? Would she be flat-footed or up on her toes? Would she look straight ahead, or would she flash a look over her shoulder so that no one could sneak up on her?

LONELY

Having a character hug herself is a very effective way to communicate, through body language, the fact the character feels entirely alone in the world.

INDECISIVE

The head tilt and the hand near the head are surefire signs that the character is weighing what to do next.

POUTING

Arms folded across the chest usually mean defiance, but with the head turned backward, it's a signal to her boyfriend that she's not buying his story. Her closed eyes help the idea.

EXHAUSTED

It's not enough for her to huff and puff—not if she's really spent. Her body must also be out of fuel; therefore, her posture is slumped, just like the standing version on page 69.

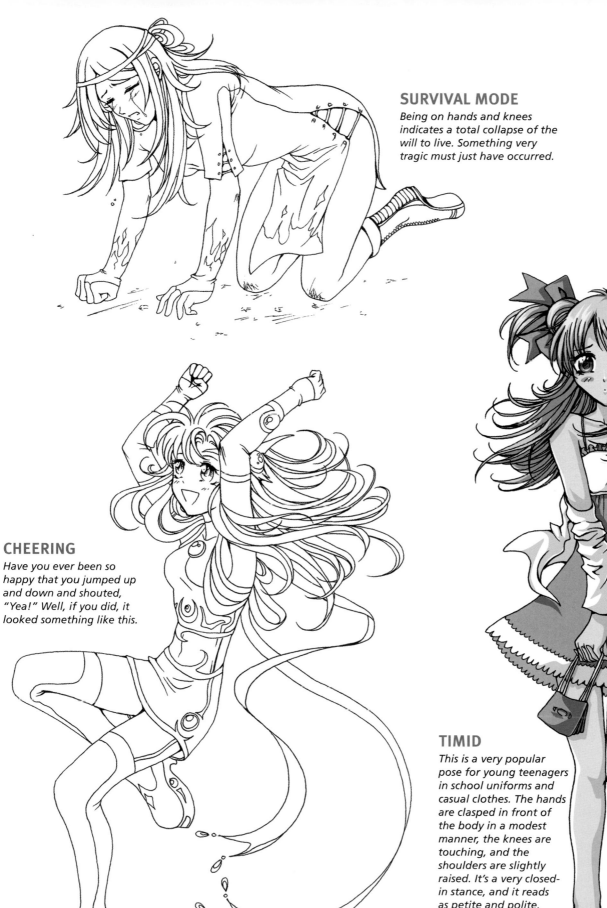

SURVIVAL MODE

Being on hands and knees indicates a total collapse of the will to live. Something very tragic must just have occurred.

CHEERING

Have you ever been so happy that you jumped up and down and shouted, "Yea!" Well, if you did, it looked something like this.

TIMID

This is a very popular pose for young teenagers in school uniforms and casual clothes. The hands are clasped in front of the body in a modest manner, the knees are touching, and the shoulders are slightly raised. It's a very closed-in stance, and it reads as petite and polite.

Turning a Plain Pose into a Sexy One

What makes a pose sexy? First of all, a sexy pose is fluid, never stiff. Generally, the legs are placed apart or one leg bends more than the other. This causes the hips to tilt to one side, which is essential for a sexy pose. Don't position the hips square; they must be tilted unevenly if they are to be attractive. You can also push the hip area forward, which causes the figure to lean back and the breasts to rise up slightly.

SHIFTING THE LEG

Simply moving a leg further to one side dramatically improves a pose. When you do this, it's not just the legs that are affected. The entire body adjusts, like a set of dominoes falling into place. Look at the line of the hips and shoulders: the hips appear curvier and the shoulders more severely angled.

BENDING THE LEG

As one leg bends, the arch in the small of the back increases and the rear end pushes outward, accentuating the curves of the figure more. The upper back also adjusts, leaning back slightly, which in turn causes the breasts to lift slightly.

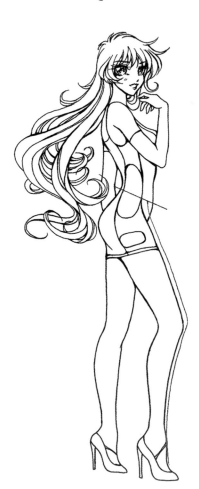

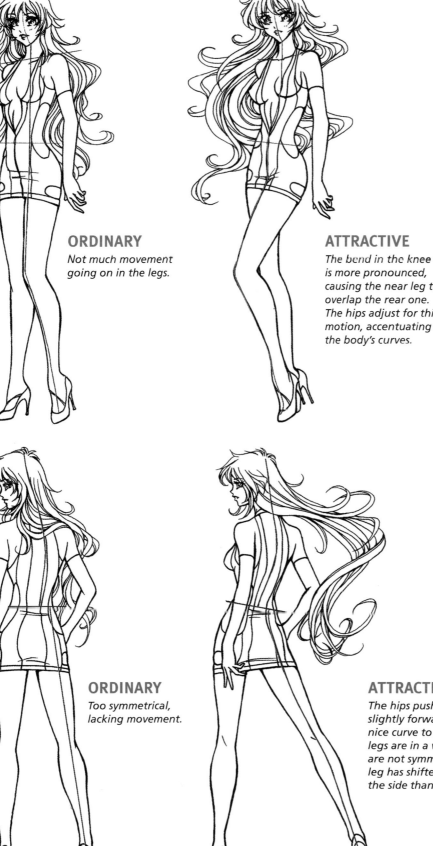

Comparing these before-and-after examples will give you an idea of what you're looking for.

ORDINARY

Not much movement going on in the legs.

ATTRACTIVE

The bend in the knee is more pronounced, causing the near leg to overlap the rear one. The hips adjust for this motion, accentuating the body's curves.

ORDINARY

Too symmetrical, lacking movement.

ATTRACTIVE

The hips push to the left and slightly forward, revealing a nice curve to the back. The legs are in a wider stance but are not symmetrical; the right leg has shifted out farther to the side than the left one.

ADVANCED ACTION POSES

These are the razor-sharp, cutting-edge bishoujo characters—the sexy but dangerous women of the Action

Sci-Fi manga genre. These poses are a little more complex, but fear not, because we're going to take this step by step, just as before. You can call it the Master Class in Drawing Manga. We'll start with the overall form, then work toward the details. By doing that, you'll be amazed at how simple it really is, even when drawing these advanced poses.

What Makes an Action Character?

The Action gals of bishoujo are usually about twenty to twenty-five years old. Sometimes this bishoujo Action genre is referred to as *bijo*. In this style, characters of this age have heads that are not as large in comparison to their bodies as the younger characters and schoolgirls. The proportions of the bodies are more realistic, and the eyes are not so huge. In addition, these are characters on a mission, sent by the secret service to rescue someone or complete some other equally dangerous assignment. They don't wear anything that would get in the way of accomplishing their goals. They're sharp, pretty, and highly attractive characters.

MILITARY CHARACTERS

Military characters like this commando gal have been through the gauntlet. They're tough and proud. They look you straight in the eye.

When drawing commando gals, I suggest that you make her look as if she has crawled through a few trenches and left behind a few garments in the process. It makes her mission look more dramatic than if she's wearing a starched uniform.

Classic Action Character Pose

This crouching posture is famously employed by spy characters working undercover. As she infiltrates enemy territory, she must take care not to reveal her presence. Therefore, her body language tells us she's hiding, tucking everything in. Keep the shoulders tensed and the character's back slightly hunched in a pose like this. The arm that holds the gun should either be held straight or should be bent and at eye level—both ways show the character on edge, ready for a split-second response.

Draw the entire leg before you draw the boots.

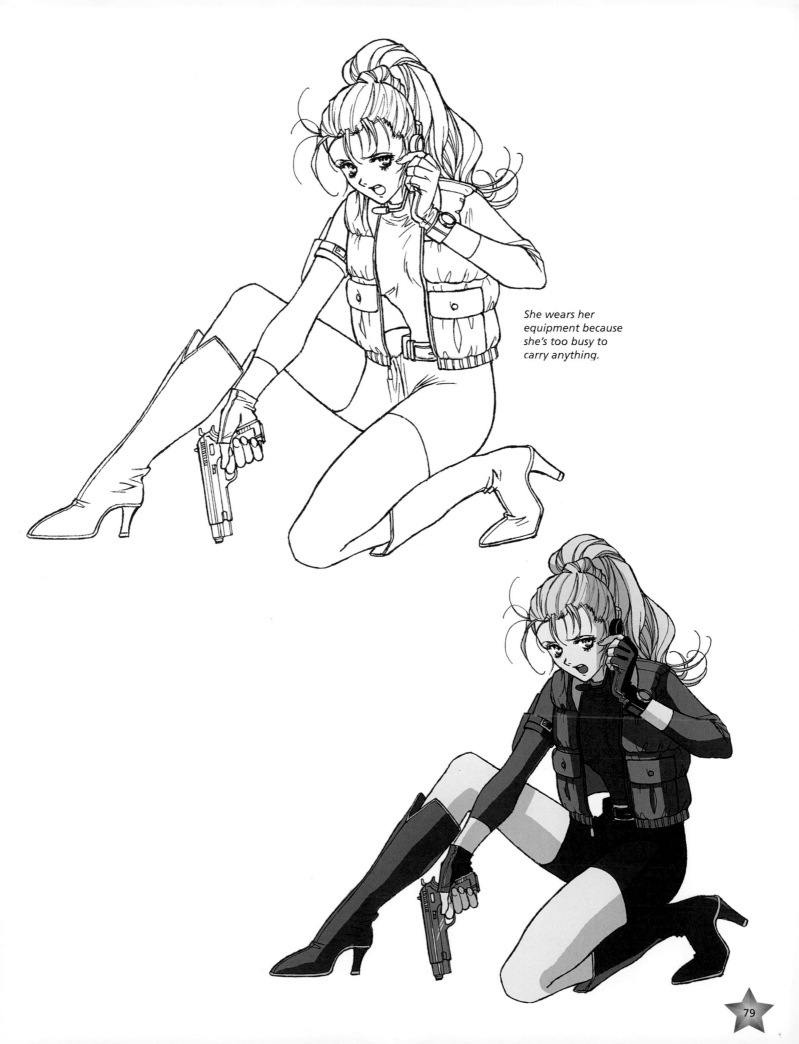

She wears her equipment because she's too busy to carry anything.

Running

Here's a good running pose. It's not the typical pose most artists think of. Instead of the legs being spread apart in the widest possible stride, they are depicted in a "crossover" position in midstride. While the open stride is very effective at showing a running character striving for speed, it also tends to make the character look frozen in time because it's so evenly balanced and symmetrical. The crossover position, on the other hand, looks like a quick snapshot—a moment captured in an action sequence.

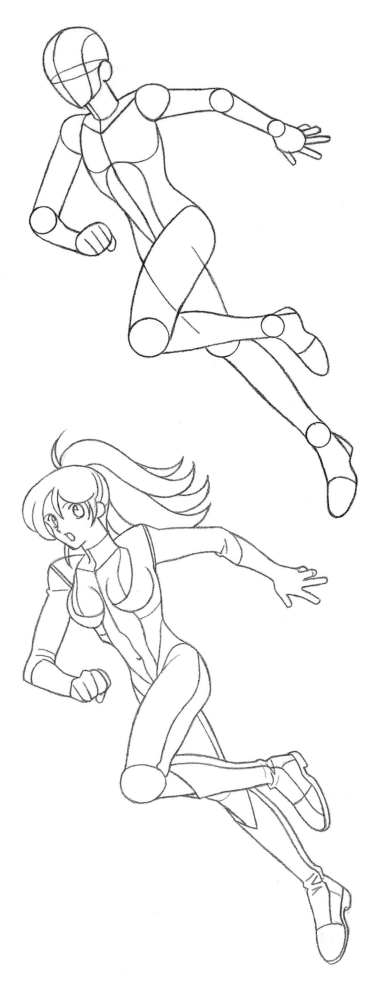

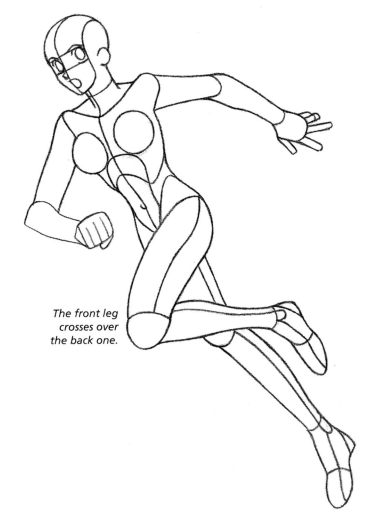

The front leg crosses over the back one.

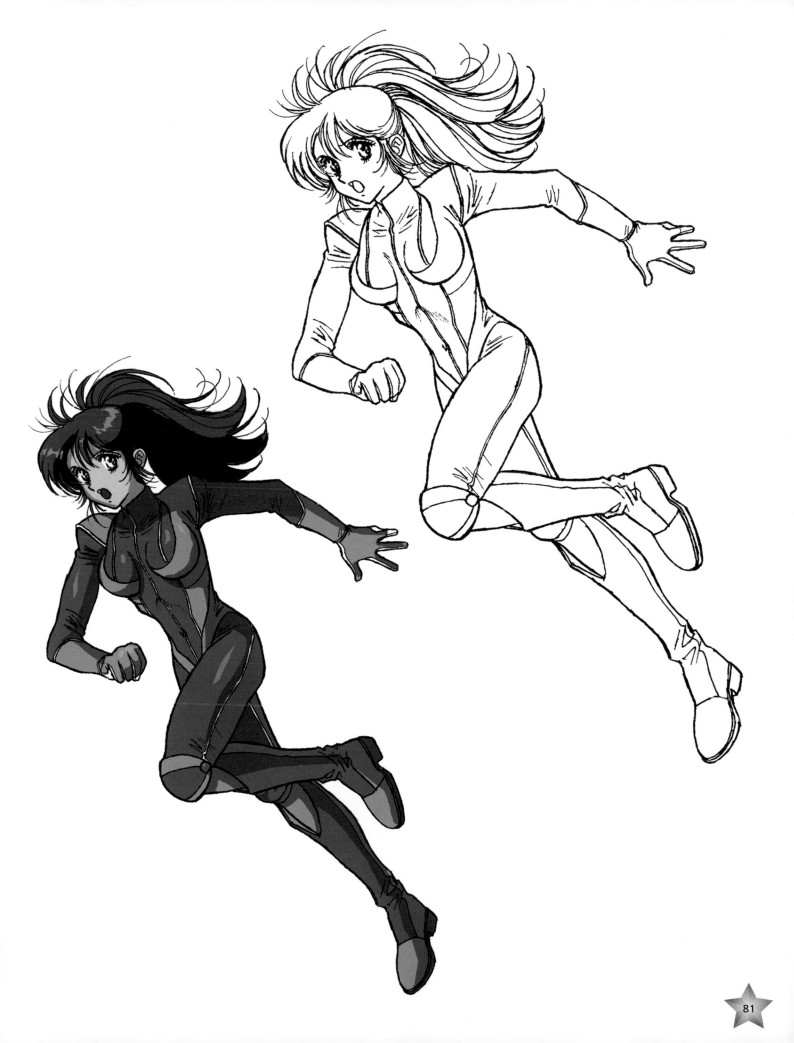

Running Variation

The body positions at both the beginning and the end of an action are dramatic. One example is when a character starts or stops running. Here, the runner comes to a sudden halt. The body assumes a dynamic pose: one leg in contact with the ground, with the knee locked and toes pointed in order to cushion the sudden change in motion. The one outstretched leg creates a long, attractive silhouette. The rest of the body is still in the running mode, including the arms, which are still bent and swinging. It's a cool pose.

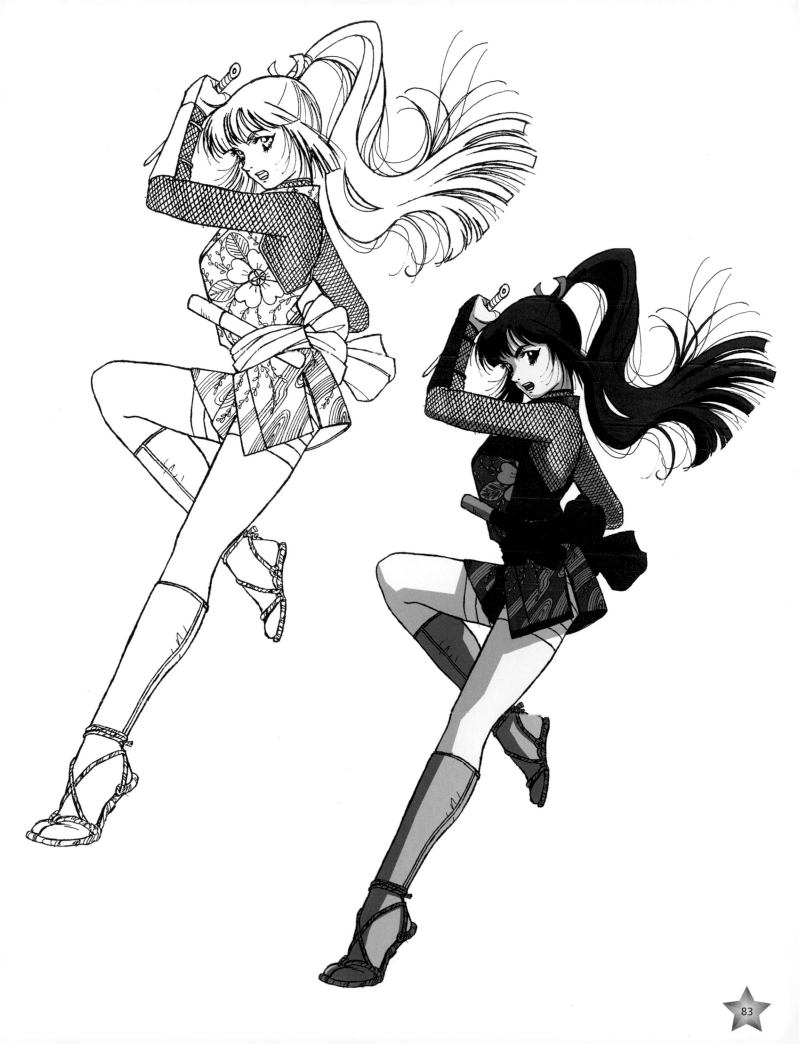

Martial Arts

In comics, martial arts should always look dramatic. Actual martial arts combat is more straightforward and far less flashy. But this is manga, and over-the-top action looks cool. More motion is always better than less. The stances should be open, with arms and limbs away from the body in mysterious positions. Vary the hand gestures between fists, knife-edges, and claws.

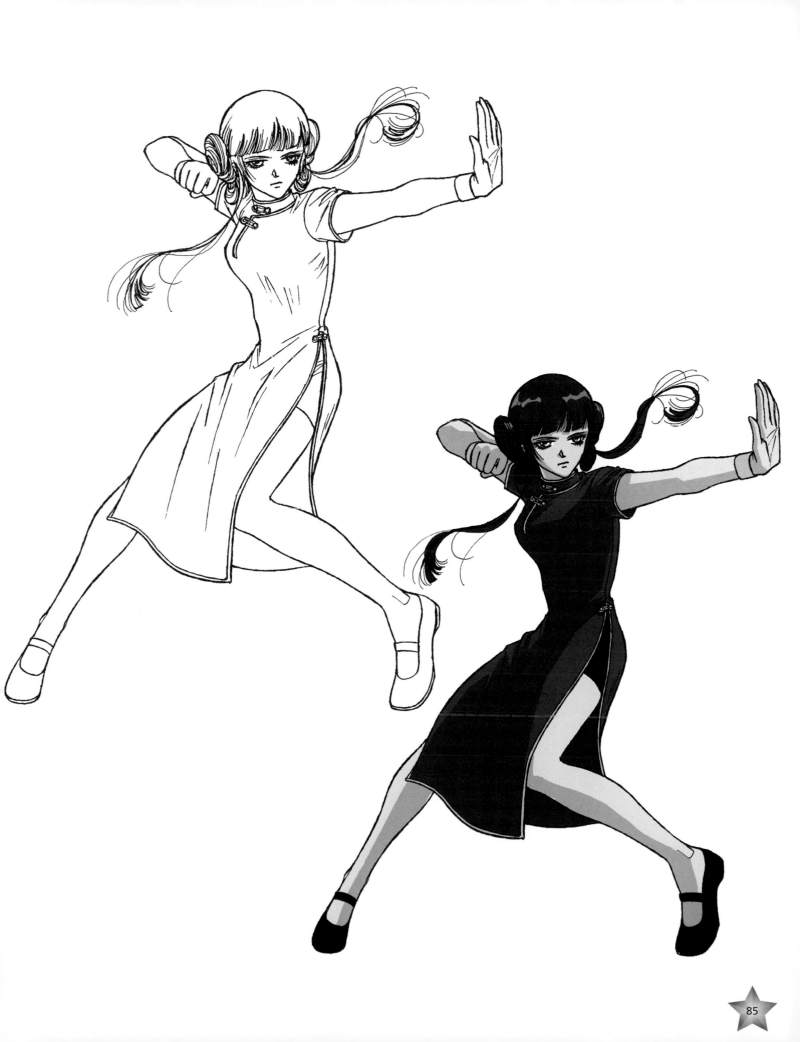

Dancing is Action, Too

Magicians and cabaret stars are a popular component of bishoujo. The lifted leg creates a common pose that reads "showgirl." It's reminiscent of chorus lines. Since she's a performer, she needs to twist her body to face the audience in front of her, even if she's walking sideways across the stage, as she is here.

BODY IN
3/4 VIEW

LEGS IN
SIDE VIEW

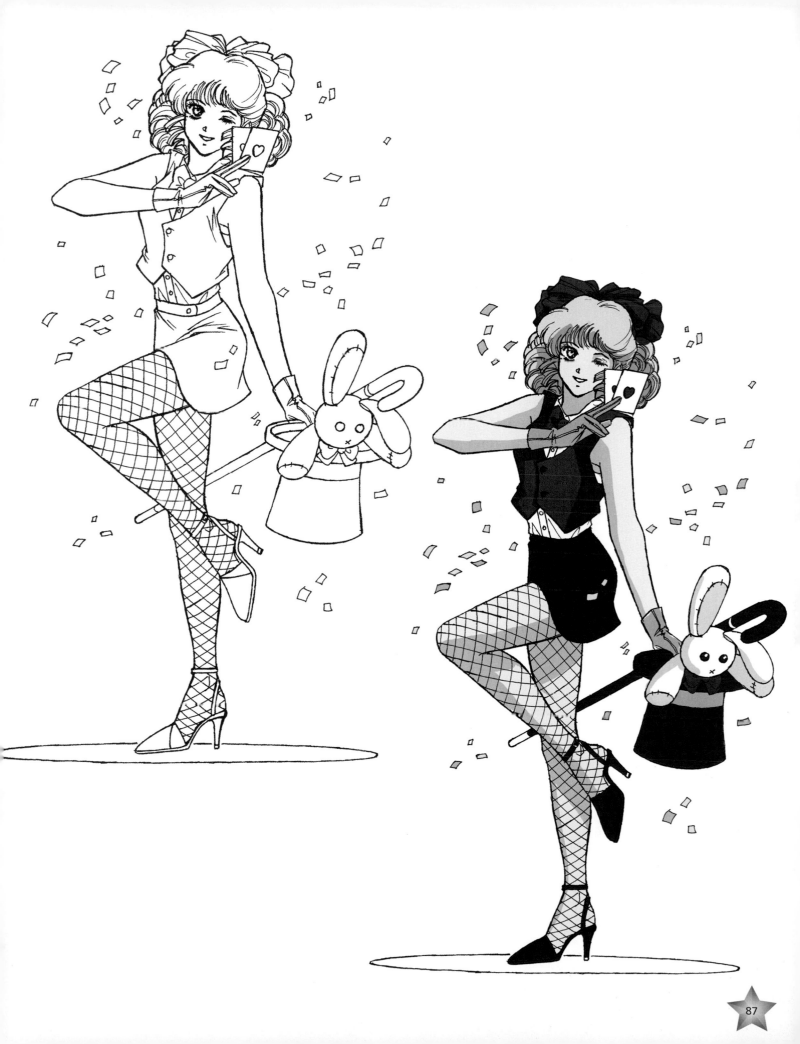

BISHOUJO
CLOTHING

Now that you've got the body down, it's time to turn your attention to the flashier part of the bishoujo world: the clothing. Clothing cements a character's identity and places her firmly in a role or occupation. It can enhance a character's , look making a glamorous woman look even more glamorous; or it can play against type, toning down a glamorous character, for example. Sometimes, the clothes so clearly categorize a character that the outfit alone identifies the character as belonging to a certain manga genre.

Fabrics and Other Clothing Elements

When designing a character's garments, you should pause to think about the type of materials that would be used. For example, a primitive character might wear animal skins. A Sci-Fi character might wear spandex.

HAIR RIBBON DETAIL

FANTASY

The coolest manga costumes can't be found in mail-order catalogs. They come from the worlds of Sci-Fi and Fantasy, and are edgier than regular clothes—designed and cut to bring out the characters' sexiness. Soft fabrics, such as silk, are good choices for Fantasy costumes.

BOOT ZIPPER DETAIL

SCI-FI

Spandex and shiny leather work well for futuristic costumes. Zippers up the legs create lines for the eye to follow, making the legs look longer and sleeker.

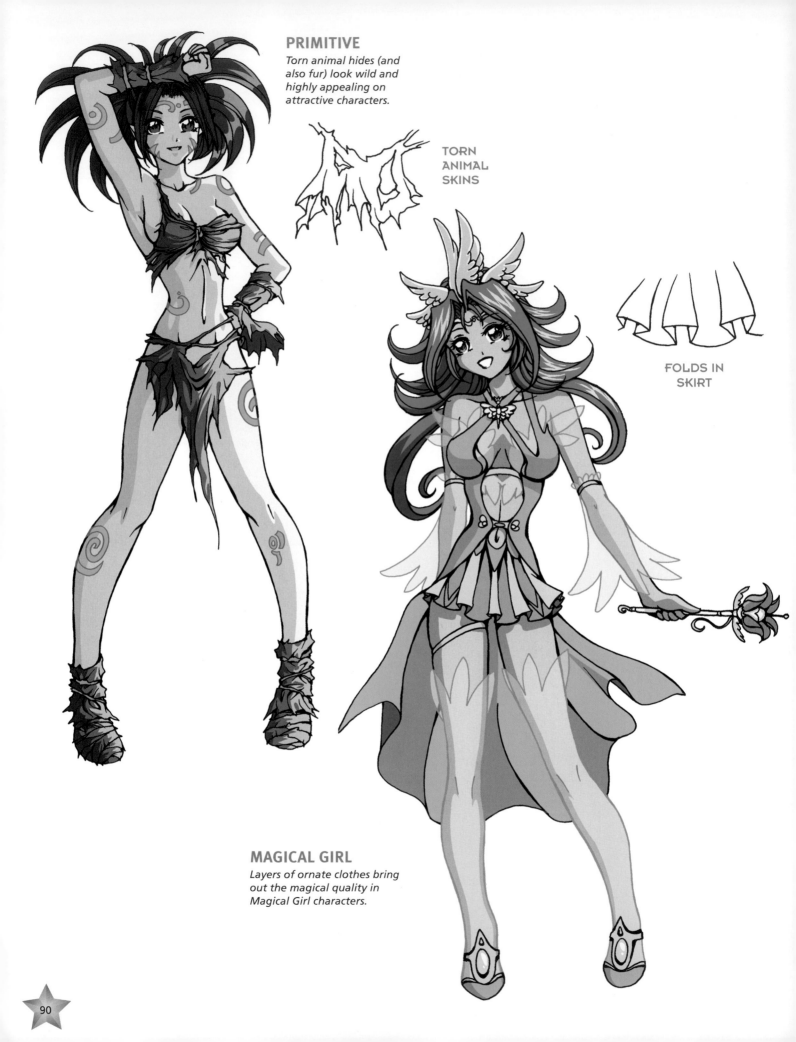

PRIMITIVE

Torn animal hides (and also fur) look wild and highly appealing on attractive characters.

TORN
ANIMAL
SKINS

FOLDS IN
SKIRT

MAGICAL GIRL

Layers of ornate clothes bring out the magical quality in Magical Girl characters.

STRAPS
Straps are drawn round (to go around an arm or leg), not straight across.

FIGHTER
Leather straps are good accents that can break up larger areas, such as the legs and waist. Add thigh straps like the ones here or upper arm bands. Trailing, flowing material is always a good Fantasy look.

HARDWARE ACCESSORIES
These elements can be small.

TECHNO SOLDIER
Gear, cables, headsets, night vision goggles, and other electronics are often married to techno costumes in order to make them look functional.

School Uniforms

Schoolgirls are some of the most popular manga characters, and are seen in some of the most popular Japanese comics. School uniforms are quite typical in Japan, so they should be drawn correctly. These examples are based on authentic Japanese school uniforms. The two types are the private school uniform and the public school (sailor) uniform.

SCHOOL SWIMSUIT

Schools have swim teams whose members wear teams uniforms, as well. It's a one-piece bathing suit with vertical racing stripes on the sides and a cap and goggles.

PRIVATE SCHOOL UNIFORM

Private school uniforms are typified by tailored jackets and short, pleated skirts.

PUBLIC SCHOOL/ SAILOR UNIFORM (WINTER)

Public school uniforms are usually of the sailor style, which was influenced by British navy uniforms.

PUBLIC SCHOOL/ SAILOR UNIFORM (SUMMER)

Traditional Japanese Costumes

Traditional Japanese costumes are worn for special occasions and ceremonies. There are two main types of long robes made out of silk and satin.

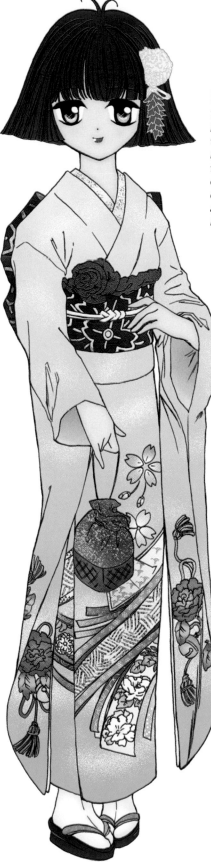

FURISODE KIMONO

The furisode kimono has long sleeves and shows off the character's sleek figure. It is worn by maidens on formal and ceremonial occasions, and is highly decorated with pictures and patterns. An obi (sash) is tied around the waist.

HAKAMA

Shinto priestesses are popular characters in manga and are called miko. The miko battle demons and monsters. Their skirts, which are crimson colored and look like billowing pants, are called hakama. The entire outfit is somewhat bulkier than the kimono. Although the skirt is red, the rest of the outfit is white to indicate purity of spirit.

Professional Uniforms

The costume is all-important in communicating the occupation of the character. Service professions—such as nurses, waitresses, and maids—are popular in bishoujo manga. For all of you politically correct folks out there, don't shoot the messenger! The culture is different in Japan, and these characters are not only perfectly acceptable there, but are very popular. And they're becoming quite popular over here, too.

NURSE

The cap is the most important piece of the costume in identifying the character as a nurse. Without it, she might be mistaken for a doctor. She usually has her own stethoscope and a clipboard, on which she keeps the medical charts. The length of the uniform should be just above the knee.

WAITRESS

In Japan, waitresses who work in the coffeehouses wear frilly uniforms that are quite popular, and as a result, many teenagers apply for jobs there.

Uniforms for More Active Professions

Many popluar bishoujo characters have assertive professions, including those in the military and sports arenas.

RACE CAR DRIVER

This type of character would typically appear in Sci-Fi Action comics. The outfit is a bodysuit with extra padding to protect the joints, forearms, and shins. A few lines on the padding create a much needed design element. Leave off the helmet until absolutely necessary; otherwise, you'll hide the character's face—and expressions—from the reader.

MILITARY OFFICER

Like the cap? Don't leave out the feather! The military officer's outfit has an appealing, ceremonial quality to it, almost like the leader of a military band. High collars are common.

Magical Girl Costumes

The Magical Girl genre uses costume as an integral part of the story. For example, the star of the story, a magical girl, may transform herself into a super marching band conductor who battles demons that are trying to take over the world by corrupting the youth through evil messages encoded in their music.

MASCOTS

Magical girls often have little mascots. These are cute creatures who don't reveal themselves to anyone except the magical girl herself. They offer comic relief, but can also help in defeating the bad guys.

Nonhumans run the gamut from cat people to elves, faeries, and even androids. They're popular and a lot of fun. They add novelty to a story and really stand out. Use them to inject a little visual spice.

Nonhumans are human-animal hybrids, but their costumes are always based on human clothing styles and character types.

CAT PEOPLE

Place furry cat ears and a tail on a cute bishoujo character and you've got a cat person. Sometimes, artists add tiny little fangs and claws as well, but these elements should be petite enough not to make the character look too feral and, therefore, unattractive. Cat people look more like humans than they do cats, but they retain more of their cat instincts. For example, they like to drink milk, curl up on the couch, and chase after a ball of yarn.

ELVES

There are many different styles of elf ears, but all of them are pointy. This is an example of oversized ears. Some sort of jewelry on the forehead is an indicator of magic. The hair should be long and flowing. Note the difference between elves and faeries: faeries can also have wings, whereas elves do not.

ANDROIDS

Only a few visual hints may be needed to indicate that a character is indeed a machine. The trend is to keep these characters looking much more human than robotic. They have incredible strength but one drawback: they've got to go for an oil change every so often. But seriously, if they don't recharge, they run out of juice and it's curtains for them. Also, if a single small part is damaged or lost, all of an android's programming can get corrupted.

WINGED FIGHTER

Sometimes, it's not the clothing that identifies the character, but other elements, such as wings, fins, or scales. These elements are among the most popular of the Fantasy genre, and their design is just as important as "regular" clothing.

When using wings, make them oversized and feathered for good characters; bad characters get prehistoric, skin wings (like those on bats or on pterodactyls, "birds" of the dinosaur era).

MERMAID

Mermaids have a solid place in bishoujo. Their hair is always long and wavy as it moves with the gentle currents of the water. Note the seashell hair accessories that exploit the ocean theme.

DRAWING CHARACTERS IN COSTUME

This chapter outlines, step by step, just how to draw costumed characters, and also provides two different style and costume approaches to each character in order to show you just what you can do with clothes. You may favor one style over the other, or you may be able to put your own spin on a costume, turning it into something uniquely your own. It's almost always better to sketch out the underlying figures before adding the clothes. Pros adhere to this rule of thumb.

Futuristic Fighter

Block out the figure first, using this basic construction. Since she's coming toward the viewer, which is more dramatic than a neutral pose, her body must get smaller around the feet as the figure recedes.

The toe points down for a sleeker look.

The bent knee hides the lower leg.

VERSION 1 (SCI-FI)

She's a space pilot, perhaps even an on-board science officer. The long gloves, boots, and cape are gone. She wears an insignia on her chest and helmet that tells us she's part of the official space fleet. She would be more at home in a Sci-Fi manga than a Fantasy manga.

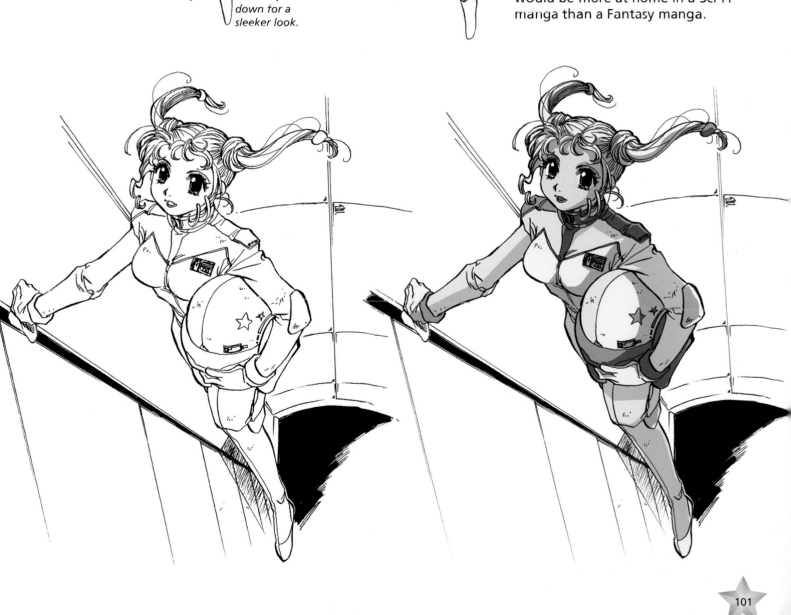

VERSION 2 (MEDIEVAL)

In manga, capes are more of a design element than a tool to show flying, as they are in American-style comics. It may be physically impossible, but having ponytails that are located above the helmet is a cool look—and if readers like it, they won't ask questions, so give it a try! Long gloves and high boots are frequent costume elements in Medieval-style futuristic stories.

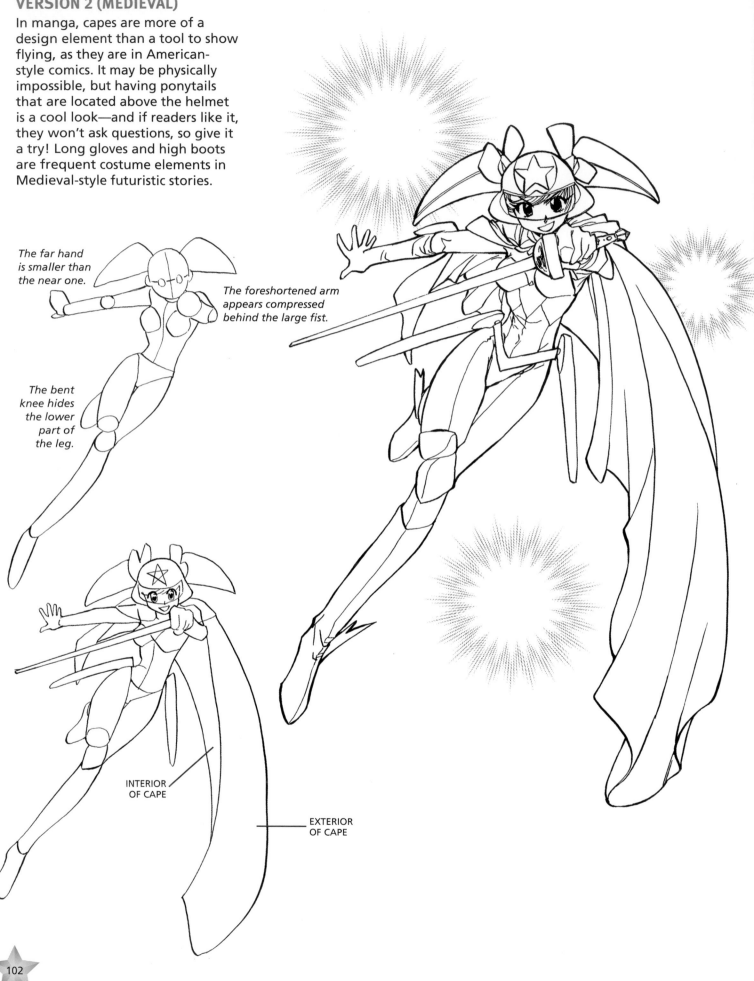

The far hand is smaller than the near one.

The foreshortened arm appears compressed behind the large fist.

The bent knee hides the lower part of the leg.

INTERIOR OF CAPE

EXTERIOR OF CAPE

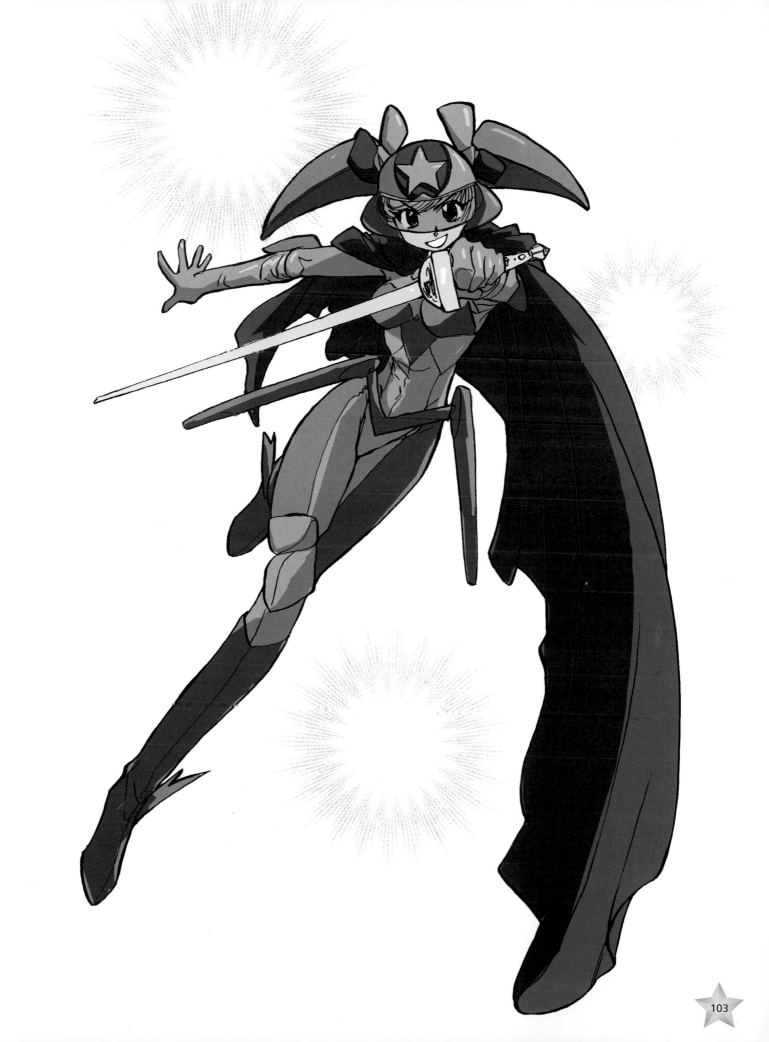

Fantasy Elf Princess

The fantasy princess is a favorite character in bishoujo. The elfin ears on these two versions identify them as magical types. Note that, in manga, faerie or elfin ears can point down as well as up.

VERSION 1 (EARTHY)

This is an earthy style of fantasy elf who goes barefoot. Her garment is sleeveless. She wears more jewelry than the rich-style elf princess (opposite), including on her upper arms and forehead (which is also an earthy sign), but no crown. The slit dress is a nice touch, which reveals that unlike the pampered and rich princess, she doesn't have mounds of ruffled undergarments. The bird shows that she communes with nature's beings as a friend and equal, a gentle soul.

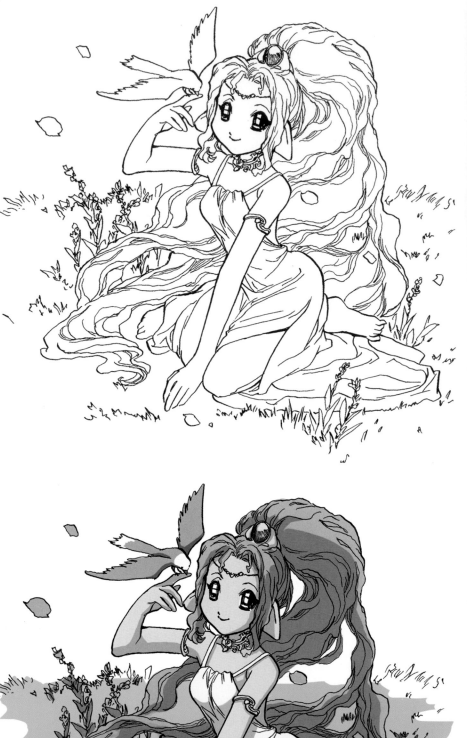

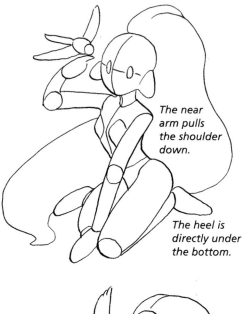

The near arm pulls the shoulder down.

The heel is directly under the bottom.

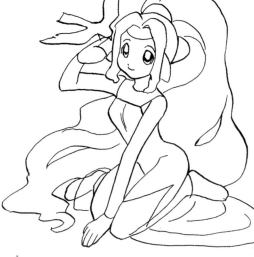

The dress fans out around the figure.

VERSION 2 (RICH)

She wears a dramatically flowing or billowing dress that reveals the ruffles of the undergarments. The sleeves are long and also show ruffles. A princess never wears boots, but has dainty shoes instead. Note the amazing hair, ribbons, and petite crown that's almost a tiara.

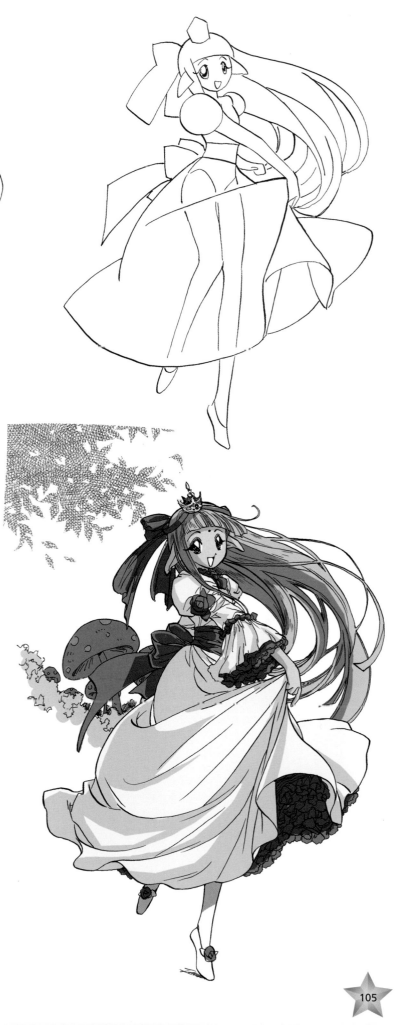

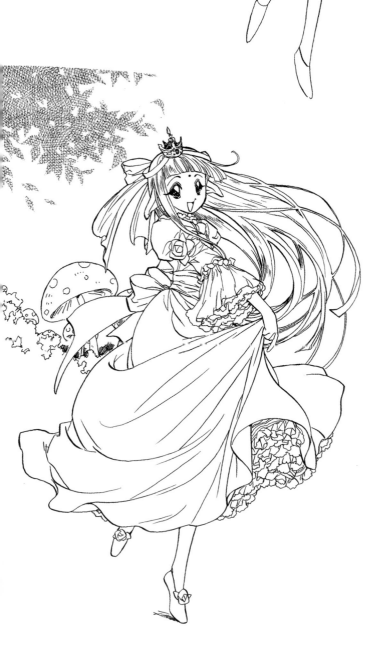

Traditional Figure

The design of traditional costumes is related to class structure. The higher the class, the finer the materials and the more ornate the dress.

VERSION 1 (COUNTRY)

The clothes are layered, but the fabric looks sturdy—nothing made of silk or anything too fine. The basket is a nice touch that indicates that she's doing chores, perhaps going to the local market. Another sign that she lives a simple life is her plain haircut.

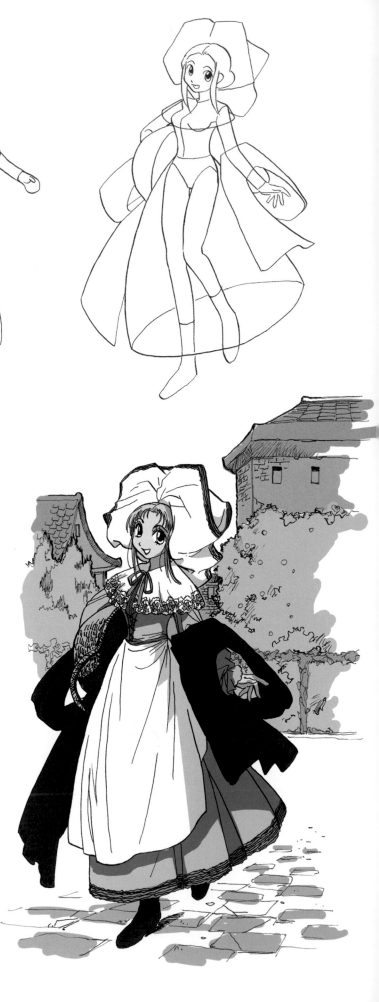

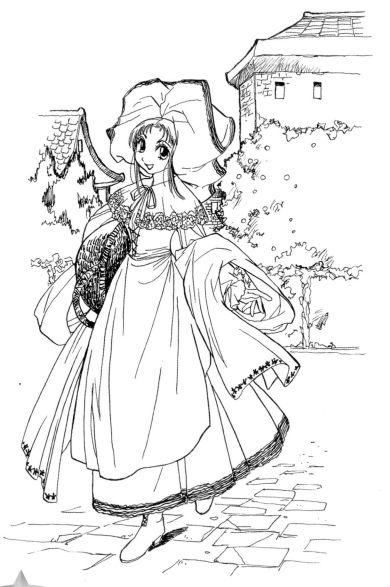

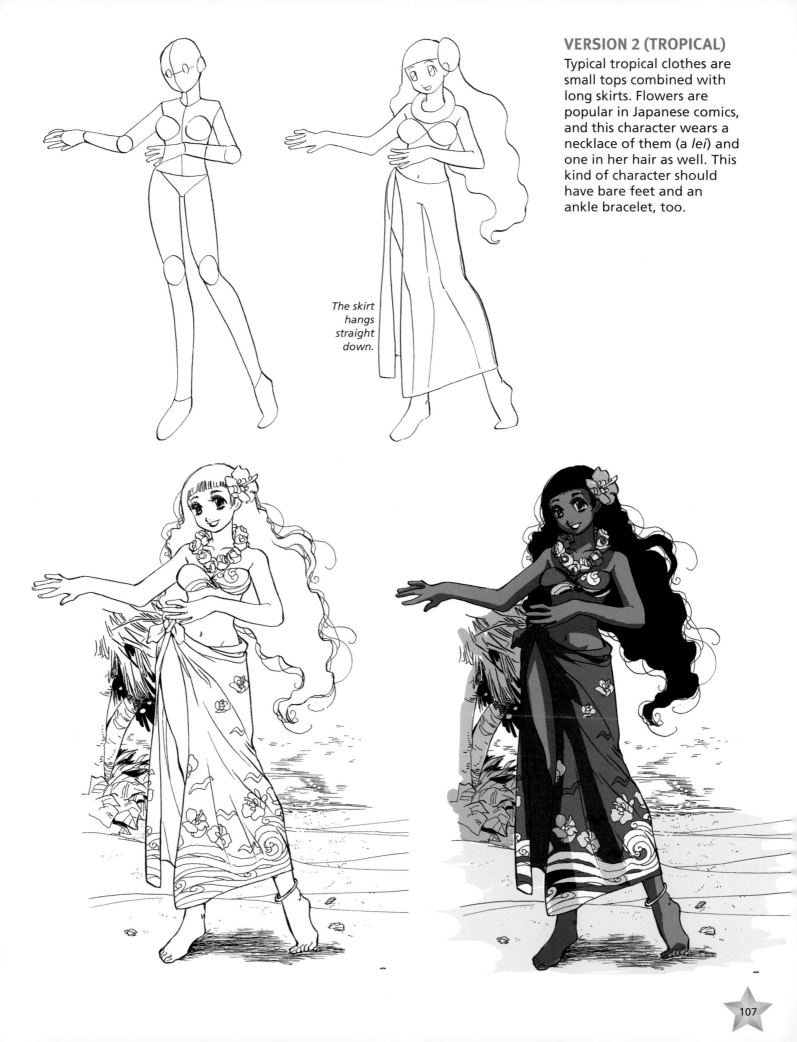

VERSION 2 (TROPICAL)

Typical tropical clothes are small tops combined with long skirts. Flowers are popular in Japanese comics, and this character wears a necklace of them (a *lei*) and one in her hair as well. This kind of character should have bare feet and an ankle bracelet, too.

The skirt hangs straight down.

Athlete

Sports are a *big* part of Japanese culture and tradition. Uniforms are not flashy and are almost always traditional in look.

VERSION 1 (GYMNAST)

Athletic achievement combined with grace and beauty is what gymnastics are all about, and therefore, gymnasts make great characters for manga. The costume is easy. It's the swirls of handheld ribbon that provide the visual interest. Draw the ribbon in repeating spirals. The hair must be clipped back and neat. Long, flowing hair would interfere with the character's moves. Ponytails are the favored style.

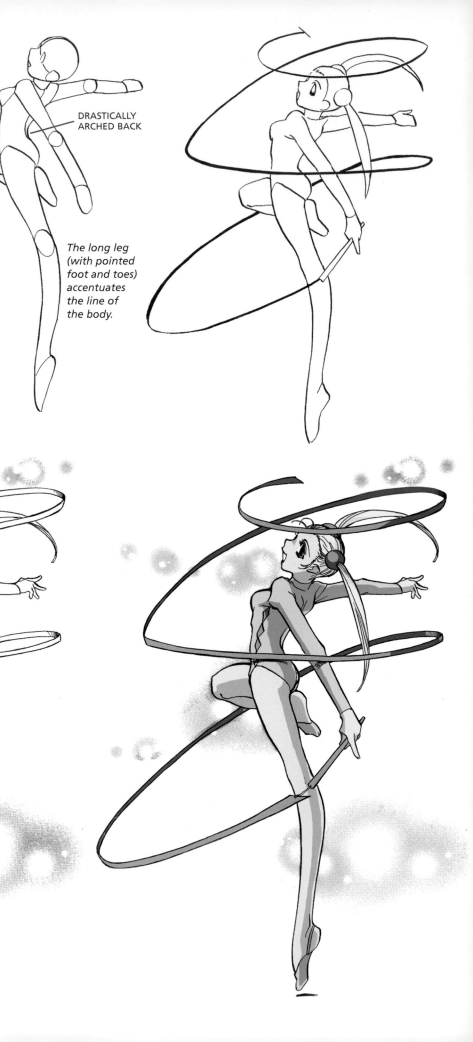

DRASTICALLY ARCHED BACK

The long leg (with pointed foot and toes) accentuates the line of the body.

VERSION 2 (RUNNER)

Here's a determined track star. Between competitions, this "strictly business" athlete can be seen training, hitting the pavement and logging in those miles. She wears shorts, a windbreaker, and a headband or sweatband. Does she need the kneepads and the extra-high socks? Not likely. But the axiom that "form follows function" has never filtered down to the comics world! Rather, "if it looks cool, draw it" is more the motto.

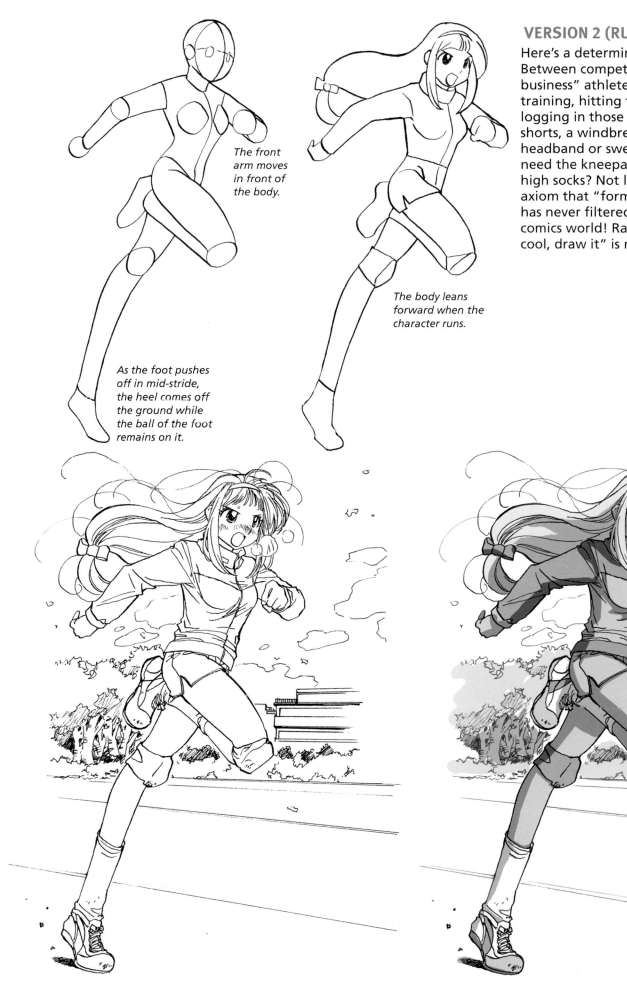

The front arm moves in front of the body.

The body leans forward when the character runs.

As the foot pushes off in mid-stride, the heel comes off the ground while the ball of the foot remains on it.

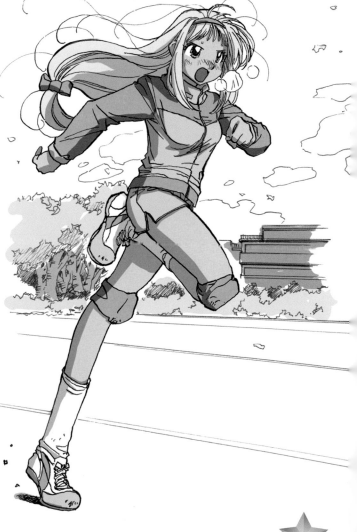

Villainess

VERSION 1 (FANTASY)

Tall boots are a giveaway that she's in the Fantasy or Sci-Fi genre. But it's really the extreme ponytail and craggy tiara that put this villainess squarely into the Fantasy realm. She'd have to be wearing some kind of body armor (even if only a few shoulder pads) if she were to be a true Sci-Fi villain. The cutouts on the waist area of the outfit are a cool look—and a good alternative to straps. The double seam running down the front of the boots gives them a trendy look, and gloved hands are almost a requirement for villainesses. But it's the eyes—with their heavy-duty mascara treatment and slanting eyebrows—that really exude evil thoughts.

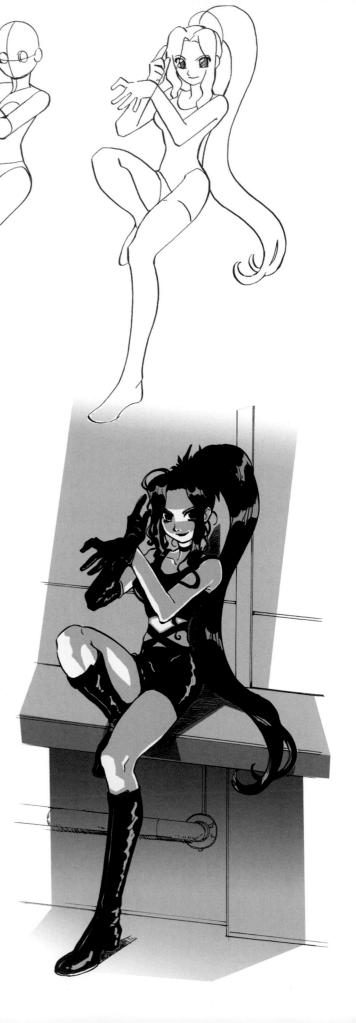

VERSION 2 (SCI-FI)

The full bodysuit typifies the assassin of the future. She has cool gadgets, too, like the earpiece and single-eye visor. Her hair is cut close in an extreme style. (*Note*: short hair is for Sci-Fi villainesses; long hair is for Fantasy villainesses.) In the Sci-Fi—as well as the Hard-Action—genre, female characters have narrow eyes that are longer horizontally than typical manga eyes. And just like the villainess opposite, gloves and boots are a must for this bad lady, too.

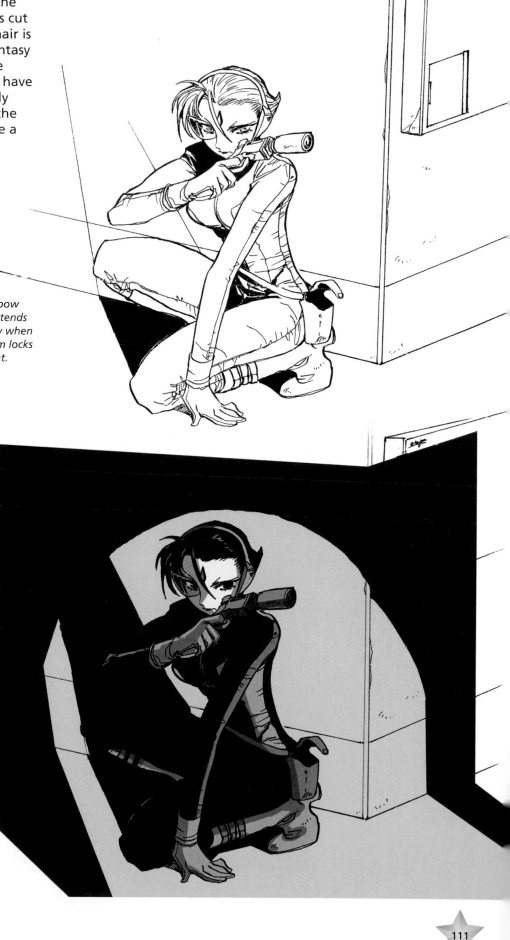

The elbow overextends slightly when the arm locks straight.

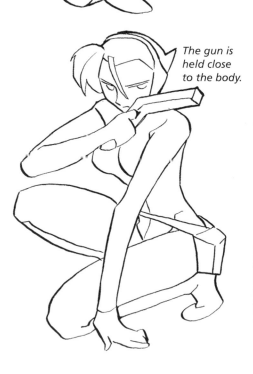

The gun is held close to the body.

Scientist

VERSION 1 (PRETTY)

Proper, seated characters sit with their backs arched and their feet tucked back under their chairs. The upper part of the outfit remains unaffected by the seated posture, but the bottom half bunches up and gets wrinkled.

Brainy characters often wear glasses in comics. And unfortunately for them, these are not cool lenses but large, rounded frames. Still, girls with glasses can be pretty. This lab technician looks pretty but is unaware of it. She has a long lab coat and wears her hair back so that there's nothing about her that could be considered sexually provocative. Plain shoes complete the look.

ARCHED BACK

KNEES TOGETHER

The lab coat opens at the knees and falls around the calves.

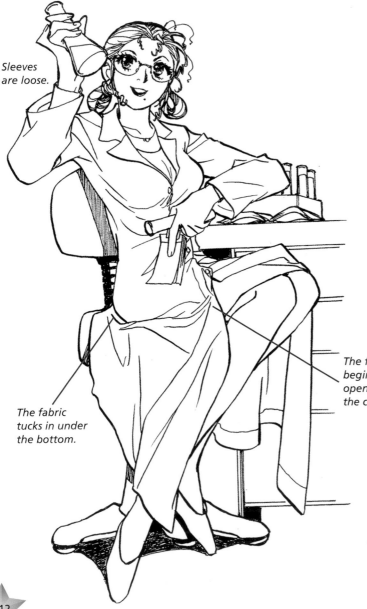

Sleeves are loose.

The fabric tucks in under the bottom.

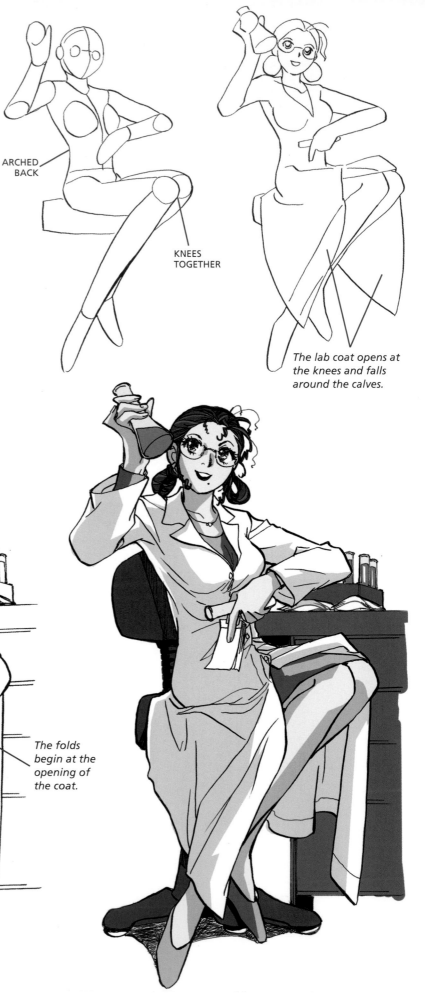

The folds begin at the opening of the coat.

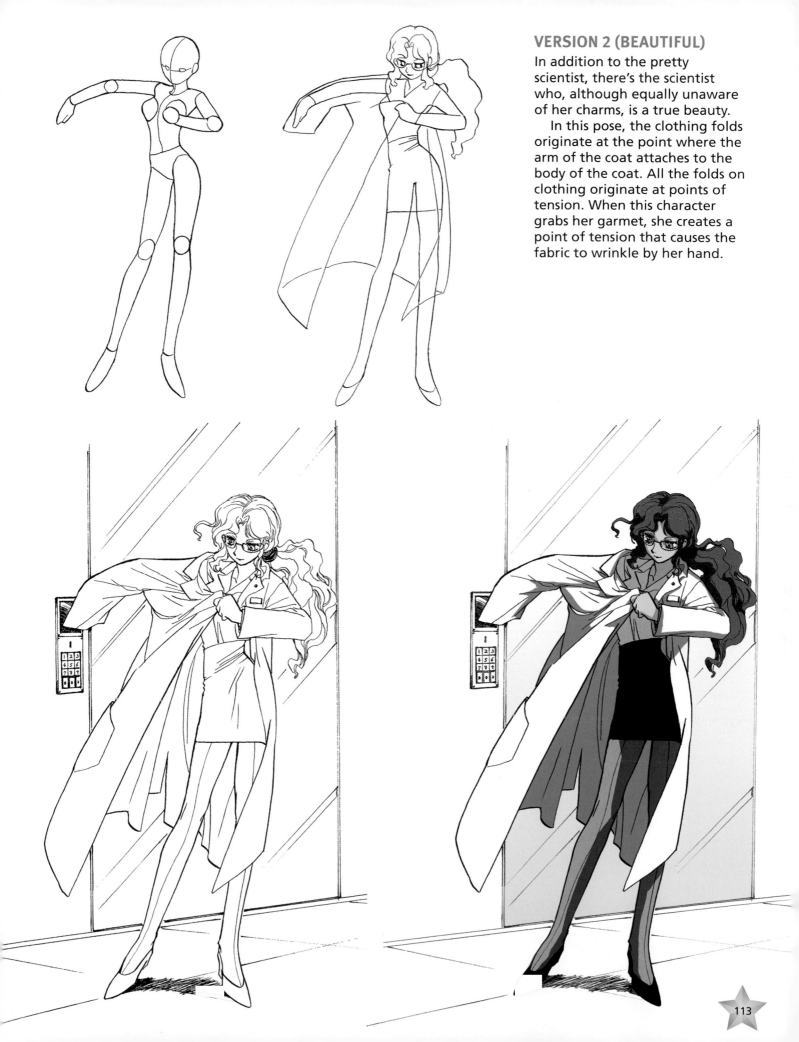

VERSION 2 (BEAUTIFUL)

In addition to the pretty scientist, there's the scientist who, although equally unaware of her charms, is a true beauty.

In this pose, the clothing folds originate at the point where the arm of the coat attaches to the body of the coat. All the folds on clothing originate at points of tension. When this character grabs her garmet, she creates a point of tension that causes the fabric to wrinkle by her hand.

Schoolgirls

A book on bishoujo would not be complete without information on how to draw character types based on what is arguably the most popular manga genre: Schoolgirl comics. Schoolgirls can be sweet or bratty, meek or heroic, ordinary or magical. In other words, they can be anything you want them to be! Teens and tweens love these characters because they relate to them. And through these idealized characters, the readers can see themselves triumph in romance, in social circles, and of course, in the never-ending battle against evil and demons!

In Japan, Schoolgirl comics are so popular, they're read by all ages and by both males and females. Remember, even though they're about girls, these stories offer plenty of compelling male costars, which broadens the appeal.

The arms and legs on young teens are soft and round.

Hair ribbons are a good accessory for young teens. High leggings are a frequently used device on young teenage characters, whether they're magical girls or regular schoolgirls.

Ponytails create a youthful look and are popular on schoolgirls.

When drawing the Magical Girl type, it's important to base her outfit on the public school sailor-style uniform. But, create a super-elaborate version of it to place it in the Fantasy genre. For example, this character has flounces at the ends of her sleeves, a bow and a star on her jacket, and high boots. Fantasy characters always—always—have flowing, long hair. This character wears hers in long ponytails tied with fancy, oversized ribbons. To complete the look, she has a magical staff.

Other Popular Schoolgirl Types and Outfits

Of course, not every outfit a girl wears is designed to identify her as a character from a particular genre, such as Occult or Sports. But casual clothing must also be put together in an appealing way.

SWEATER-VEST OUTFIT

Instead of a jacket, a V-neck sweater-vest is also a good look for school uniforms. Put a little ribbing detail around the neckline and armholes. The schoolgirl can wear a long sleeve shirt with it or can roll up her sleeves for a more casual look. Pleated skirts are, by far, the most common look for schoolgirls in manga, followed by skirts with plaid patterns and sailor designs.

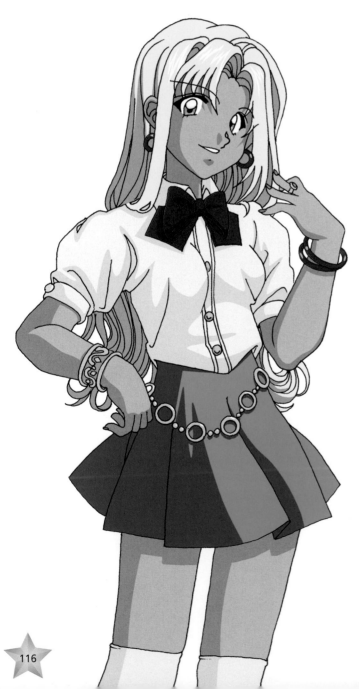

JACKETLESS

We often see schoolgirl uniforms that include jackets (for private school) or with sailor elements (for public school), but characters also appear without their jackets. For these occasions, avoid a plain white blouse. This one has puffed shoulders, short sleeves, and a bow at the collar. Schoolgirls in the same school all wear the same uniform. But that doesn't mean that they haven't cleverly figured out some ways to carve out their own identities. One way is to personalize their hairstyle. Another is to wear jewelry. This character, for example, wears two types of bracelets, a ring, hoop earrings, and a chain belt. This added glitz would be good for a lead character, who needs to stand out from the pack.

JACKET AND SWEATER

Combining a conserative jacket with a sweater-vest creates the formal look of the serious student. Large eyeglasses underscore this character type, as does the book she's holding. The shoes are appropriately conservative, and this points out how important it is to be consistent in your concept of the character when drawing the outfit. For example, if you generally like to draw flashy hairstyles or cool earrings, you should not do it on this character. Yes, it might look cool in a vacuum, but she would no longer be a well-conceived character. The reader wouldn't know which impression of her was correct: her conservative clothes or her extroverted flashy hair and jewelry. Strive for a clear, overall concept.

BUTTONED VEST WITH OPEN COLLAR AND TIE

This is an appealing look for a change of pace. It's a very authentic Japanese look. The menswear-style tie is a cool look, especially if it's worn loosely around an unbuttoned collar.

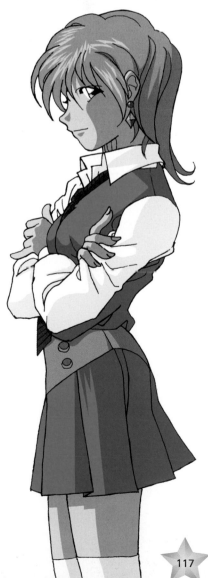

TOMBOY TYPE

No jewelry for her—that includes earrings. Often, she's athletic and can get herself into a few scrapes (note the bandage on the knee and the wrap on her forearm). A cool cap is a popular choice for pretty tomboy characters. This girl doesn't take the bus to school, preferring, instead, to race there on her Rollerblades, beating all of her school chums whose parents are stuck driving them in the morning traffic!

117

CREATING GLAMOUR

Nothing is so eye-catching as a glamorous character. But what exactly is glamour? While certain adjectives come to mind—flash, style, radiance, luster—glamour is not necessarily synonymous with sex appeal. For example, you can draw teenage girls who have a flair for glamour without highlighting a sexuality that would be inappropriate for their age. In a nutshell, I would say glamour is the difference between something that is shiny and something that is not. How do you apply this concept to your drawings? How, exactly, do you transform a sweet, pretty bishoujo character into a glamorous one? Let's take a closer look.

From Ordinary to Beautiful

Glamour is in the details. You can easily turn a pleasant, plain character into a glamorous one by embellishing the eyes, lips, hair, posture, and costume. You don't have to start with an extravagant beauty. See? I've just made your life easier.

PLAIN

Nice, simple—but no head-turner.

BEAUTIFUL

The eyes are the focus of every manga face; but on a beautiful character, they must be especially radiant. Thicken the eyeliner (especially on the upper eyelid), as well as the eyelashes. Use light markings beneath the eyes, which make them stand out even more. The lips should have slightly heavier treatment, most notably becoming fuller (not wider) and showing a shadow under the lower lip. A slightly opened mouth is sexier than a tightly closed one. The nose remains the same—diminutive. And you need to give the hair more body, building up its size and letting it go wild.

PLAIN BODY VS. GLAMOROUS BODY

Compare this figure to the one on the opposite page. This is an average, nice-looking character that doesn't have enough charisma to captivate readers. You need to make changes in three main areas: posture, costume, and curves.

The figure opposite is not that drastically different, but the way she holds herself creates a dramatically new presence. Don't underestimate how important it is for a beautiful character to carry herself with confidence. In addition, note that attractive manga women are not built like American fashion models, who are skinny and usually on starvation diets. Manga women have curves. And while, yes, her curves are emphasized more here, the costume is also doing a lot of the work for her. And by the way, in case you haven't noticed, all beautiful manga women have great hair.

Glamorizing the Face

The larger you draw your character—in a close-up, for example—the more detail is required to maintain the reader's interest. When you draw something smaller, you try to simplify it so as not to clutter the image. Therefore, how do you add detail to a fairly simple girl's face in a close-up? By adding glamour.

In the full-length view, this girl is pretty. But in the close-up, a lot more detail has been added, and as a result, she's brilliant! What's the difference? The eyes have much more detail; specifically, the irises have been indicated with light, repeating lines. In addition, shines have been added to the pupils, causing them to glisten and appear moist. Because of the larger face size, the addition of extra eyelashes is now possible, and the eyelids have been darkened. Full lips have replaced the single line for the mouth, and blush lines have been added to the upper cheek areas. Lastly, the eyebrows have been given thickness, rather than being just lines.

A NOTE ABOUT PRETTY VS. GLAMOROUS CHARACTERS

Pretty, plain girls make great supporting characters, but for the main character—the star—whether she's bad or good, a glamorous character is hard to beat. The eye will naturally be drawn to her, and a certain excitement will surround her wherever she is in the story.

Adding Sex Appeal

The figure on the left starts out with an attractive pose, a shapely figure, and beautiful eyes. And although she is certainly stylish, she exudes no real glamour. But with only a few adjustments, her look can be retooled into one of glamour and sex appeal without changing one pencil stroke of her posture. First, the figure on the left is covered from head to toe, while the sexier figure on the right is not so hidden by her outfit. The wide cut of the lapels reveals a low-cut camisole top that mimics a bra. The sleeveless shirt and short skirt also reveal more of her shape. The shoes are minimal, revealing more of the foot. A sexier look is usually a more relaxed look; therefore, the figure on the right, with hair down and flowing, has more appeal. The full, darkened lips also add to the effect.

HINT

Always sweat the small stuff. In other words, even the small changes add up to a big difference in the end. Little things, like the necklace, ring, earrings, two bracelets, top of the stocking, and shoe fringe combine to bring a level of dazzle to this character.

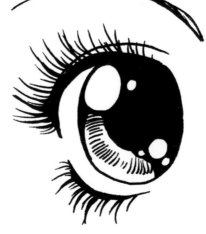

There's a large shine that falls into the upper part of the pupil area, and two smaller shines punctuate the lower part. The iris contains small, repeated lines. The upper part of the eye is a pool of black, which serves to mimic the shadow that naturally occurs under the eyelid, creating a sexy look.

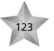

Swimsuits

Swimsuits are common glamour attire. A full-body wet suit might keep her warmer, but it won't warm the readers as much as a bikini. In keeping with what we've covered so far in this section, when a female character has an attractive shape, it's more glamorous and appealing to reveal it, rather than to cover it up.

Relaxed hair is sexier than hair that's perfectly set in place.

THIN STRAP

HIGH CUT

The space suit on the left is basically a simple unitard. It's fine for its purpose, but it doesn't do much for the attractiveness of the character. It's so undefined and long that it turns the body into a large, bland area.

You need to add accessories in order to define various parts of the body, which will give the eye certain landmarks in order to help better digest such a long figure. Shoulder pads are always a good choice for space suits, as are forearm guards of any size. The waist-grip is a cool look for fighter pilots. And instead of drawing one long bodysuit, divide it into two pieces, resulting in high-cut leg openings.

Note the change in hairstyle, from up in a ponytail to loose and flowing.

On glamorous characters, thick lower eyelids punctuated by heavy lashes look good. On sweet and innocent characters, such heavy lash treatment is distracting.

Elfin Glamour

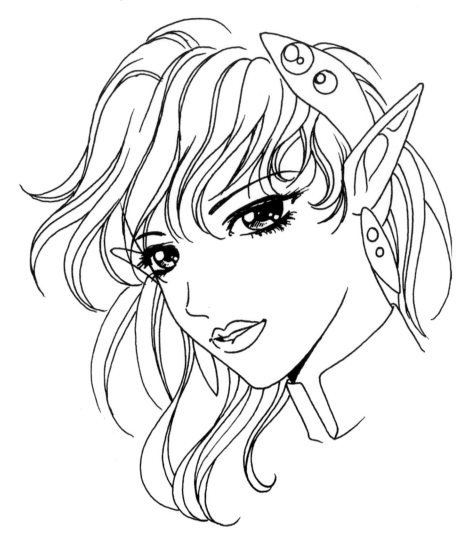

An average manga artist might draw an elfin creature like the one below. And there's nothing wrong with it. But the costume covers up her body with excess clothing. Giving the clothing more shape and some dramatic flair would create more glamour and better serve the character.

The glamorized elf wears a heavily ornamented cape. There's nothing more romantic and sweeping than a long cape, and so it's included here. Her top is formfitting but still has seamwork that gives it a faerielike, medieval look. The sleek, long gloves and long boots (with thin, high heels) are much more glamorous than the shorter versions. Her hair is wavy and longer. And the hair accessory and earring are more details that add up to a glamorous look.

Because she's elfin, her eyes are more horizontally shaped than other bishoujo characters.

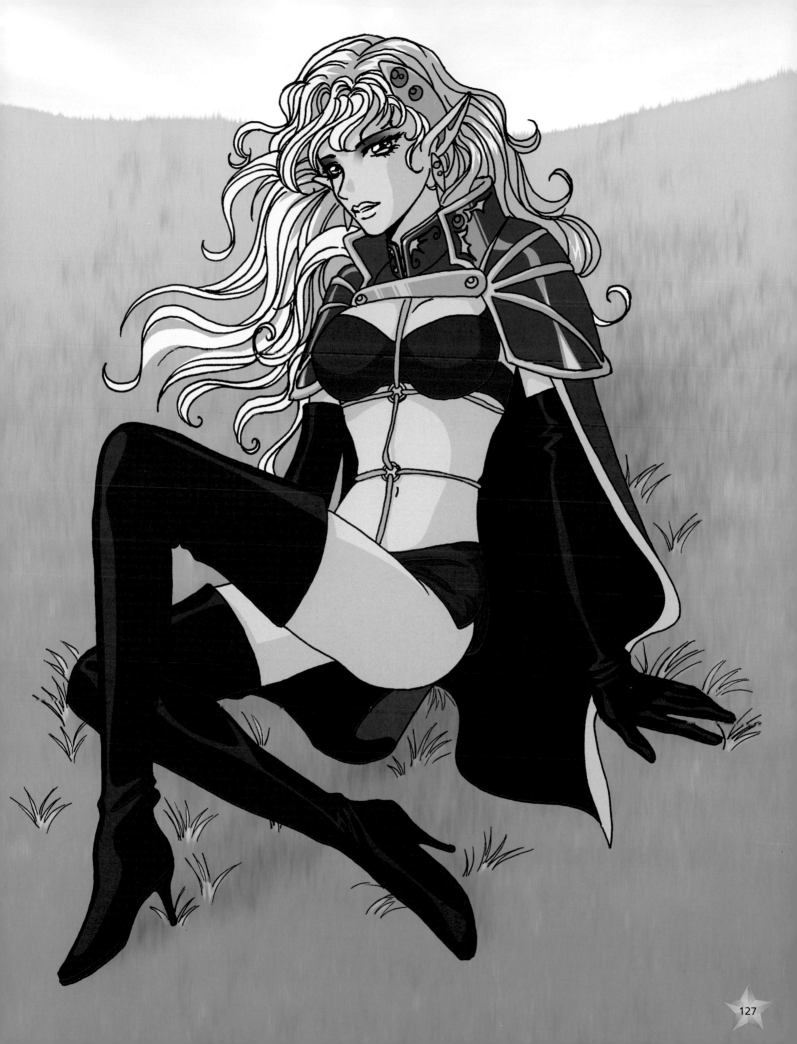

CREATING CHEMISTRY

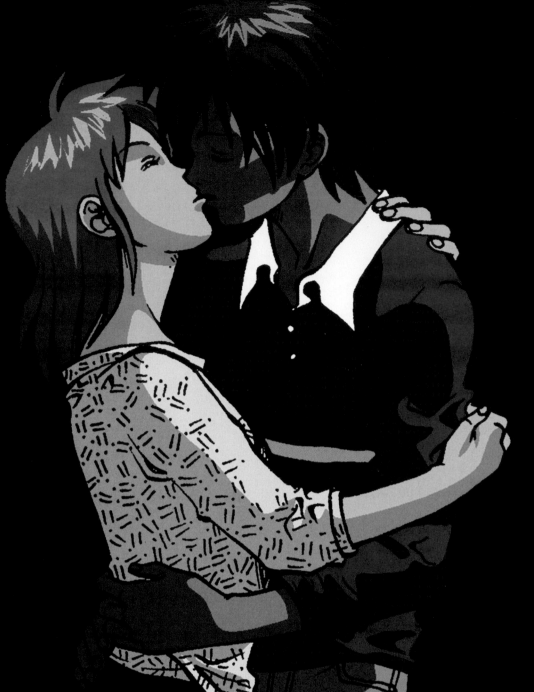

When you create an attractive female lead character, readers expect that sparks will fly between her and a story's leading man. There should be romantic tension, giving the story an underlying edge and a subtext to a lot of the dialogue. Comic books are primarily a visual medium, and so this magnetic attraction must be effectively communicated by your drawings. How do you show something that is just a feeling between two people? That's what we're going to find out.

Closing the Distance

TOO FAR

Eye contact (see page 130) certainly helps when trying to communicate the attraction between two people. But sometimes, two people who like each other try not to look at each other, for fear of being too obvious. And eye contact alone can't sustain that heat across numerous sequential panels. No, there's more to it than that—a lot more.

Attraction is like gravity, the closer two objects are to each other, the stronger the pull. Two characters sharing a park bench for a chat won't ignite any sparks if they're too far away from each other. But closer together, the chemistry starts to happen. So, before you worry about eye contact, pay attention to the distance between your characters.

BETTER

BEST

Eye Contact

Now that your characters are closer together, have them lock eyes. This brings the romantic tension up a notch. A deep stare, straight into each other's eyes, creates the most riveting, intimate moments. It helps to put them on the same wavelength, emotionally, and to establish a bond between them.

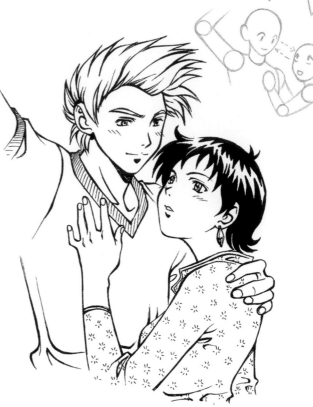

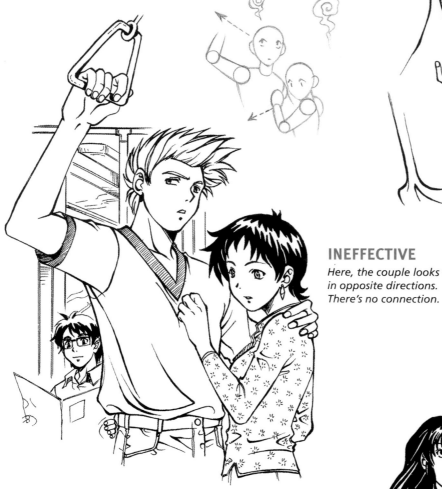

INEFFECTIVE

Here, the couple looks off in opposite directions. There's no connection.

EFFECTIVE

Here, the couple turns toward each other so that you can see the chemistry between them.

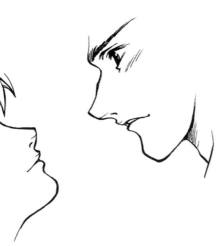

Eye Contact and Character Positioning

Making eye contact doesn't require two characters to face each other, especially if it's an initial meeting. It's more inventive—and more natural—for people to initiate eye contact without committing themselves overtly. After all, if a boy is rebuffed, he would want to regain his dignity; and he wouldn't be able to do that if he walked up to a girl and stared straight at her. There must be some hesitancy, either from him or her. And that should show in the oblique way you position the characters in relation to one another.

BACK TO BACK

SIDE BY SIDE

AROUND A CORNER

Touching

There are many ways that you can signify your characters' romantic attraction to each other by touching. Not all touch is meant to be overtly intimate. Sometimes, it's just a sign of affection. Here are a few prime examples of displays of affection that do not stop the story in its tracks.

CARESSING THE HAIR

HUG FROM BEHIND

BRUSHING PAST

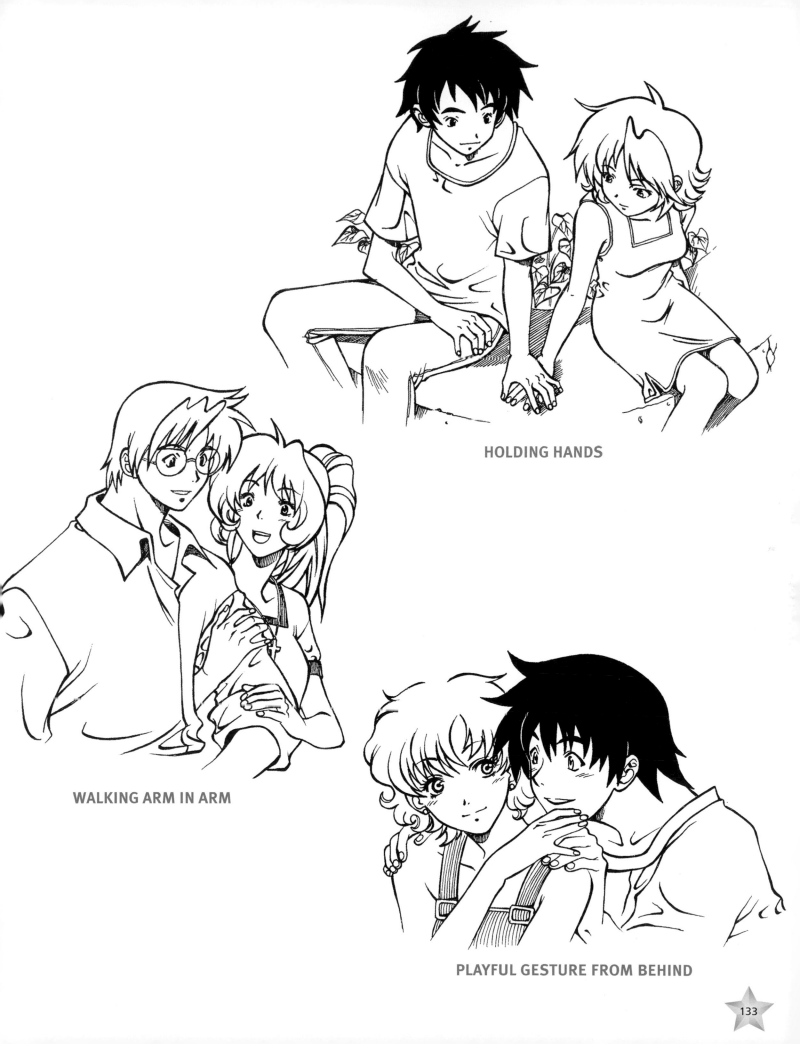

HOLDING HANDS

WALKING ARM IN ARM

PLAYFUL GESTURE FROM BEHIND

The Kiss

To draw an effective kiss, you need to have the faces overlap each other, with noses side by side. The eyes must be shut. If one character has an eye open, they will read as a person who is deceiving his or her lover (which can also be an effective gesture). When two characters kiss, they must also embrace each other and be close together. There should be no space between them. Creating a height difference between the characters makes the image more dramatic than if they were both the same height. Generally, the man (being the taller of the two) tilts his head down, while the woman tilts her head up, creating a long line for the neck, an attractive position for female leads.

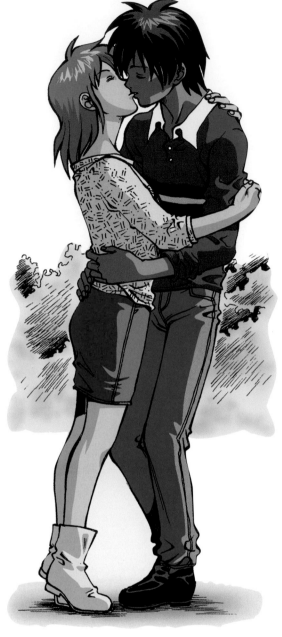

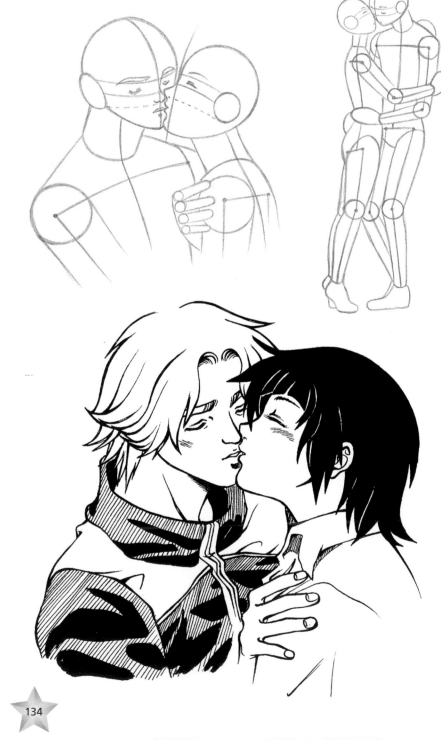

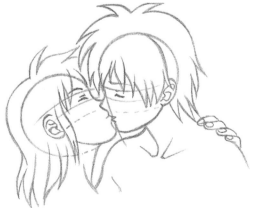

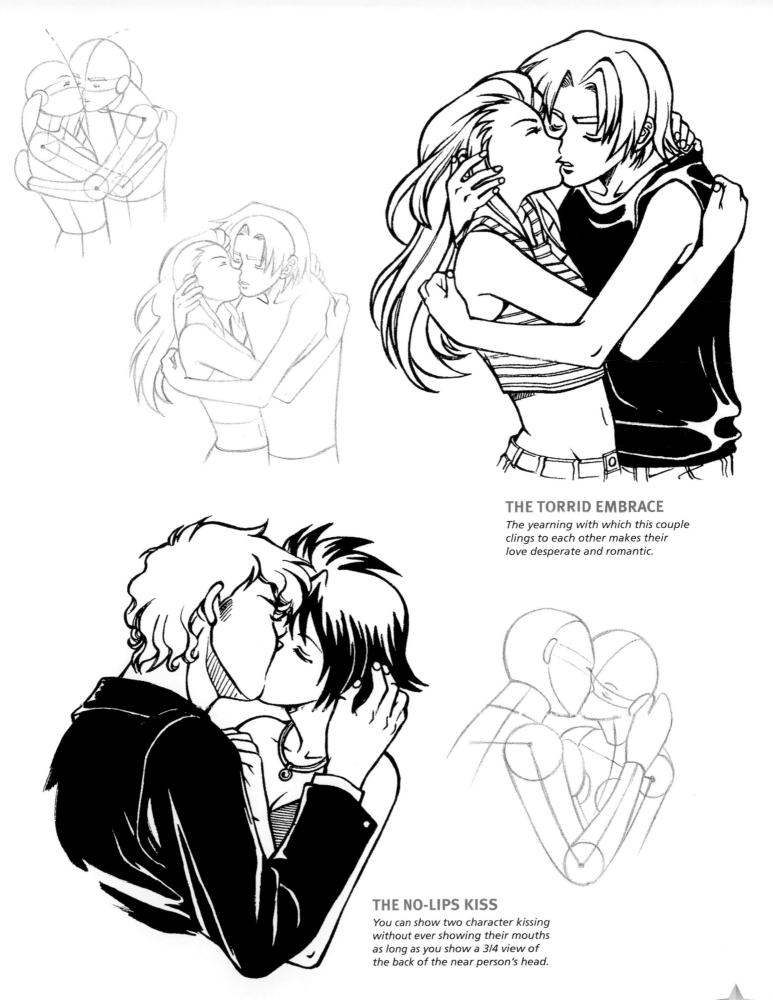

THE TORRID EMBRACE

The yearning with which this couple clings to each other makes their love desperate and romantic.

THE NO-LIPS KISS

You can show two character kissing without ever showing their mouths as long as you show a 3/4 view of the back of the near person's head.

MAGICAL GIRL
SPECIAL
EFFECTS

Some of the most brilliant and spectacular characters in all of bishoujo are the magical girls. I've briefly introduced you to the type in earlier chapters. However, since they are everyone's favorite, they're certainly worth their own section. So, here are the girls with the most flair, the most magic, and the coolest costumes. They are beautiful but determined fighters who are out for justice. They have mysterious and awesome powers, and they use them against mighty opponents. These magical effects supercharge any comic book page and are sure to hold the reader's attention, so you need to know how to draw them.

Cool Magic Effects

There are as many types of magical effects as there are people with imaginations. Some have become so popular that they're eagerly anticipated by loyal readers. Let's put a few of them into your drawing arsenal.

ELECTRICAL STORM

When she flies off to bring justice to a world in chaos, her powers are sometimes so great that they set off electrical charges around her, like wakes that follow a boat cutting through the water. This is a very cool look, and I would urge you to use it in your drawings of magical girls.

The arm gets smaller as it recedes.

The leg gets smaller as it recedes.

When sketching the back leg, draw through the front leg in order to get the correct position.

Manipulating Natural Forces

Magical girls can use their powers to direct the very forces of nature, even causing major storms if necessary. (But they still have trouble cleaning their rooms. Hey, they're still teenagers, after all!)

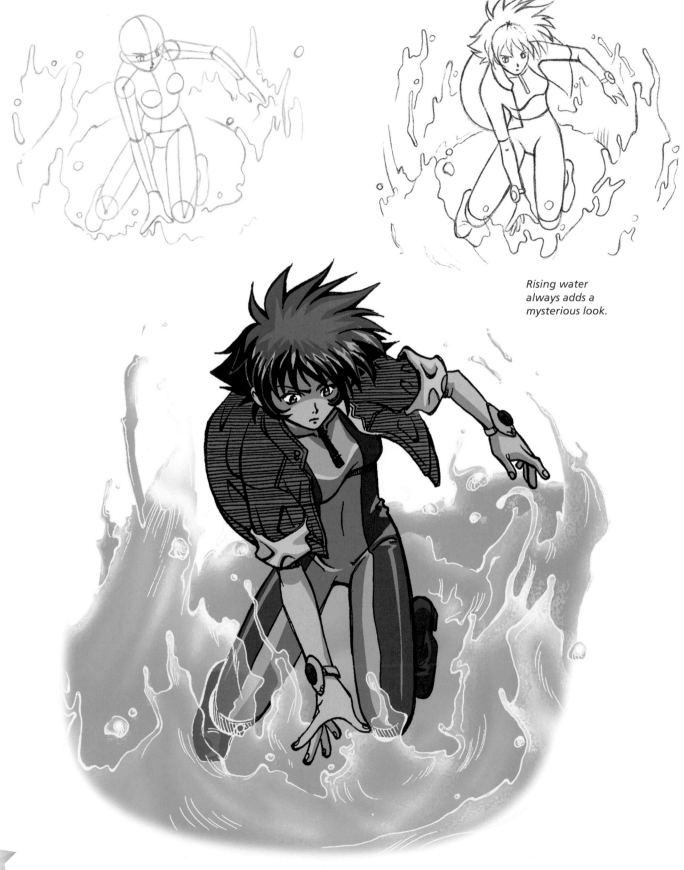

Rising water always adds a mysterious look.

Her magical ring supplies all the power she needs, but only she knows how to make it work. Her costume is reminiscent of the public school sailor uniform, but it's styled for an Action heroine. Note the long ponytail. . . so long, in fact, that it takes two bands to hold it! The forearm guards and boots are part of all Action characters' outfits. (I think it's in their union's charter.) The open skirt reveals spandexlike shorts, spandex being a favorite material of Action characters. And the flowing quality of the skirt adds the dramatic flair that a cape otherwise would, without being too cumbersome or overwhelming.

The hair wraps around the body.

139

Creating Matter

When giving shape and form to matter, start with glows and bubbles of effervescent energy. Little sparkles of energy should crackle all around these bubbles, as if the process of creating were filling the air with static electricity.

The far arm and leg get smaller as they recede.

The energy effect surrounds the hand and does not come from the fingertips.

Making Storms

Want to know what the weather will be like? Ask her. You don't want to get her ticked off if you're planning a picnic. When she summons a powerful storm to wreak havoc upon her enemies, the storm always brings darkness of night, thunder, wind, and rain. Always place her at the center of the storm, and make it surround her. (It's not dramatic to have her summon a storm far away where we can't see it.) Therefore, you must show the effects of the storm on her by having her hair and clothing flap violently.

Forces of nature swirl upward; they never rise in a straight line.

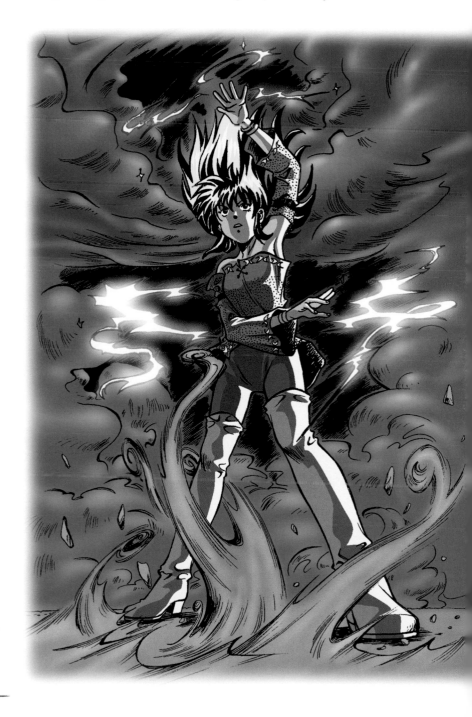

Making Fire

You can try keeping the matches away from her, but it won't help. She has a talent, one might say. To make fire, she whips her hand in an arc around her body, creating a circle of flames. The circle of flames is a very strong, ancient motif that is embedded in fantasy culture. When a bishoujo character brings her power to life—whether it be the ability to make fire, lightning, water, or wind—you shouldn't make it look too easy. That would rob the event of its dramatic element. It should look as if it takes real work to pull this off. This concept has its basis in Greek mythology. The ancient Greek gods were said to have become tired after using their powers, and they would retire to their domains to rest and become renewed. As you can see from her pose, she's using effort and skill, crouching down to release the flames.

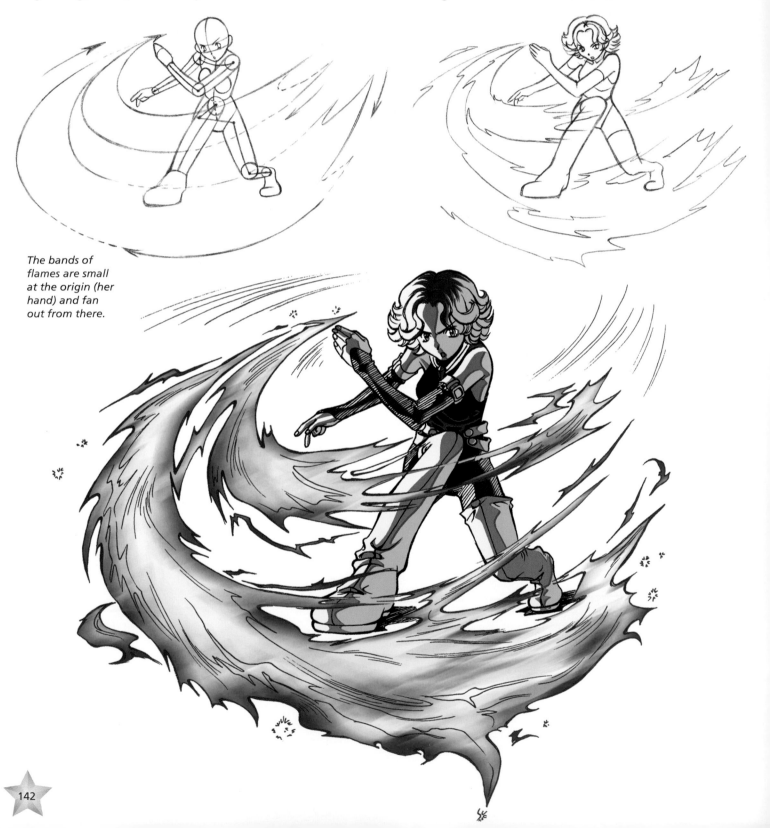

The bands of flames are small at the origin (her hand) and fan out from there.

Flairs of energy radiate from the bursts.

When you're fighting something that looks like a cross between Hercules and a giant walking popcorn maker with a pituitary problem, you're going to need a good deal of firepower. For situations like this, a huge burst of magic works best. The burst should be in the shape of a jagged star and should look like an explosion with crackling energy radiating outward in thin, jagged streaks. Make the burst sizable enough to cause Mr. Metal to hiccup.

INDEX

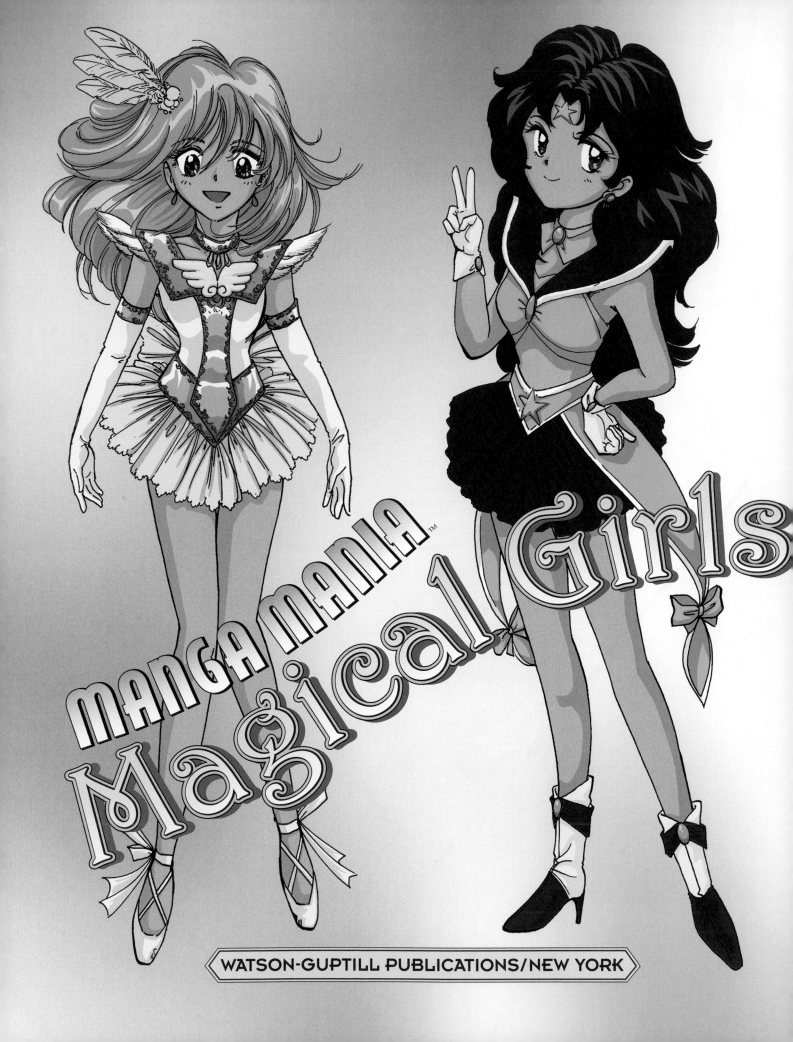

MANGA MANIA™
Magical Girls

WATSON-GUPTILL PUBLICATIONS/NEW YORK

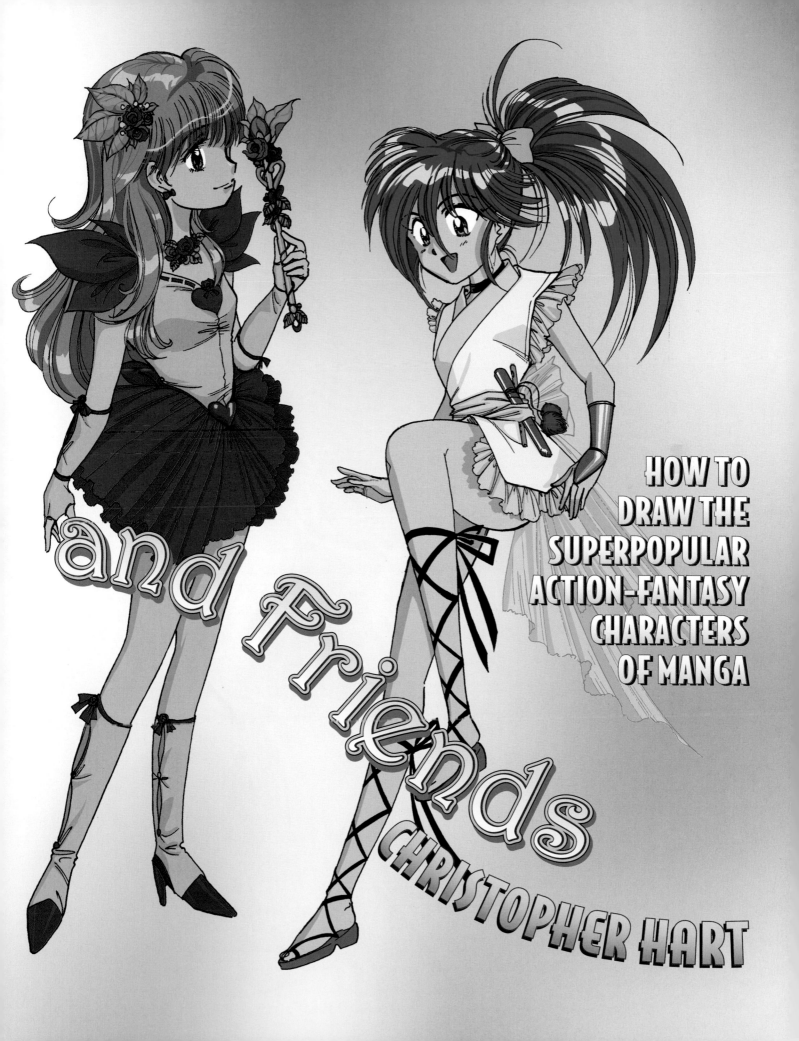

and Friends

HOW TO
DRAW THE
SUPERPOPULAR
ACTION-FANTASY
CHARACTERS
OF MANGA

CHRISTOPHER HART

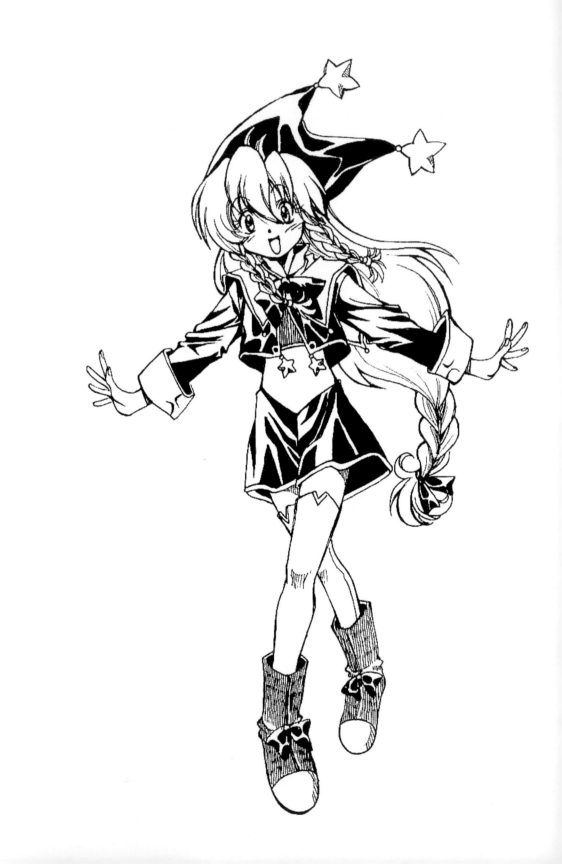

Contents

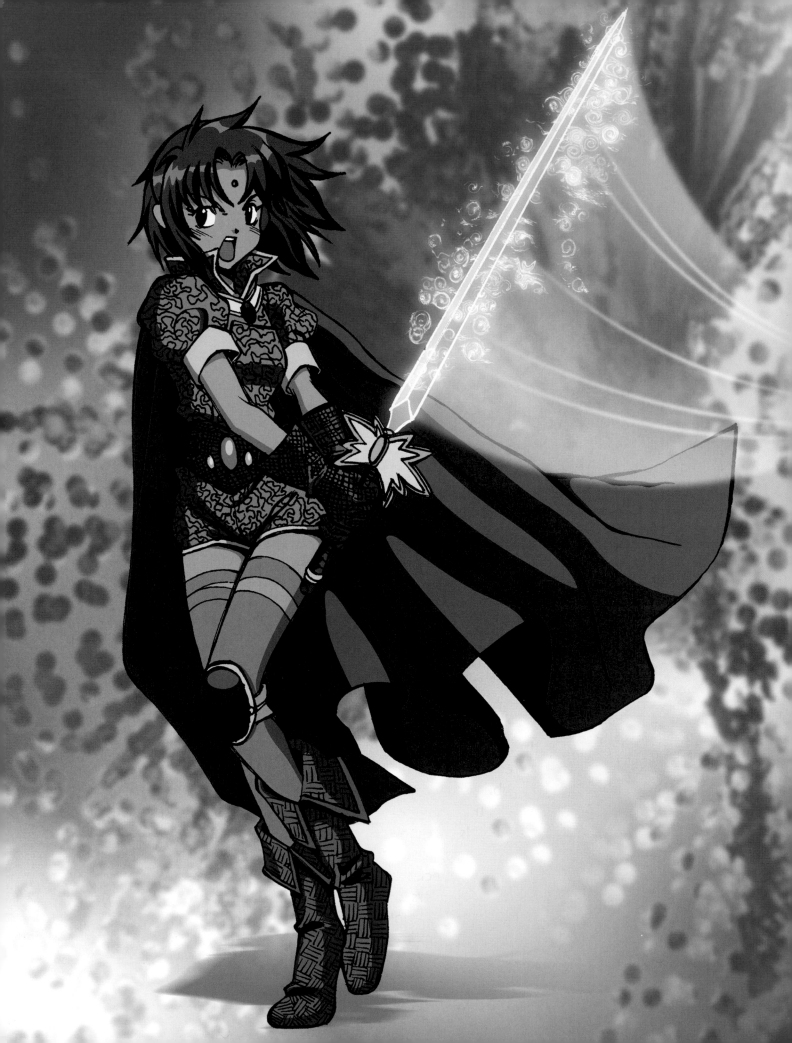

Introduction

*T*HE MAGICAL GIRL CATEGORY is a huge part of the famous shoujo (pronounced show-joe) genre of manga. Shoujo is the giant genre that focuses on the charming look of Japanese comics, and leans more toward female characters and relationships. However, the readership is both male and female in North America, as well as in Japan.

The Magical Girl subgenre is a particularly popular twist on the shoujo theme—and perhaps the most popular of all. It owns a fiercely loyal fan base. Don't be surprised to see some of the most popular manga titles in this category. Among them are: *Sailor Moon, Magic Knight Rayearth, Saint Tail, Fushigi Yuugi, Cutey Honey, Tokyo Mew Mew, Card Captor Sakura, Magical Angel Sweet Mint*, and *Pretty Sammy*.

Magical girls are, typically, schoolgirls who are suddenly called upon to save another world that's in danger. To do this, they are given special powers that transform them into superidealized "magical" versions of themselves, which are glamorous and amazing. Sometimes, a magical girl can be sent from another world to come to Earth and fit in as an Earth girl, which is difficult given the superior powers that she must keep under control if she is to conceal her secret identity.

These stories show how ordinary girls are really extraordinary, and how we all possess amazing abilities if only we look deep within ourselves. These stories are packed with an abundance of compelling characters in addition to the magical girl. There are the magical girl's classmates, who sometimes also transform to create a team of magical fighters. There's the handsome, slightly older boy on whom the magical girl has a secret crush. There are the magical boys, who may also come from another dimension and who fight on the same side as the magical girls. And then there's everybody's favorite: the manga mascot! It's the cute, little, furry and squeezable sidekick. This humorous monster-creature helps the magical girl—or at least tries to but ends up getting in trouble more times than not.

This book will take you through all of the techniques you need to draw the newest breed of magical girls and their friends, from how to draw magical girl faces and body proportions, action poses, costumes, expressions, magical transformations, and special effects to designing funny mascots, magical boys, supporting characters, and layouts to creating girl fighting teams and more. There's no other book like this one—if you're a manga fan, this is a must-have. So put a little magic in your arsenal of drawing techniques, and let's get ready to bring some adventure to our sketch pads!

The magical girl's face is open, charming, and appealing. She is most often represented as being in the tween years. Although she's growing into adolescent proportions, she still retains the soft contours, roundness, big features, and innocent eyes of a youngster. This makes for a compelling leading character. Steer clear of sharp angles, place large eyes far apart, and draw a petite nose and mouth. With these basics in mind, everything else will begin to fall into place.

Magical Girl Faces

The face of the magical girl retains the soft, round look of a preteen but with the feminine features of an older teenager, notably the heavy eyeliner and eyelashes. The magical girl should have a friendly, youthful face, which you can give her by drawing large eyes. Leave a good amount of space between the eyelids and the eyeball. That makes her look sincere and honest. Keep her face on the round side. If you make it too angular or sleek, she'll look older and less innocent.

It's very important, when drawing the front view, to use horizontal guidelines so that you make sure to keep both eyes, as well as both ears, at the same level. You don't want one to look higher than the other!

Front View

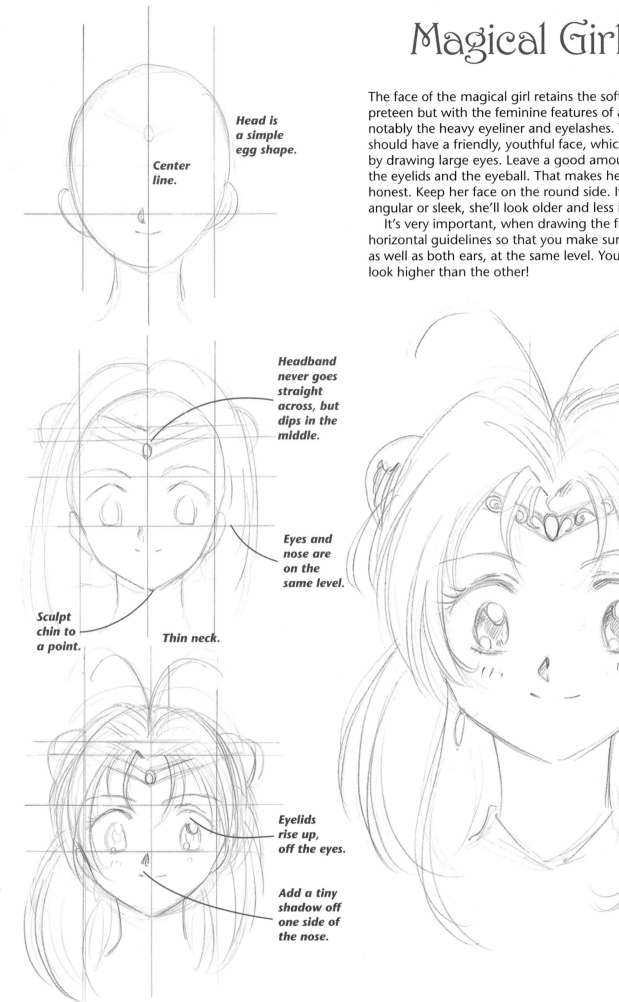

Head is a simple egg shape.

Center line.

Headband never goes straight across, but dips in the middle.

Eyes and nose are on the same level.

Sculpt chin to a point.

Thin neck.

Eyelids rise up, off the eyes.

Add a tiny shadow off one side of the nose.

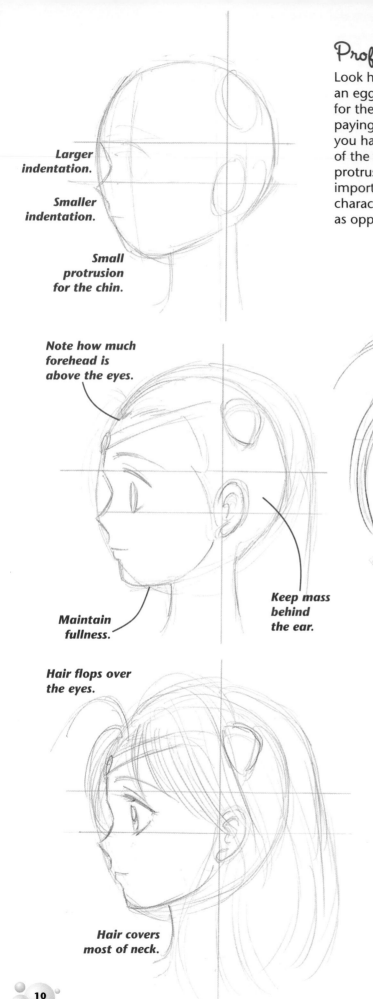

Larger
indentation.

Smaller
indentation.

Small
protrusion
for the chin.

Note how much
forehead is
above the eyes.

Maintain
fullness.

Keep mass
behind
the ear.

Hair flops over
the eyes.

Hair covers
most of neck.

Profile

Look how easy this is! When you draw the front view, you start with an egg shape. For the 3/4 view, you start with an egg shape. And for the profile, you start with . . . an omelet. Just seeing if you were paying attention! Yes, this starts with a simple egg shape, too. But you have to delicately carve out small areas and curves in the front of the face while leaving the general outline in place. No big, boney protrusions—these aren't American-style comics. It's especially important to leave a soft underside to the chin. This keeps the character youthful and feminine. It makes her a "good" character, as opposed to an "evil" one, who is hard and angular.

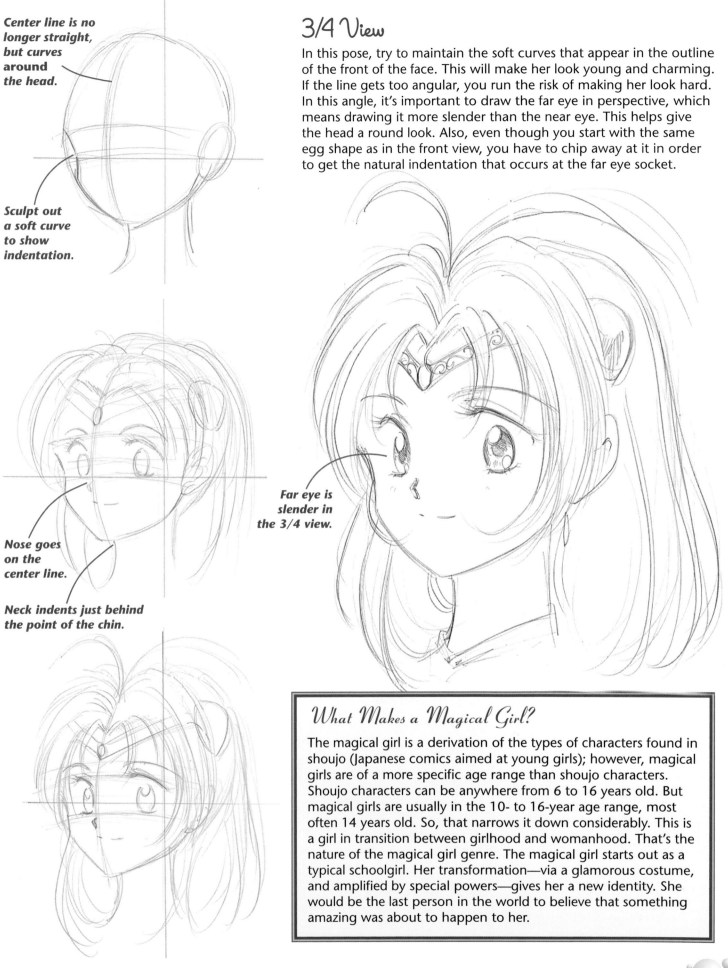

Center line is no longer straight, but curves around the head.

Sculpt out a soft curve to show indentation.

Nose goes on the center line.

Neck indents just behind the point of the chin.

3/4 View

In this pose, try to maintain the soft curves that appear in the outline of the front of the face. This will make her look young and charming. If the line gets too angular, you run the risk of making her look hard. In this angle, it's important to draw the far eye in perspective, which means drawing it more slender than the near eye. This helps give the head a round look. Also, even though you start with the same egg shape as in the front view, you have to chip away at it in order to get the natural indentation that occurs at the far eye socket.

Far eye is slender in the 3/4 view.

What Makes a Magical Girl?

The magical girl is a derivation of the types of characters found in shoujo (Japanese comics aimed at young girls); however, magical girls are of a more specific age range than shoujo characters. Shoujo characters can be anywhere from 6 to 16 years old. But magical girls are usually in the 10- to 16-year age range, most often 14 years old. So, that narrows it down considerably. This is a girl in transition between girlhood and womanhood. That's the nature of the magical girl genre. The magical girl starts out as a typical schoolgirl. Her transformation—via a glamorous costume, and amplified by special powers—gives her a new identity. She would be the last person in the world to believe that something amazing was about to happen to her.

Magical Eyes

The eyes of the magical girl must be captivating and enchanting. For that to happen, they've got to be the center of attention of the face. They must pull the reader's attention away from everything else. Manga characters are, by definition, set up to feature the eyes as the center of focus. Manga eyes are oversized, contrasting with the rest of the facial features, which are "underdrawn."

For magical girls, however, more glamour is required. Use of heavier lines for the eyelids and more detail for the eyelashes is necessary. To make the eyeball itself sparkle, you'll need to use contrast. That means you need to draw shines amidst heavy pools of black. Shines only "sparkle" when surrounded by dark areas. But if the dark area is pure black, the shines may end up looking like white spots, not reflective or moist, which is what you're after.

Manga artists have developed very effective methods of creating brilliant canvases on which to lay down their eye shines. They use solid black areas that radiate outward into streaked lines that mimic the look of irises. The results are so effective that the eyes seem to almost glitter. This streaked effect—migrating out of the pools of darkness, combined with multiple shines of varying sizes—makes the eyes really pop. In addition, note the natural path that the eyelashes take, as well as the heavy lines of the eyelids. Remember this rule: The heavier the eyelids, the more glamorous the eye!

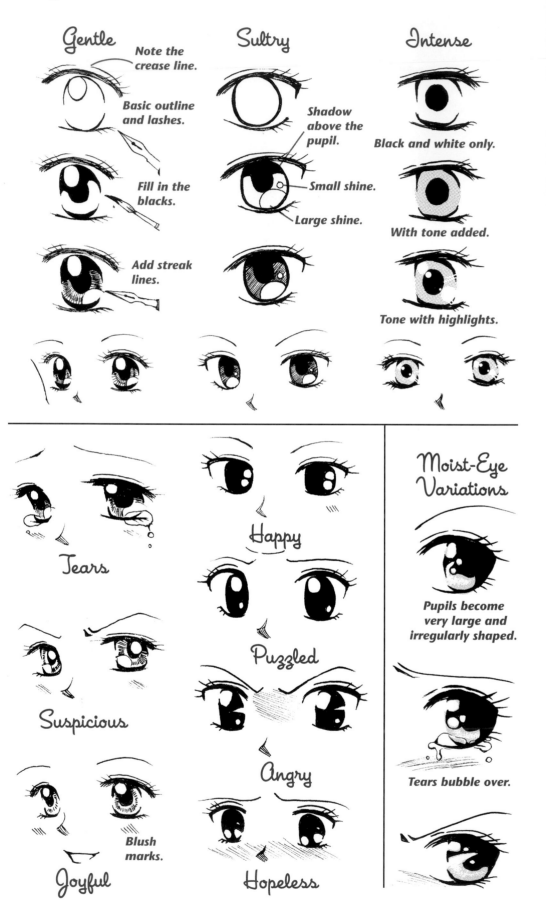

Gentle

Note the crease line.

Basic outline and lashes.

Fill in the blacks.

Add streak lines.

Sultry

Shadow above the pupil.

Small shine.

Large shine.

Intense

Black and white only.

With tone added.

Tone with highlights.

Tears

Suspicious

Joyful

Happy

Puzzled

Angry

Blush marks.

Hopeless

Moist-Eye Variations

Pupils become very large and irregularly shaped.

Tears bubble over.

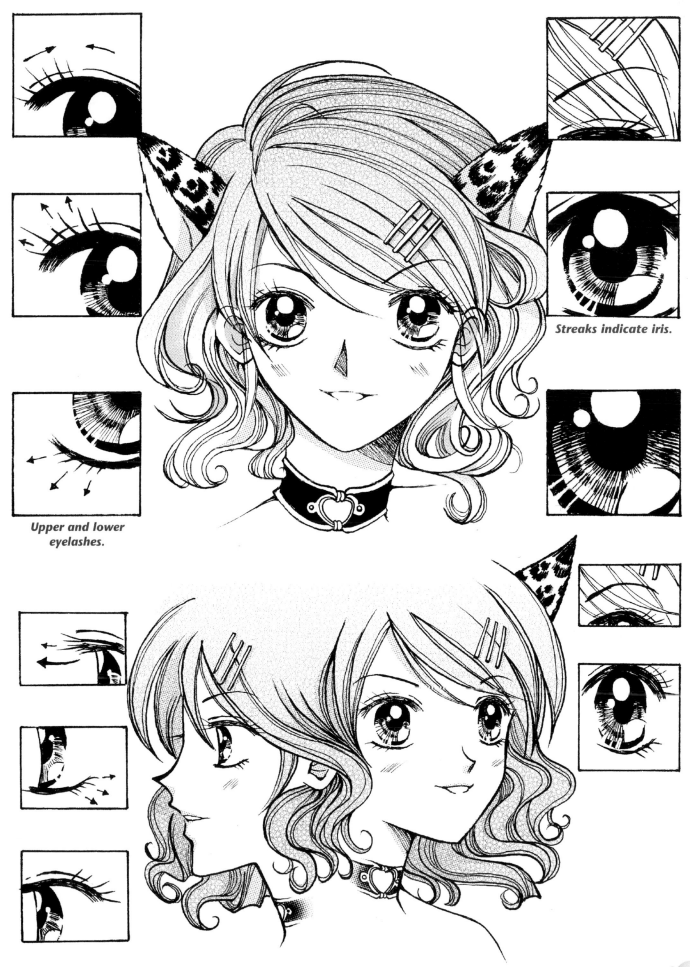

Streaks indicate iris.

Upper and lower
eyelashes.

The Magical Salon

Ready for your magical makeover? This is the only salon where the customer comes out with more hair than when she came in! When a magical girl transforms, her hair—like everything else—goes into glamour and grace overdrive. It becomes longer, more flowing, more dramatic—a real eye-catcher. But—and here's a secret that most people won't tell you—you have to work backward to achieve this effectively. What do I mean by that? You don't want to start with a character who's too charismatic, too over-the-top to begin with; otherwise, you'll have nowhere to go. You'd have to exaggerate her to ridiculous lengths to transform her into a magical girl. Remember, you want her to look idealized as a magical girl, not bizarre. The whole conceit of the magical girl genre is that any "average" girl can turn into a superstar.

It's a concept that pops up in many cultures: Remember how "average" Lois Lane became Superman's girlfriend? It's more dramatic if something spectacular happens to someone ordinary. That way, everyone can relate to it. So make your life easier—start with a character whose hair isn't wildly cutting edge to begin with. Then, when she transforms, you'll have more room to play with.

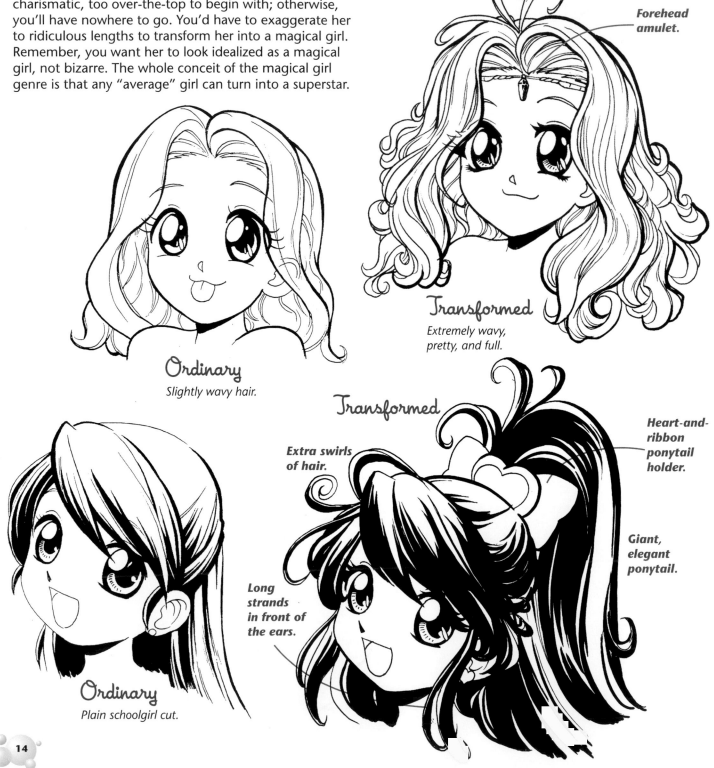

Forehead amulet.

Ordinary
Slightly wavy hair.

Transformed
Extremely wavy, pretty, and full.

Transformed

Extra swirls of hair.

Heart-and-ribbon ponytail holder.

Giant, elegant ponytail.

Long strands in front of the ears.

Ordinary
Plain schoolgirl cut.

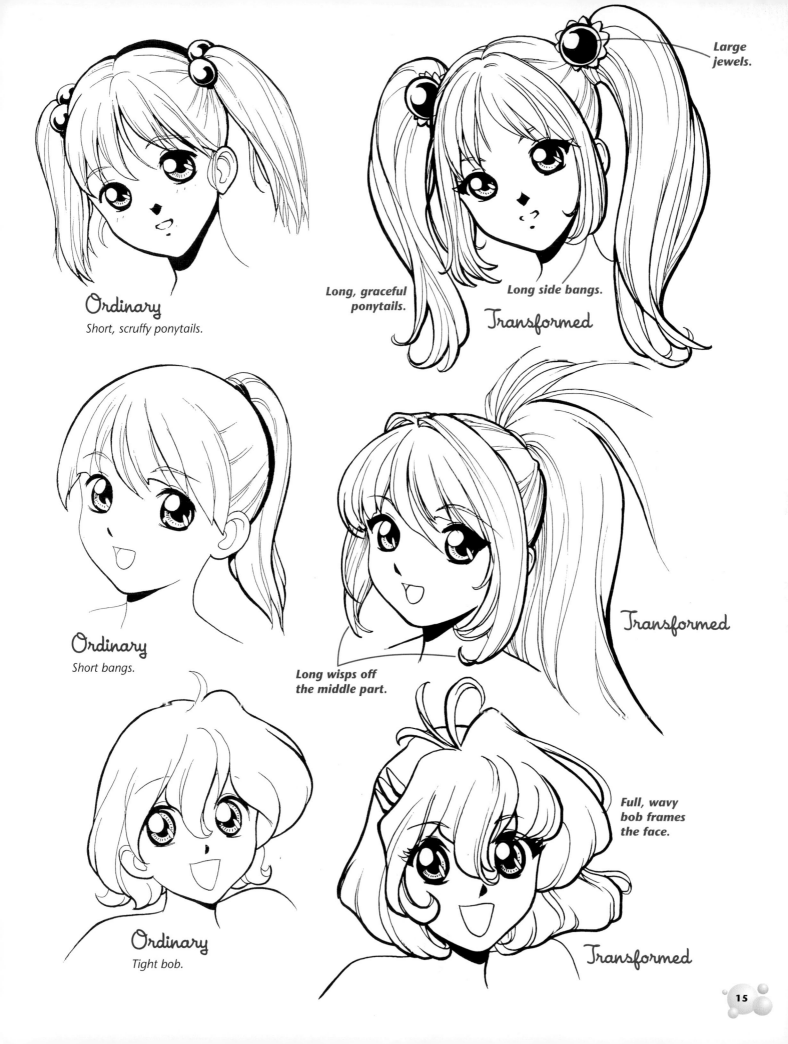

Large jewels.

Ordinary

Short, scruffy ponytails.

Long, graceful ponytails.

Long side bangs.

Transformed

Ordinary

Short bangs.

Long wisps off the middle part.

Transformed

Ordinary

Tight bob.

Full, wavy bob frames the face.

Transformed

Expressions

Okay, let's set down the ground rules: You must draw expressions exactly like this and never vary them. KIDDING!!! You can draw them any way you like—hey, you're the artist. What I'm showing you are the classic renderings of magical girl expressions. In other words, you can't go wrong by drawing expressions like the ones shown here. However, if you want to make adjustments and add your own personal touches to these examples, great. Use these as a starting point, a springboard for your own creations. And keep in mind that just because magical girls are pretty and graceful doesn't mean that they don't clown around. You know from reading your favorite manga that even the prettiest magical girls can be giant klutzes! Go broad with expressions and attitudes.

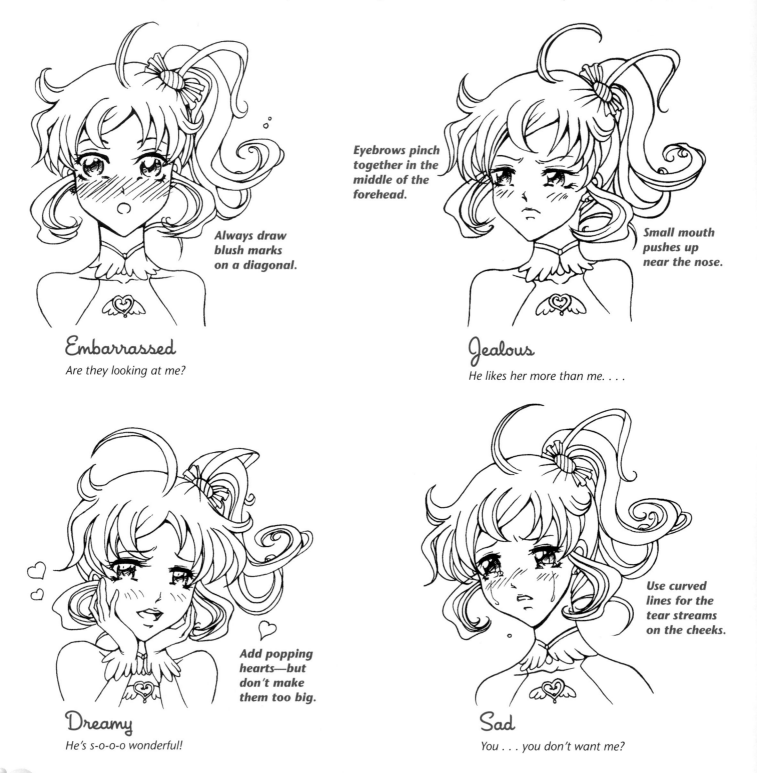

Always draw blush marks on a diagonal.

Embarrassed
Are they looking at me?

Eyebrows pinch together in the middle of the forehead.

Small mouth pushes up near the nose.

Jealous
He likes her more than me. . . .

Add popping hearts—but don't make them too big.

Dreamy
He's s-o-o-o wonderful!

Use curved lines for the tear streams on the cheeks.

Sad
You . . . you don't want me?

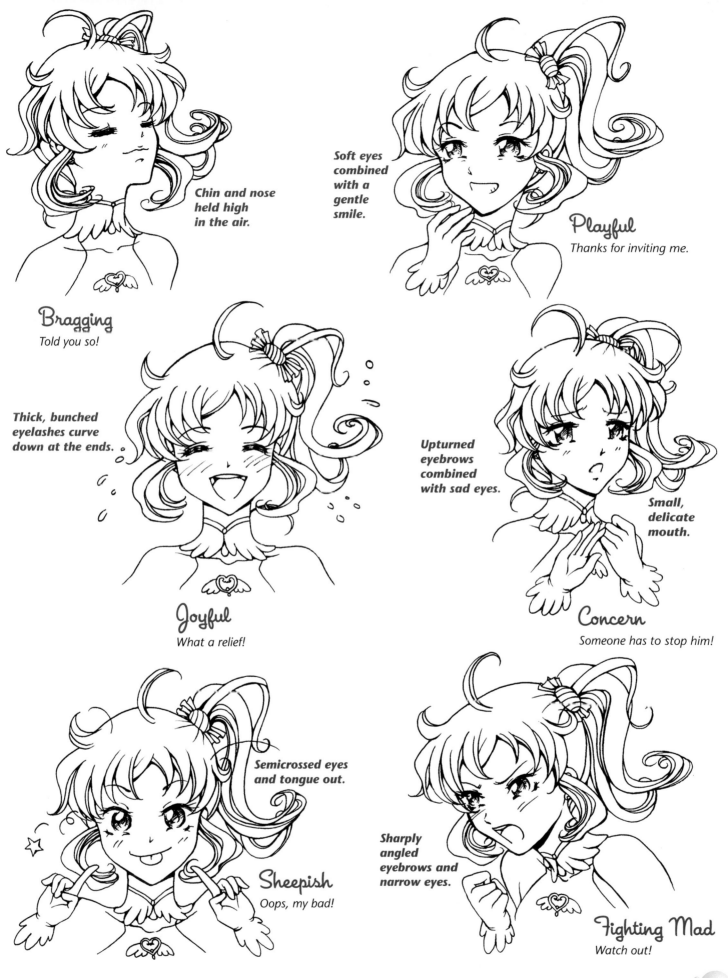

Bragging

Told you so!

Chin and nose held high in the air.

Soft eyes combined with a gentle smile.

Playful

Thanks for inviting me.

Thick, bunched eyelashes curve down at the ends.

Joyful

What a relief!

Upturned eyebrows combined with sad eyes.

Small, delicate mouth.

Concern

Someone has to stop him!

Semicrossed eyes and tongue out.

Sheepish

Oops, my bad!

Sharply angled eyebrows and narrow eyes.

Fighting Mad

Watch out!

The Body

Want to draw the body of the magical girl so that it makes the character look exciting? The trick is to learn a few basics about drawing the female figure first—rather than starting with costumes or action poses, even though those are cool things to draw. If you start with the underlying form, you'll be 75 percent of the way there. So, get the foundation in place, and the rest will be icing on the cake.

Schoolgirl vs. Magical Girl

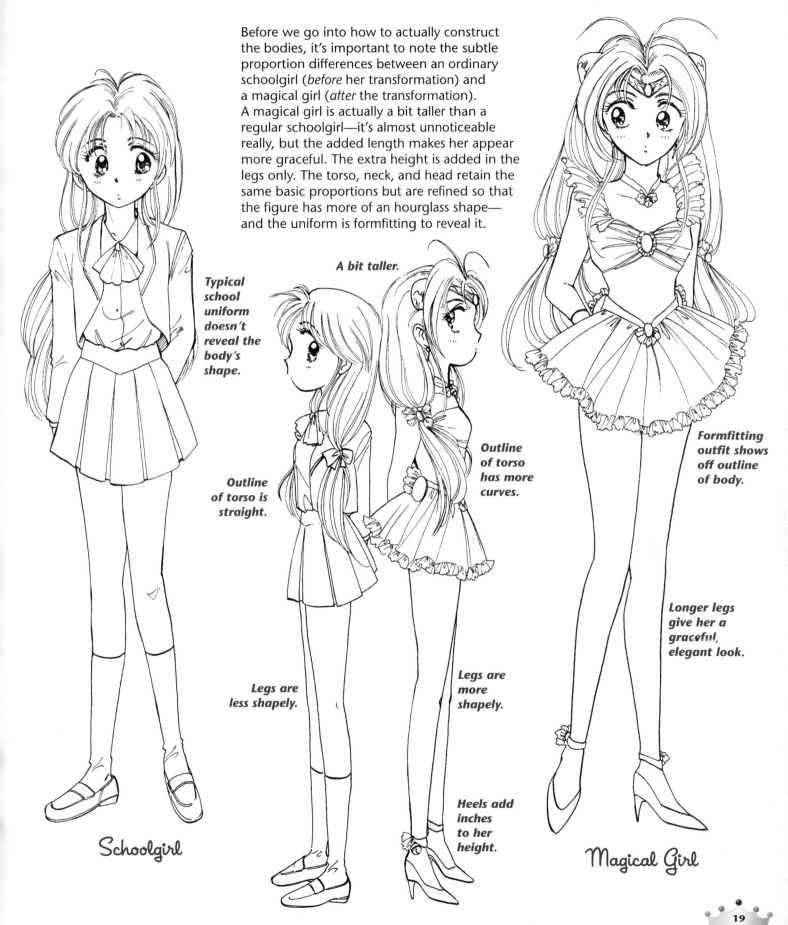

Before we go into how to actually construct the bodies, it's important to note the subtle proportion differences between an ordinary schoolgirl (*before* her transformation) and a magical girl (*after* the transformation). A magical girl is actually a bit taller than a regular schoolgirl—it's almost unnoticeable really, but the added length makes her appear more graceful. The extra height is added in the legs only. The torso, neck, and head retain the same basic proportions but are refined so that the figure has more of an hourglass shape—and the uniform is formfitting to reveal it.

Typical school uniform doesn't reveal the body's shape.

A bit taller.

Outline of torso is straight.

Outline of torso has more curves.

Legs are less shapely.

Legs are more shapely.

Heels add inches to her height.

Formfitting outfit shows off outline of body.

Longer legs give her a graceful, elegant look.

Schoolgirl

Magical Girl

Where to Add the Extra Height

By lightly sketching horizontal guidelines across the pit of the neck and the hips of both the magical girl and the schoolgirl, you can see that the proportions of the two upper bodies are identical. But when you draw a guideline at the ankles of the schoolgirl, you see that it doesn't match up with the ankles of the magical girl, whose legs have been lengthened to give her extra height. The longer legs give her that "runway model" look—proportions that add glamour.

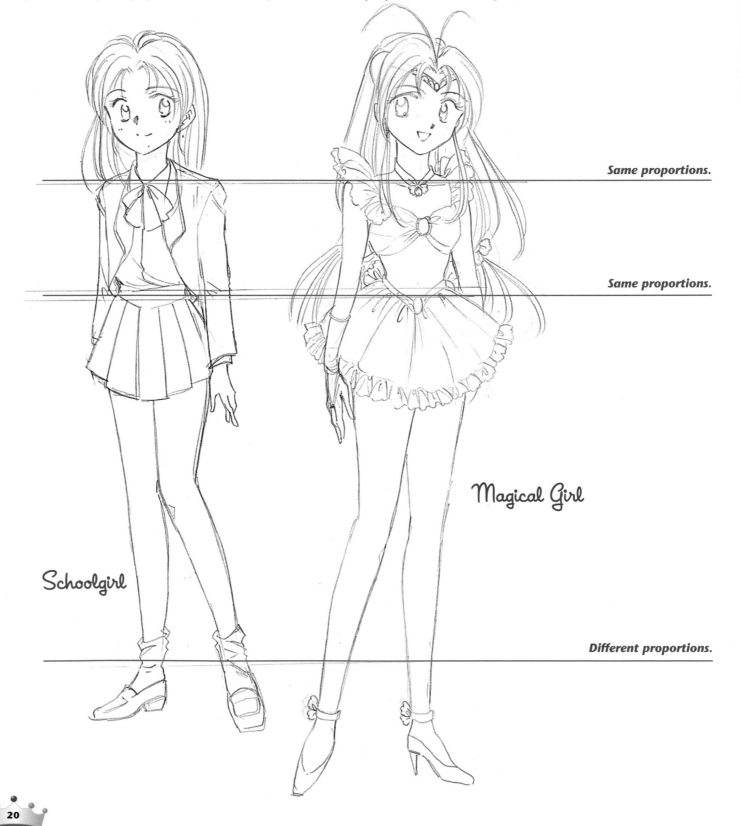

Same proportions.

Same proportions.

Magical Girl

Schoolgirl

Different proportions.

Yes, I know, you love drawing the face but worry that you'll ruin it when you draw the body. Don't worry. A few important hints will take the guesswork right out of it, and you'll be able to draw the body with confidence.

The first hint is this: Two-thirds of the upper body are taken up by the rib cage, and only one-third is taken up by the hip area. In addition, you can simplify both these areas into easy-to-draw shapes, as shown on the first construction step.

Now, here's something really important to keep in mind: The rib cage area *wedges down* into the hip area, so that both areas fit snugly into each other like a lightbulb into a socket. The torso is small and compact on magical girls and, therefore, must have a sharply accentuated waistline.

The next thing to notice is that the legs attach to the hips at a *diagonal*. See the labels on the first construction. This hint will help you whenever you're drawing legs, whether on magical girls, boys, villains, or any character!

Magical Girl Front View

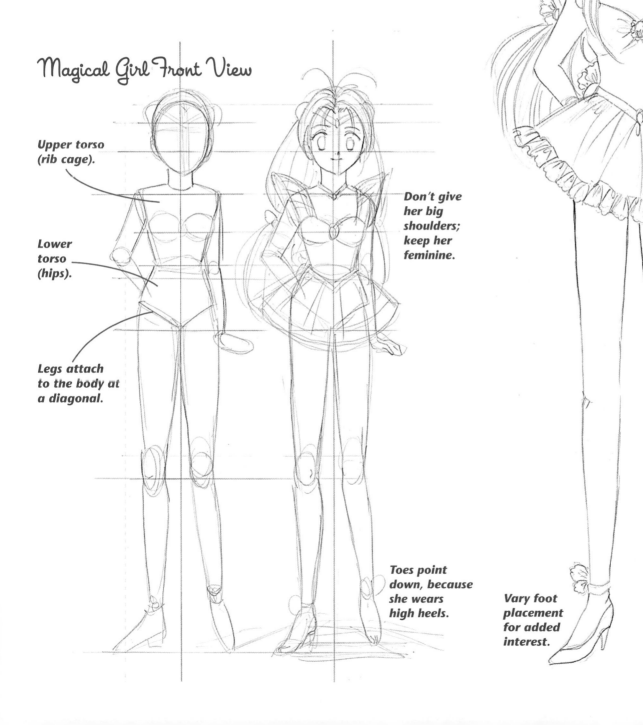

Upper torso (rib cage).

Lower torso (hips).

Legs attach to the body at a diagonal.

Don't give her big shoulders; keep her feminine.

Toes point down, because she wears high heels.

Vary foot placement for added interest.

Magical Girl Side View

As in the front view, in the side view the torso snaps together like pieces of a plastic model, one part into the other. The rib cage snaps into the top of the hips, and the legs snap diagonally into the bottom of the hips.

If you want to define the torso further, you can draw the midsection. That's the area within the rib cage that appears below the sternum (the chest bone) and above the pelvic bone. Health club devotees call this the "abs" or the "core." On manga schoolgirls and magical girls, the midsection is short because of the truncated upper bodies, so it often goes unarticulated. Older teens have longer midsections; it's something that comes with age. A longer midsection gives a character added flexibility in a pose, because it acts as connective tissue that can bend, turn, and twist.

Rib cage.

Midsection.

Hips.

Kneecaps only appear in front of the knees. (They are actually each a floating bone called the patella.)

Anatomy Overview

Front View

I've never heard an artist complain, "I would have been so much better at drawing if I had just learned a little *less* anatomy in art school!" Luckily, you don't need an anatomy class to learn how to draw magical girls. But over the next few pages, you'll get some basic pointers that will help you avoid mistakes that have probably frustrated you in the past. Let's see how a few simple concepts can wipe away years of bad habits with no effort at all!

A Torso widens out.

B Collarbones meet in the middle (the resulting bump shows through the skin).

C Collarbone bumps also appear on the shoulders.

D Pelvic bones protrude in the front view.

E Always sketch horizontal guidelines across the arms and legs to make sure the elbows and knees are at the same height.

F These shaded areas are the two major neck muscles, which travel from just below the ears to the collarbones.

G The basic shape of the midsection looks like a larger oval topped by an overlapping smaller circle.

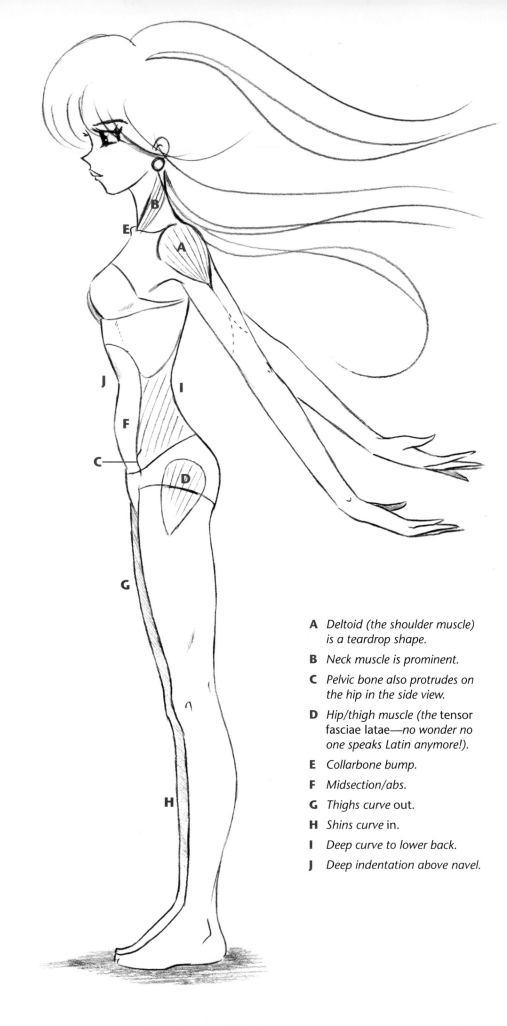

A Deltoid (the shoulder muscle) is a teardrop shape.

B Neck muscle is prominent.

C Pelvic bone also protrudes on the hip in the side view.

D Hip/thigh muscle (the tensor fasciae latae—no wonder no one speaks Latin anymore!).

E Collarbone bump.

F Midsection/abs.

G Thighs curve out.

H Shins curve in.

I Deep curve to lower back.

J Deep indentation above navel.

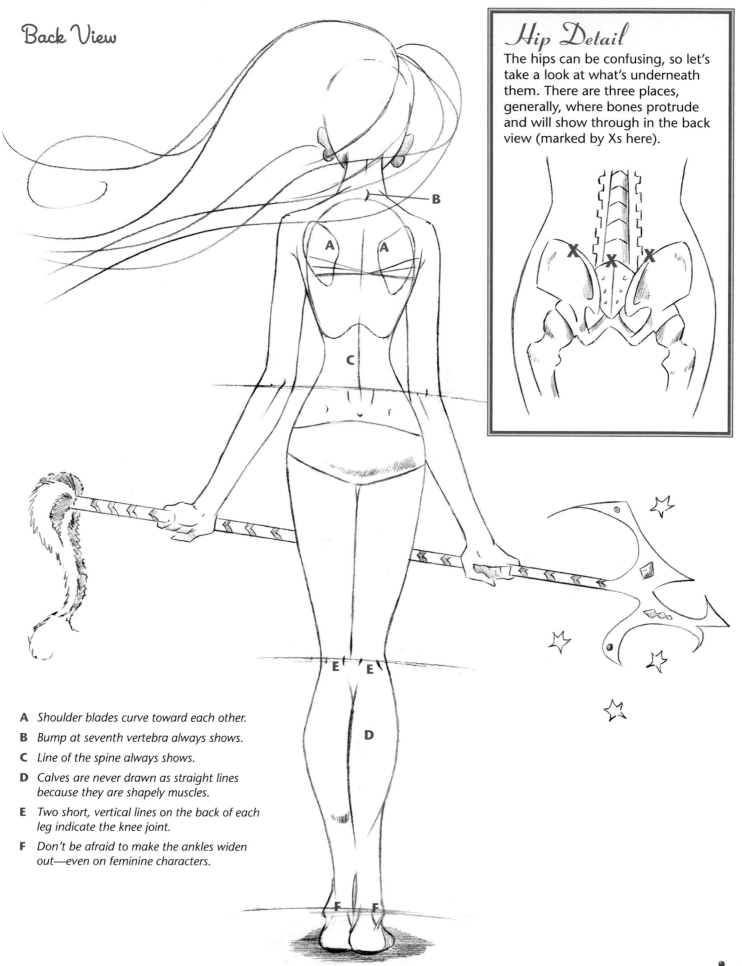

Back View

Hip Detail

The hips can be confusing, so let's take a look at what's underneath them. There are three places, generally, where bones protrude and will show through in the back view (marked by Xs here).

A Shoulder blades curve toward each other.

B Bump at seventh vertebra always shows.

C Line of the spine always shows.

D Calves are never drawn as straight lines because they are shapely muscles.

E Two short, vertical lines on the back of each leg indicate the knee joint.

F Don't be afraid to make the ankles widen out—even on feminine characters.

25

Tips for Drawing Hands

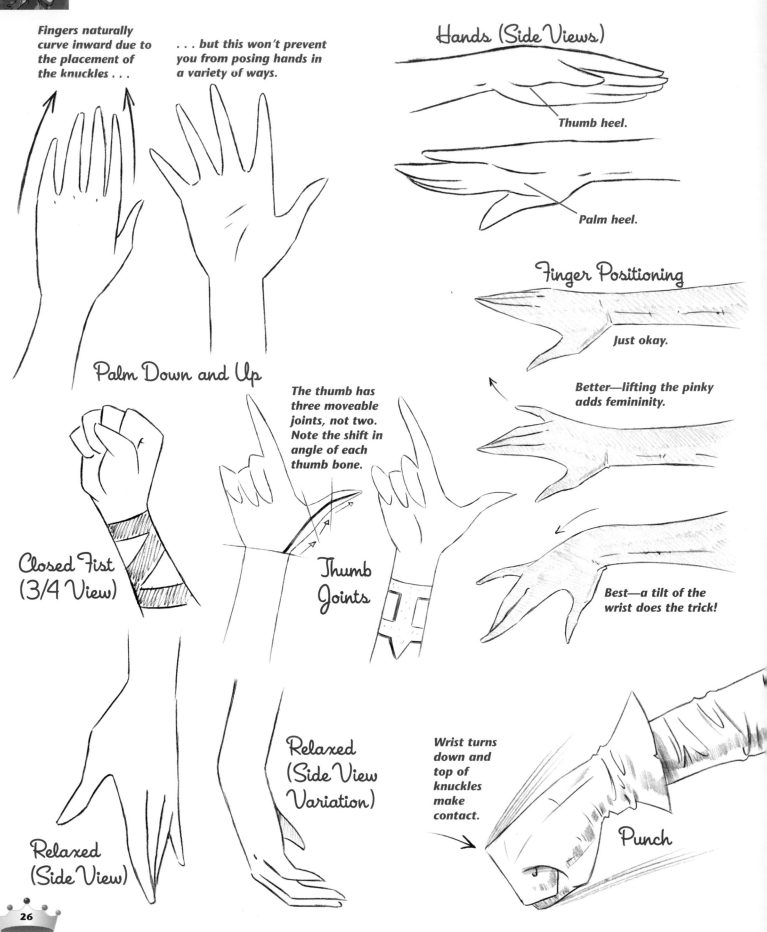

Fingers naturally curve inward due to the placement of the knuckles . . .

. . . but this won't prevent you from posing hands in a variety of ways.

Hands (Side Views)

Thumb heel.

Palm heel.

Finger Positioning

Just okay.

Better—lifting the pinky adds femininity.

Best—a tilt of the wrist does the trick!

Palm Down and Up

The thumb has three moveable joints, not two. Note the shift in angle of each thumb bone.

Closed Fist (3/4 View)

Thumb Joints

Relaxed (Side View Variation)

Relaxed (Side View)

Wrist turns down and top of knuckles make contact.

Punch

Tips for Drawing Feet

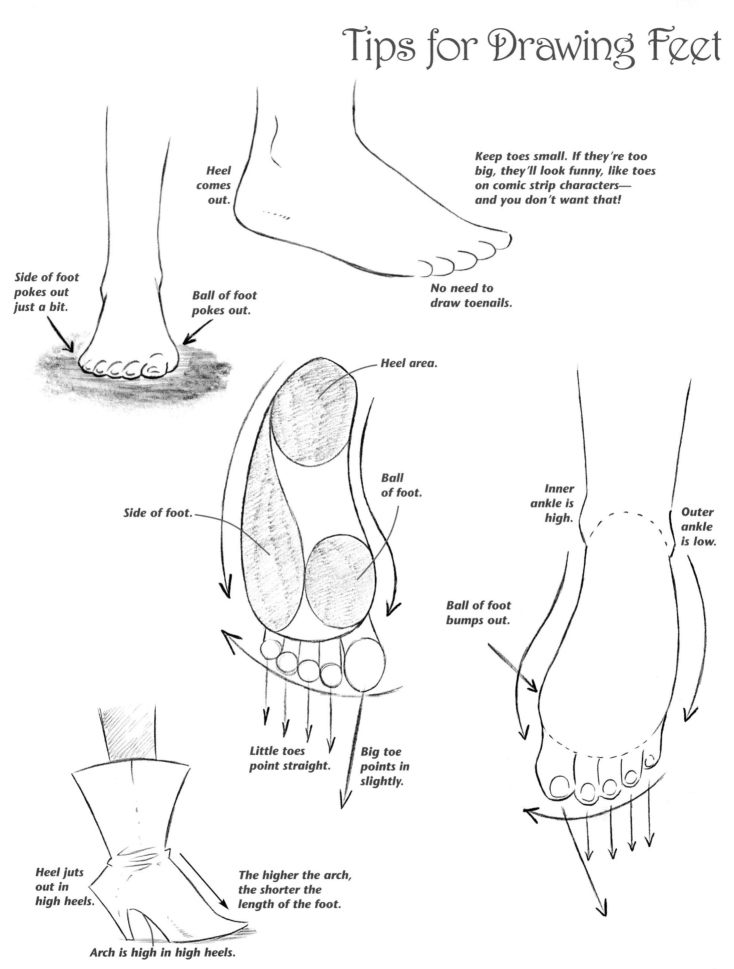

Heel comes out.

Keep toes small. If they're too big, they'll look funny, like toes on comic strip characters—and you don't want that!

Side of foot pokes out just a bit.

Ball of foot pokes out.

No need to draw toenails.

Heel area.

Side of foot.

Ball of foot.

Inner ankle is high.

Outer ankle is low.

Ball of foot bumps out.

Little toes point straight.

Big toe points in slightly.

Heel juts out in high heels.

The higher the arch, the shorter the length of the foot.

Arch is high in high heels.

Seeing through the Figure

See if you recognize yourself this scenario: You're starting to sketch a figure. Halfway through the pose, it's going well. You're impressed with yourself. Three-fourths of the way through, still no glitches. But about twenty yards from the goal line, you get that nagging feeling in your stomach. The way your character is positioned hides or cuts off part of her arm or leg so that only part of it shows. And you're not sure how to draw it so that it looks natural and not just stuck onto the body.

Perhaps the pose requires some perspective, and no matter how you draw it, you can't quite get it to look right. If only you could draw that one part correctly, you could save an otherwise terrific picture. Nonartists have no idea what I'm talking about. But you do. You're not alone, believe me! It's one of the little devils of drawing that drives us all mad at sometime in our careers. Hang on—hope has arrived. It's a process called I call *seeing through* the drawing.

A pose is like a riddle. Sometimes it needs to be solved. Best guesses are useless. Isn't that a relief? You can finally give up on guessing. Here's the answer: When drawing, it's just as important—if not *more* important—to draw the lines that the eye eventually *will not see* as it is to draw the lines that the eye will see. That's right. On challenging poses, try drawing all the lines initially—that means the limbs that are hidden behind the body or behind props, as well. Draw them as if your character were transparent and you could see right through her. This is the *draw through* method.

Far Arm Partially Hidden by Body

Very common problem. Sometimes the solution can look wrong to you when you just eyeball it. There's only one way to know for sure if you've gotten it right: Draw the far arm—but remember, since it's further away from you than the near arm, you will have to make it the slightly shorter of the two.

Far Leg Partially Hidden by Near Leg

As with the arm example, draw the entire back leg. It's important to indicate where the back leg's knee is, or you'll lose all sense of proportion. Again remember, since the back leg is further away from you than the front leg, it will appear shorter, due to perspective (which means that its knee will appear higher up than the nearer knee).

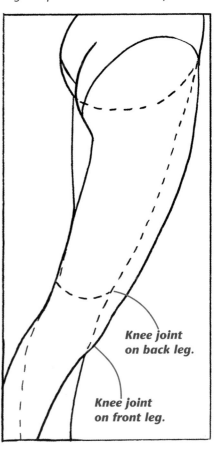

Knee joint on back leg.

Knee joint on front leg.

Perspective is the visual representation of the special relationships between forms as they appear to the eye. The rules of perspective tell us that objects that are closer to us appear larger than objects that are farther away from us. And in order for your figures to look realistic and convincing, you need to draw them in perspective. Perspective gets a bad wrap. People sometimes mistakenly think that in order to use perspective, they have to get out a set of rulers and T squares. It's not always such a complicated affair. Sometimes, it's just a matter of making a few smart adjustments to the figure in order to make a pose more convincing. Take a look at these figures to get a feel for how perspective affects the look of the body in various positions. If you keep these concepts in mind, your figures will begin to improve.

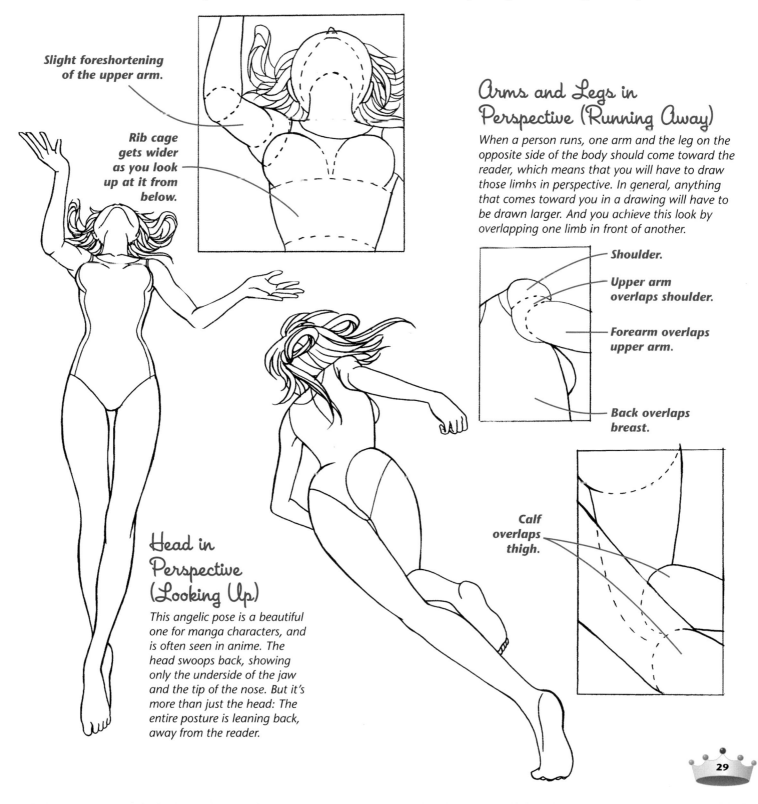

Slight foreshortening of the upper arm.

Rib cage gets wider as you look up at it from below.

Head in Perspective (Looking Up)

This angelic pose is a beautiful one for manga characters, and is often seen in anime. The head swoops back, showing only the underside of the jaw and the tip of the nose. But it's more than just the head: The entire posture is leaning back, away from the reader.

Arms and Legs in Perspective (Running Away)

When a person runs, one arm and the leg on the opposite side of the body should come toward the reader, which means that you will have to draw those limbs in perspective. In general, anything that comes toward you in a drawing will have to be drawn larger. And you achieve this look by overlapping one limb in front of another.

Shoulder.

Upper arm overlaps shoulder.

Forearm overlaps upper arm.

Back overlaps breast.

Calf overlaps thigh.

29

Poses That Illustrate Perspective

Sure, magical girls save the universe from the Lords of Evil, but they also need time to gossip online. So here are a few poses that reflect that downtime and also make good use of perspective, showing how to handle positions that hide parts of the body.

You don't want to always resort to a flat, side-view pose of a girl lying on her stomach on her bed. It's sort of plain, you know? Comics and manga are about being creative—not just in the way you draw the face, but in what you do with the character, how you pose her. Get creative. You want to come up with interesting poses. When you learn to *draw through* the figure, you're not as reluctant to try new or unusual poses.

Arm Hides the Back

In this angle, you see not only the chest but also some of the back of the character. Draw through the upper arm, as if it were transparent, in order to maintain the continuity of the line of the back. If you start the line of the back, then stop to draw the arm, and then begin the back again after you've drawn the arm, there's a good chance that the back won't look like one fluid line. You're guessing at where the back stops and starts again. By drawing through the arm, you take the guesswork out of it.

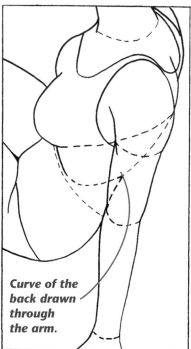

Curve of the back drawn through the arm.

Arm Hides the Rib Cage

Similarly, by continuing to draw the natural line of the rib cage and hips through the arm, you give a more fluid sweep to the torso. (Of course, any draw-through lines will be erased in the final drawing.)

| **Continuation of the natural hip line.** | **Lines drawn through the arm.** | **Continuation of the natural rib cage line.** |

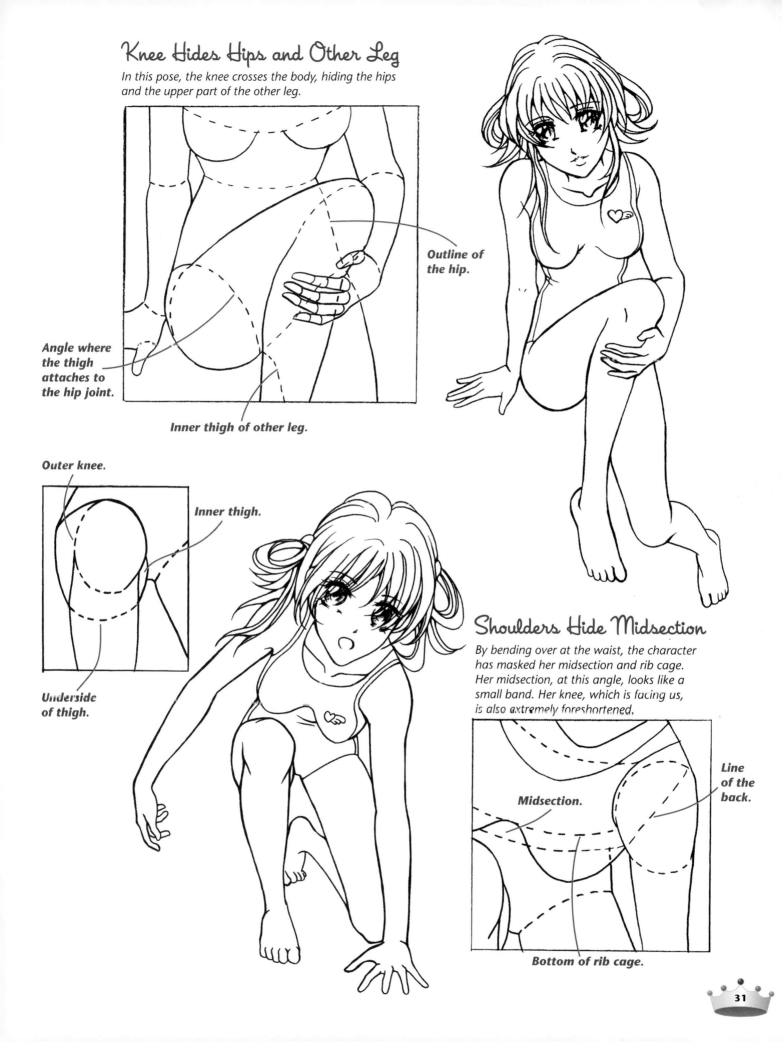

Knee Hides Hips and Other Leg

In this pose, the knee crosses the body, hiding the hips and the upper part of the other leg.

Outline of the hip.

Angle where the thigh attaches to the hip joint.

Inner thigh of other leg.

Outer knee.

Inner thigh.

Underside of thigh.

Shoulders Hide Midsection

By bending over at the waist, the character has masked her midsection and rib cage. Her midsection, at this angle, looks like a small band. Her knee, which is facing us, is also extremely foreshortened.

Midsection.

Line of the back.

Bottom of rib cage.

Finished Magical Girl Poses

Sometimes in art instruction books, after drawing a few pages of technical-looking stuff, you forget what the point was in the first place! So, it's important that we complete this section on drawing through a pose with some finished drawings of magical girls. And in the construction steps, you'll see the draw-through techniques you've been practicing. Compare the construction drawings to the finished versions of each pose so that you can see how perspective affects the final image and can then draw them.

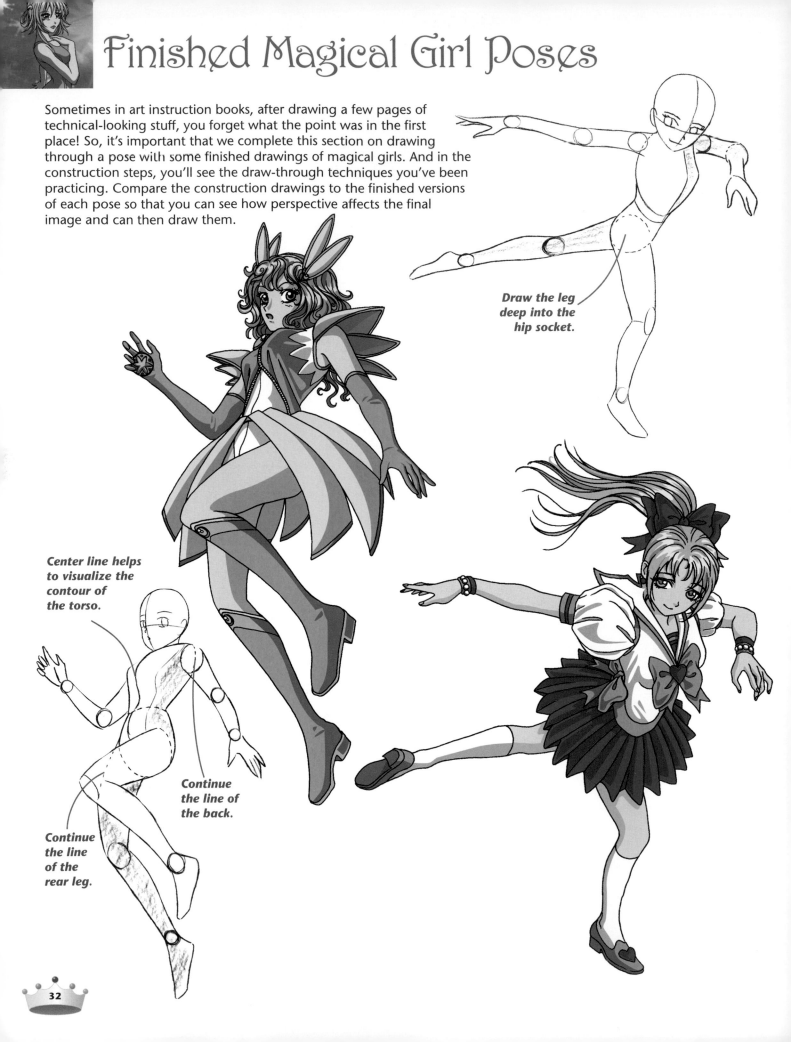

Draw the leg deep into the hip socket.

Center line helps to visualize the contour of the torso.

Continue the line of the back.

Continue the line of the rear leg.

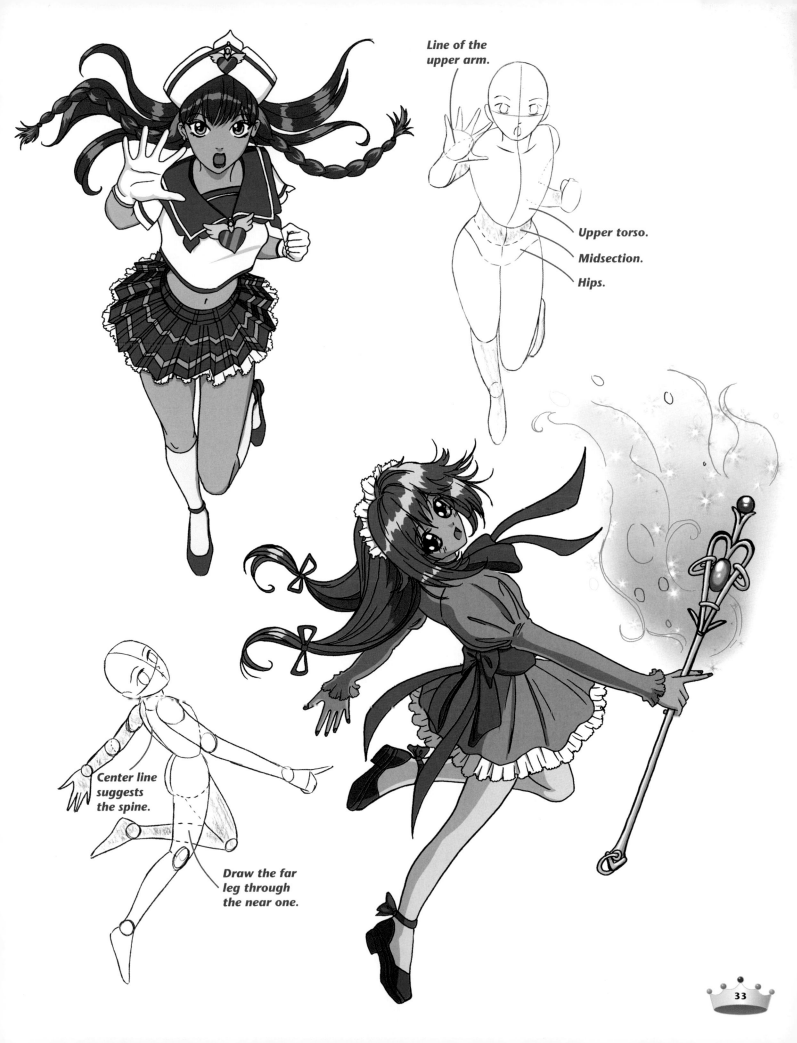

Line of the
upper arm.

Upper torso.

Midsection.

Hips.

Center line
suggests
the spine.

Draw the far
leg through
the near one.

Drawing Along Vanishing Lines

I'm sure you're well aware of the perspective effect I'm about to describe, but you may not know how to apply it to the human body. Well, you will now . . . just read on. I'm talking about the visual effect that causes a set of receding parallel lines to appear to converge. Think of train tracks that seem to meet at some distant point on the horizon. This, too, is perspective in action.

Think of a magical girl, posed in such a way that she looks as if she is moving toward you or away from you at high speed. For example, take a magical girl flying toward you. Her head is big, but her body diminishes to a really small size so that her feet are very tiny. Is it just a matter of drawing a big head and tiny feet? If it were, everyone could draw manga action scenes in perspective. But it's more complicated than that, which is actually a good thing because this means there's a secret that I can tell you that you can withhold from your friends and tease them about mercilessly. Think of all the power you will have! It will be glorious! You will rule the world!!!

But moving right along, let's turn to those sketch lines in the initial figure constructions here. Those aren't actually sketch lines; those are called *vanishing lines* because they converge to a point at the bottom right, where they *vanish*. Artists use vanishing lines as a loose guide for drawing the figure; the lines form a cone into which the artist fits the figure. This helps to indicate how the body should get gradually smaller as the figure follows the vanishing lines back to the vanishing point. It's what makes the figure look like it's receding into the distance *at a uniform rate*. Now you've got a convincing drawing.

Vanishing lines.

Vanishing point (where the vanishing lines converge).

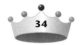

Sometimes, vanishing points converge so gradually that they don't actually converge on the page but somewhere beyond the edge of the drawing paper. In order to see vanishing lines like this converge, you'd have to tape more pages to one side of your paper! For this example, you'd probably have to add two more pages to the left side of this drawing.

In these cases, you can leave the vanishing lines open, meaning that the space between them reduces gradually but the lines never actually touch You can do this as long as the lines look as though they *would* converge if you followed them long enough, *and*—and this is important—they are not parallel!

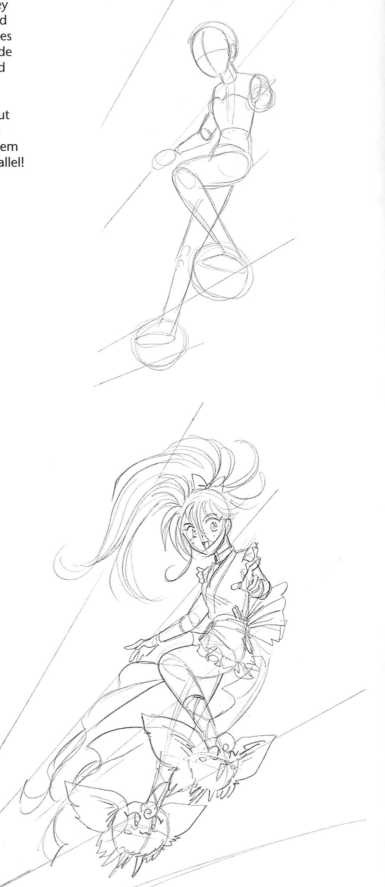

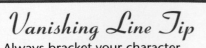

Vanishing Line Tip
Always bracket your character between the top and bottom vanishing lines so that you have "bookended" her with these guidelines. This makes it easier to follow your own sketch marks.

Magical Girl Costumes

Here's the deal: No costume, no magical girl. Proportions aside, it's the costume (and the hair, too) that makes the magical girl such a popular fantasy spectacle. The most popular type of magical girl is the one that is based on the typical schoolgirl and whose school uniform transforms into an elaborate costume that's both glamorous and ready for fighting. Special powers and amazing effects are the crescendo—but the costume really announces the arrival of the transformed character.

Costume Design: What NOT to Do

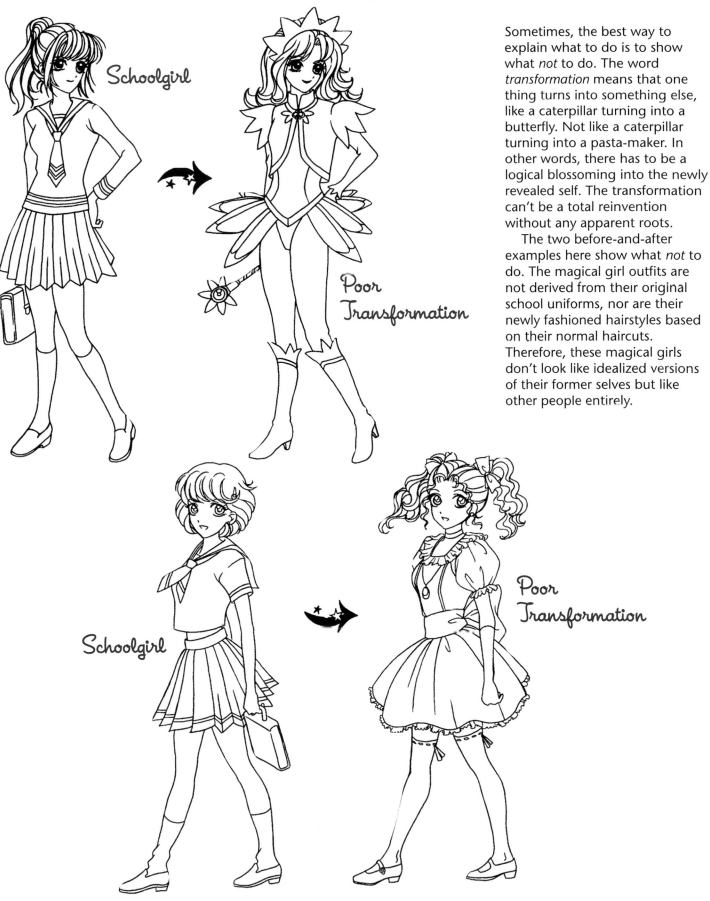

Schoolgirl

Poor Transformation

Schoolgirl

Poor Transformation

Sometimes, the best way to explain what to do is to show what *not* to do. The word *transformation* means that one thing turns into something else, like a caterpillar turning into a butterfly. Not like a caterpillar turning into a pasta-maker. In other words, there has to be a logical blossoming into the newly revealed self. The transformation can't be a total reinvention without any apparent roots.

The two before-and-after examples here show what *not* to do. The magical girl outfits are not derived from their original school uniforms, nor are their newly fashioned hairstyles based on their normal haircuts. Therefore, these magical girls don't look like idealized versions of their former selves but like other people entirely.

The "Magical Tailor"

To see how we get from here to there in a logical progression, let's go step by step from the ordinary to the extraordinary. By making a series of small adjustments, you can see how our "Magical Tailor" weaves his magic.

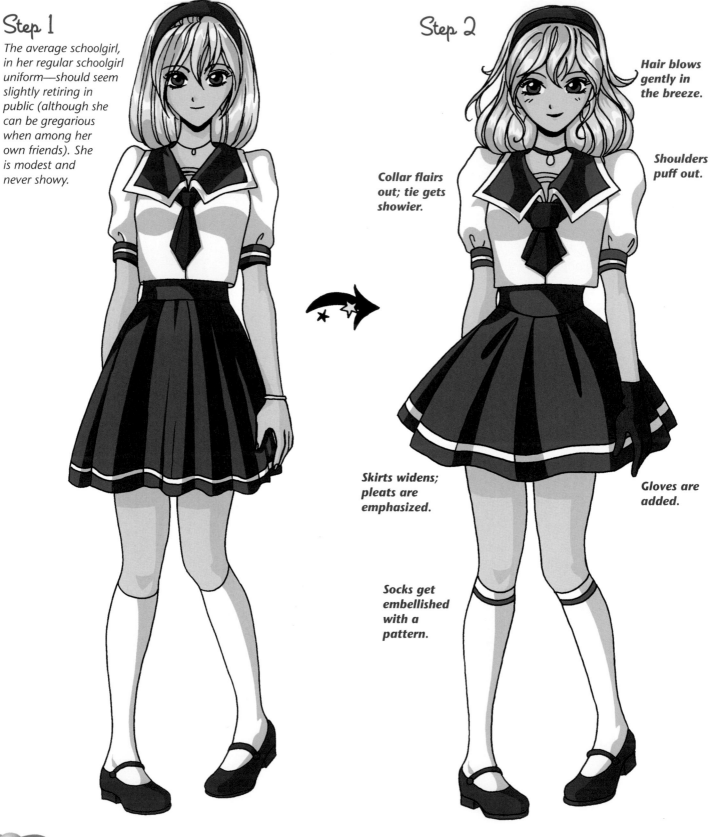

Step 1

The average schoolgirl, in her regular schoolgirl uniform—should seem slightly retiring in public (although she can be gregarious when among her own friends). She is modest and never showy.

Step 2

Hair blows gently in the breeze.

Shoulders puff out.

Collar flairs out; tie gets showier.

Skirts widens; pleats are emphasized.

Gloves are added.

Socks get embellished with a pattern.

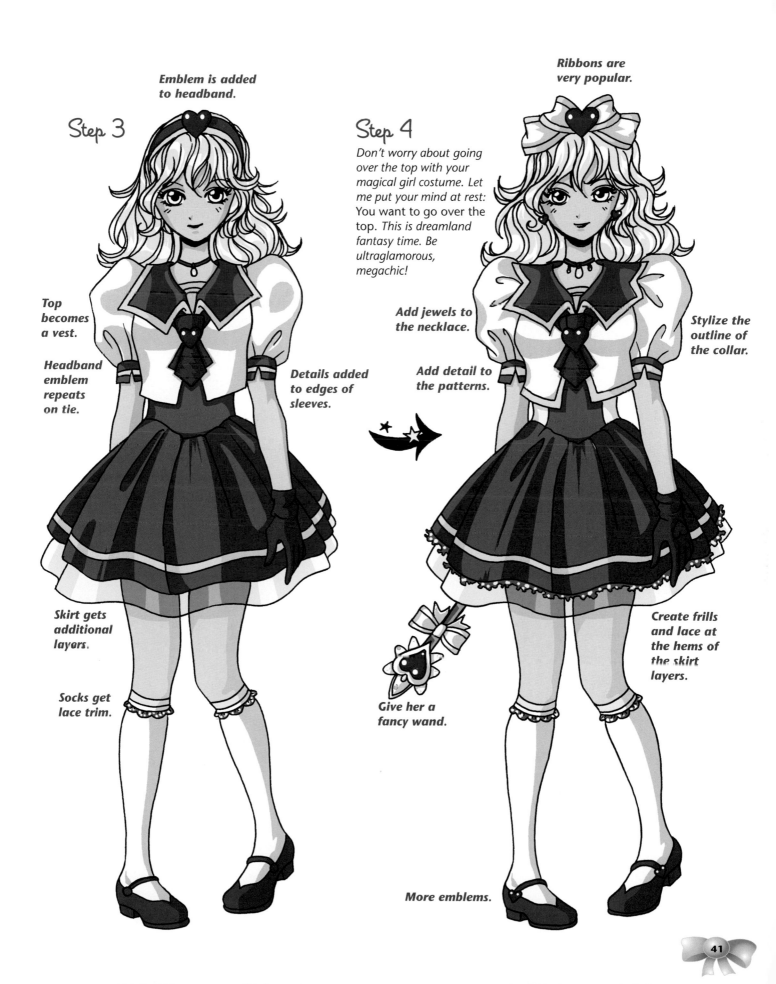

Step 3

Emblem is added to headband.

Top becomes a vest.

Headband emblem repeats on tie.

Details added to edges of sleeves.

Skirt gets additional layers.

Socks get lace trim.

Step 4

Ribbons are very popular.

Don't worry about going over the top with your magical girl costume. Let me put your mind at rest: You want to go over the top. *This is dreamland fantasy time. Be ultraglamorous, megachic!*

Add jewels to the necklace.

Add detail to the patterns.

Stylize the outline of the collar.

Give her a fancy wand.

Create frills and lace at the hems of the skirt layers.

More emblems.

41

The Secret to Transforming the Costume

Instead of inventing a magical girl costume out of thin air, try using the ordinary girl's outfit as the starting point from which to build the fantasy version. If the magical costume is too radically different from the regular, everyday outfit, it won't look like a smooth transition. Remember, the character *transforms* into something; she doesn't suddenly become a whole different person.

So, how do you go about doing that? You look for characteristics in the original clothing that you can highlight and exaggerate to create a fantastic new costume. Take a look at this magical girl's costume, noting the aspects of it that have been held over from the original outfit. See what I mean? The bare bones of the original are there, but they've been greatly enhanced. How? Through magic, of course!

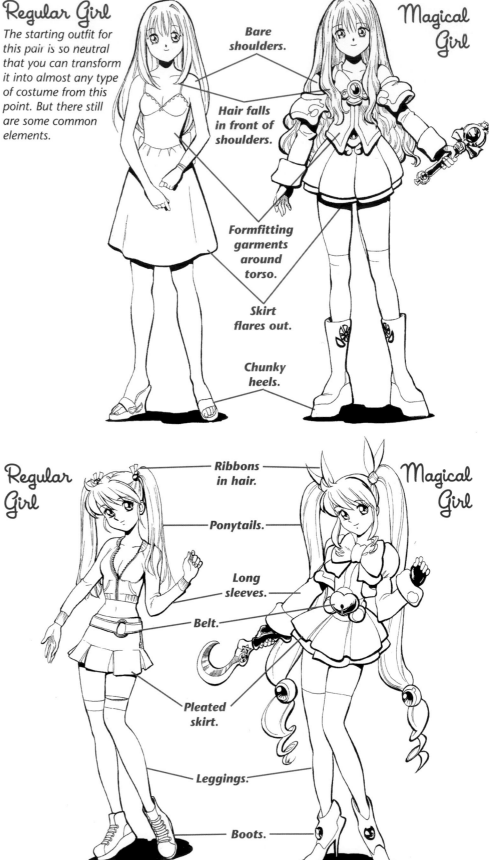

Regular Girl

The starting outfit for this pair is so neutral that you can transform it into almost any type of costume from this point. But there still are some common elements.

Magical Girl

- Bare shoulders.
- Hair falls in front of shoulders.
- Formfitting garments around torso.
- Skirt flares out.
- Chunky heels.

Regular Girl

Magical Girl

- Ribbons in hair.
- Ponytails.
- Long sleeves.
- Belt.
- Pleated skirt.
- Leggings.
- Boots.

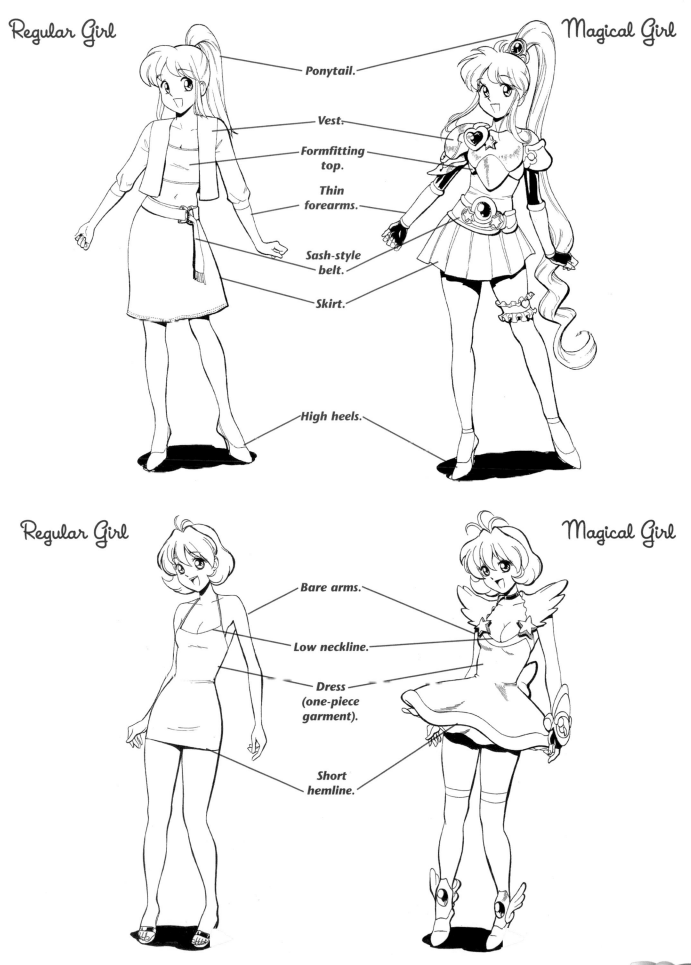

Regular Girl

Magical Girl

Ponytail.

Vest.

Formfitting top.

Thin forearms.

Sash-style belt.

Skirt.

High heels.

Regular Girl

Magical Girl

Bare arms.

Low neckline.

Dress (one-piece garment).

Short hemline.

Superstylish Gloves

Whether they're shoulder length, midlength, or short, gloves are always a glamorous addition to the magical girl costume. You can add ribbons, buttons, jewels, and lace, and you can even put bracelets and rings on top of gloves.

Shoulder Length with Bracelets

Flower Detail

Shoulder Length with Ring

Frilly Edge

Fleece Edge

Chic Footwear

Never let your magical girl go anywhere unless her shoes will make the other girls green with jealousy. Don't worry about comfort. Footwear should have high heels and cool patterns and/or decorations. Remember, your character has just walked into the fantasy shoe store and her credit card has no limit. Don't let her down!

Accessories to Die For

Amulets, necklaces, bejeweled headbands and hair clamps, ribbons, tiaras, and crowns— these are among the most popular accessories for the magical girl costume. Jewels and crystals are a theme throughout many genres of manga, where they possess special powers—and this is especially true of the magical girl category.

Accessories: Ordinary to Extraordinary!

Whatever a character is carrying with her when she is turned into a magical girl takes on a bewitched charm, as well. And yes, I did say when *she is turned* into a magical girl, meaning that it isn't always something that occurs of her own free will. In fact, the first time it happens, it's a scary experience for her. She doesn't know what's going on. Not only is she changing, but the very cell phone in her hand has suddenly turned into a gold-encrusted piece of jewelry that radiates a special aura. Oh, but don't worry, she'll get used to it quickly—really quickly. Unfortunately, when she returns to normal, her cell phone will also snap back, and she'll got be responsible for all those extra minutes she spent talking to her friends from another dimension. I think those count as overages.

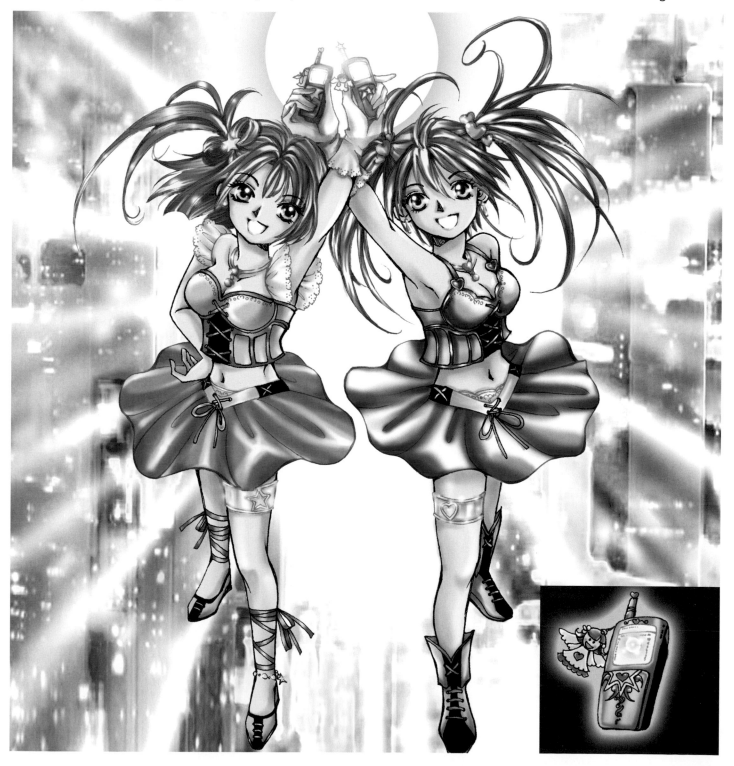

Magical Powers in Ordinary Objects

The possessions that most frequently turn into magical objects are crystals, wands, necklaces, and charms, all of which should emit rays of energy, light, and sparkles. But you can turn any feminine handheld object into a powerful force for good. Just don't let it fall into the wrong hands!

There are three elements required to make a regular object look like a magical one:

- The ability to float or spin.

- The special effects surrounding them, such as lines, swirls, and stars.

- The magical girl's pose: She should be posed so that she appears to have reverence for the object.

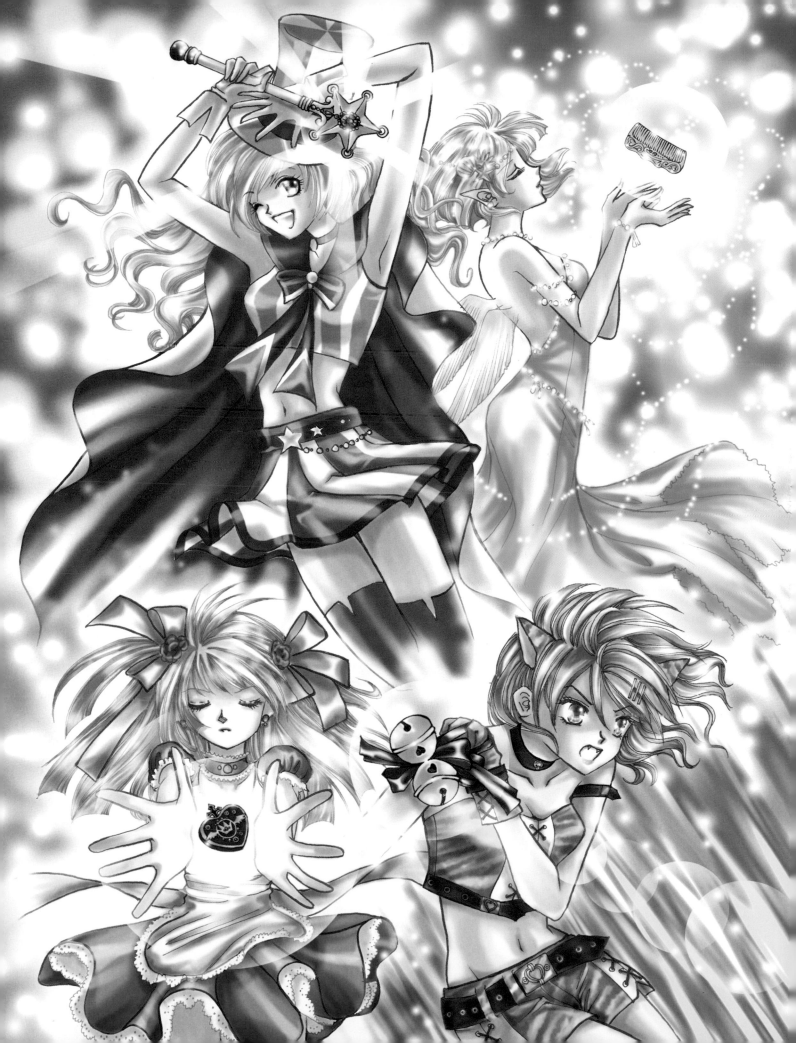

Amazing Wands

Nothing says "You're finished!" to a bad guy like a magical girl's wand. The most popular wand isn't based on the magician's, which is about two to three feet in length. Instead, think of a biblical staff, which can be raised dramatically to ward off evil forces and literally blow back the dark winds that howl. These wands must be ornate yet weaponlike. Although magical girls often wield Excalibur-type swords, these wands themselves are not used to actually strike the opponent—but their rays can be devastating.

There are also more modest wands that are used as decorative devices, almost like fashion accessories. They are short with ornate tops and may glow or cast a shower of sparkles, but they are generally not as powerful as the larger staff-style wands.

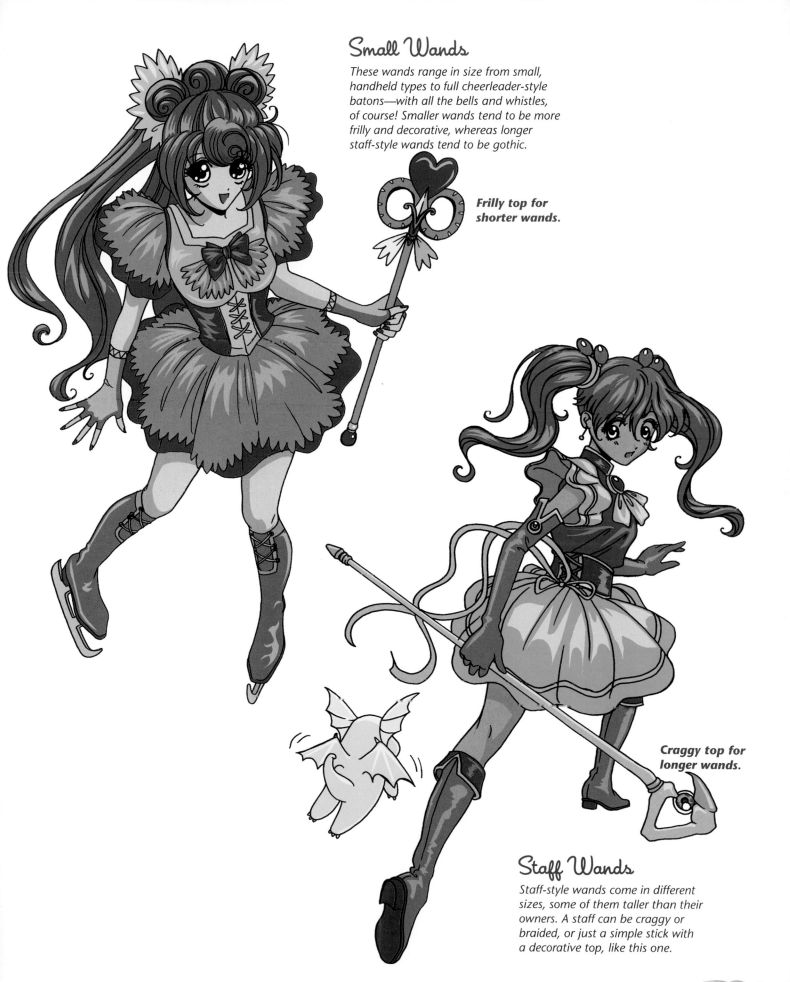

Small Wands

These wands range in size from small, handheld types to full cheerleader-style batons—with all the bells and whistles, of course! Smaller wands tend to be more frilly and decorative, whereas longer staff-style wands tend to be gothic.

Frilly top for shorter wands.

Craggy top for longer wands.

Staff Wands

Staff-style wands come in different sizes, some of them taller than their owners. A staff can be craggy or braided, or just a simple stick with a decorative top, like this one.

51

A Magical Fighter Girl and Her Sword

A magical girl will sometimes dump the wand for a sword. And then, watch out! She can go after monsters that are twenty stories tall. That sword isn't just any sword, but a weapon imbued with supernatural qualities that can make her all but invincible. The drama happens when she gets hit by the powerful tail of the monster and *drops* the sword. What then? That's when the edge-of-your-seat stuff happens as she must reach her sword before the sharp teeth of the monster reach her!

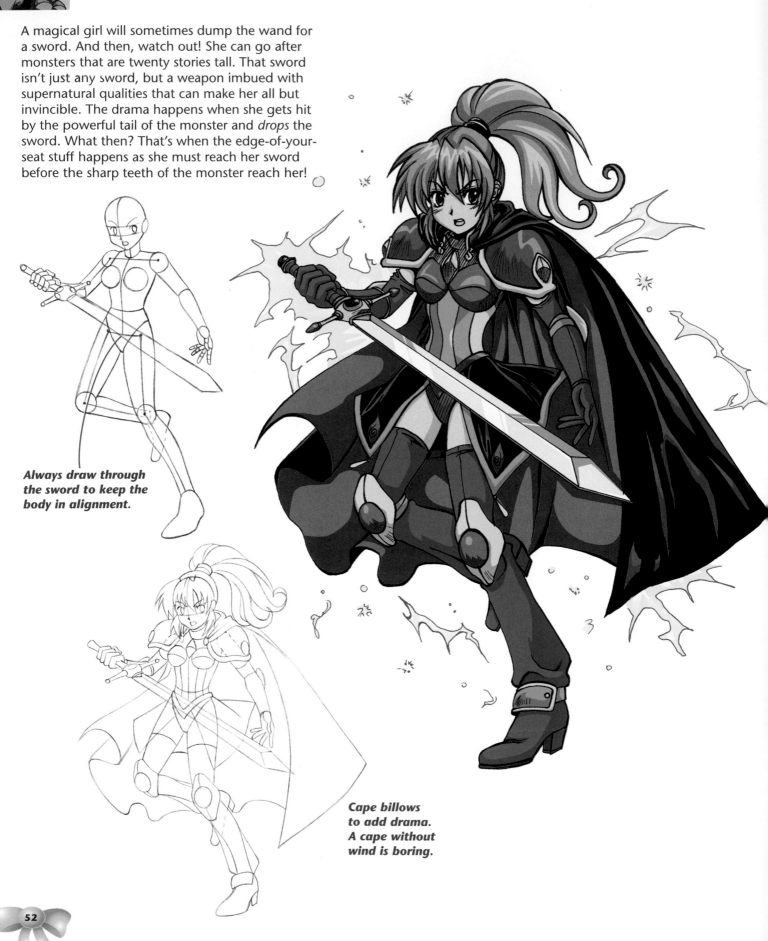

Always draw through the sword to keep the body in alignment.

Cape billows to add drama. A cape without wind is boring.

Windblown Capes and Skirts

I don't care what the weather is like outside—when your character transforms into a magical girl, the wind better be blowing, because the dramatic effect of the wind on the hair and costume is priceless. But you can have it for only three easy payments of $29.95. Oops. Been watching too many infomercials.

When we're talking about the poetic effect of windblown hair, we're not talking about a Category 4 hurricane. We're also not talking about wind coming from all directions. That's a very important note! The billowing breeze is usually directional. If it looks as if it's coming from more than one direction at a time, it's gonna blow everything this way and that—and make her hair a mess, which will make her cry. The wind should blow everything in the same direction.

The next thing to look for is the angle of the wind. "What?" you say. The wind has an angle? Yes! Stop pestering me with these questions and just listen! When the wind blows, you want it to lift the hair and costume—and not just a little but at least at a 45-degree angle. And sometimes, to give it that elegant, fantasy sweep, the wind should lift the hair *almost parallel to the ground*.

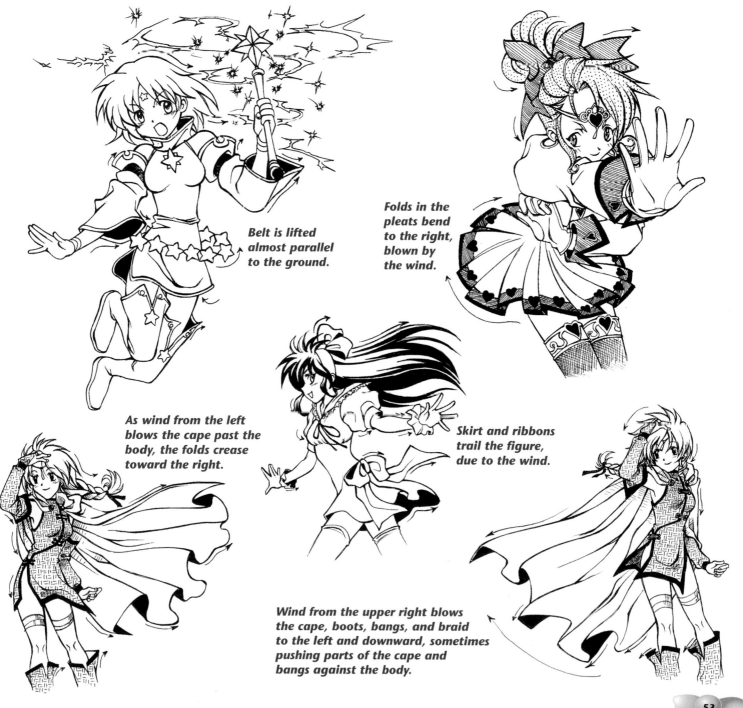

Belt is lifted almost parallel to the ground.

Folds in the pleats bend to the right, blown by the wind.

As wind from the left blows the cape past the body, the folds crease toward the right.

Skirt and ribbons trail the figure, due to the wind.

Wind from the upper right blows the cape, boots, bangs, and braid to the left and downward, sometimes pushing parts of the cape and bangs against the body.

Costume Colors

Think of costume colors as part of the theme of your character's costume. You can vary the colors to suit your character's identity, and the color theme will become synonymous with that identity. To show you how this works, the examples at right use single color themes across a variety of characters. When the color theme changes, you can see how it impacts the look of each character.

These are done with computer coloring programs. Many artists like to use Photoshop. However, artists—even colorists—do "marker comps" first. Marker comps are very rough colorings of black-and-white drawings using color markers. Sometimes, colored pencils are used. Usually, the colorist is not the penciler (who did the drawing), but I've worked with Japanese manga artists who do both because it gives them greater control over their creations.

Primary Colors

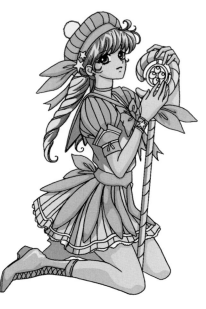

Pastel Colors

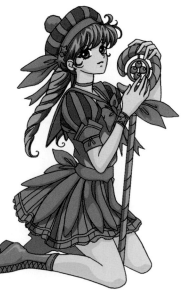

Variations on Single Colors

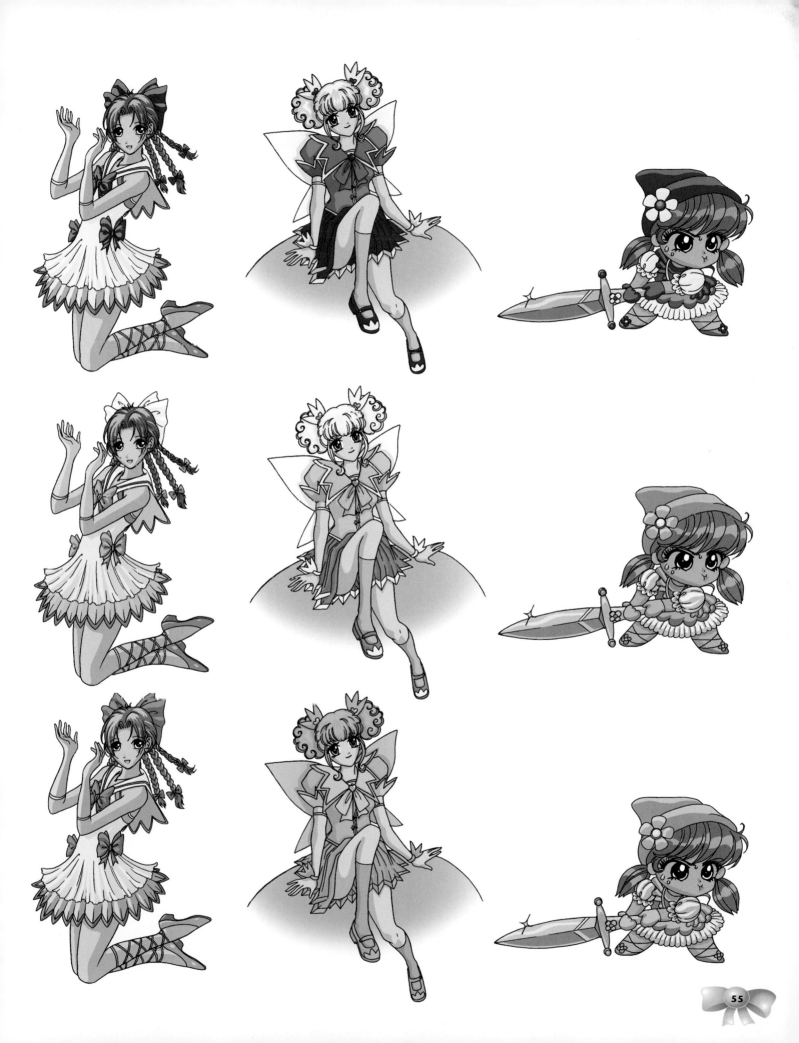

Magical Girl Varieties
The Inside Story from Japan

The schoolgirl-turned-fantasy-fighter is Japan's most popular type of magical girl story, which American manga fans get to see in the form of graphic novels. But what many American readers don't realize is that in Japan, this is a far more diversified genre. The Japanese manga that doesn't get imported has many more types of magical girls, including some who have no particular superpowers at all but who nonetheless magically transform so that they can live out fantasy lives that ordinary girls only dream about. And that's the essence of manga. It's not always about beating up the bad guys. It's also about fantasy and relationships and dreams.

The Range of Transformations

So how does a regular character become a magical girl who is *not* only out to fight bad guys? Let's take a typical schoolgirl named Aki. Aki goes to school every day, respects her parents, does her homework, and gets decent grades. But her life feels empty, and she's bored inside. Every night she reads books about glamour and intrigue, and dreams of a life of excitement. One day, while playing with friends near a lake, she stumbles over a rock and, underneath, finds a green crystal. The crystal glows. She calls to her friends to come take a look at what she's discovered. But they are too far away to hear her. She decides to bring it to them. When she reaches down to touch it, a green glow of energy suddenly wraps around her, transforming her into any number of fantasy choices. So, by day she could be Aki, going to school. But at night, she turns into magical girl Aki. And, the possibilities are endless.

Schoolgirl Aki

Flight Attendant Aki

Glamorously jetting around the world to exotic places.

Fashion Model Aki

Getting on the cover of all the trendy magazines and having lots of boys wanting to date her.

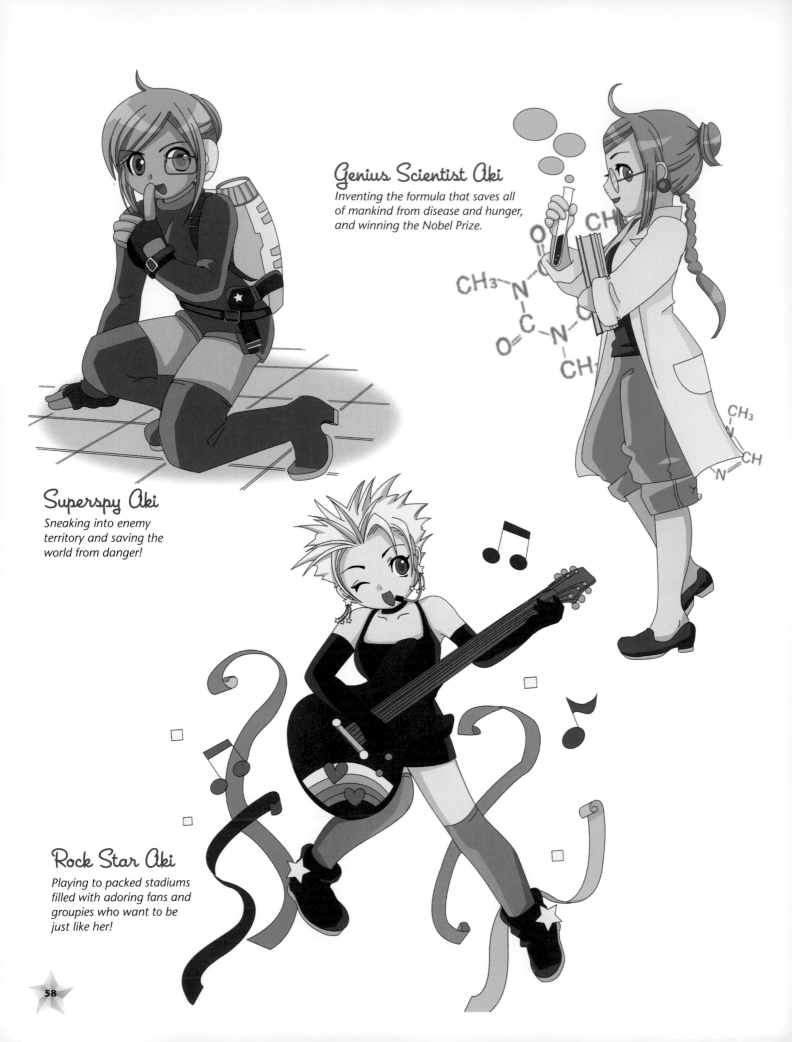

Genius Scientist Aki

Inventing the formula that saves all of mankind from disease and hunger, and winning the Nobel Prize.

Superspy Aki

Sneaking into enemy territory and saving the world from danger!

Rock Star Aki

Playing to packed stadiums filled with adoring fans and groupies who want to be just like her!

Mischievous Matchmaker Aki

Putting together just the right lovers—and also the wrong ones—just for fun.

Spell-Casting Witch Aki

Abracadabra, she'll cast a spell on you. For a modest fee, she'll sell you a potion. And for a huge fee, she'll sell you the antidote!

Cowgirl Aki

She can ride any horse, lasso any steer, and shoot better than any cowboy ever could.

59

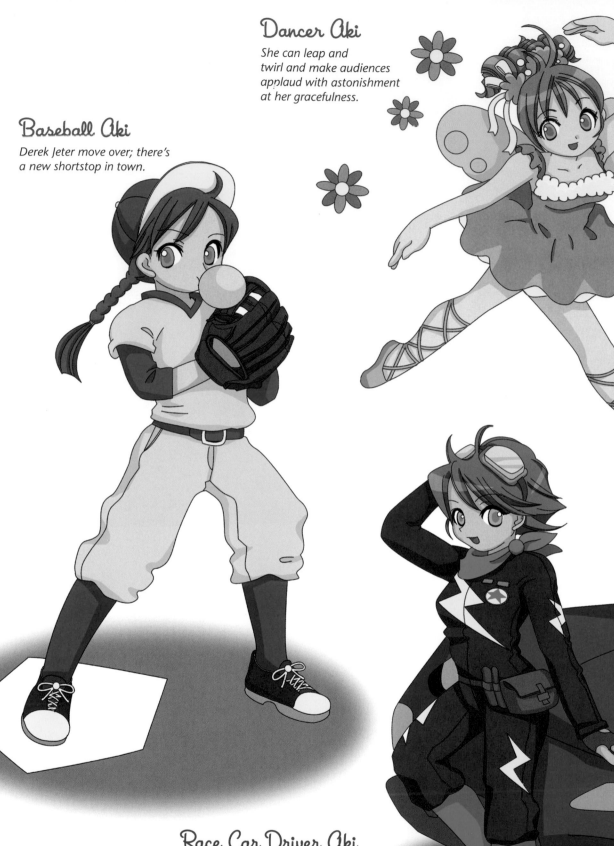

Dancer Aki

She can leap and twirl and make audiences applaud with astonishment at her gracefulness.

Baseball Aki

Derek Jeter move over; there's a new shortstop in town.

Race Car Driver Aki

Whether it's on the track or racing after bad guys, she really knows how to make those tires scream for mercy. (Remember one of the early anime superstars, Speed Racer? It's not just a boys' club any longer.)

Martial Artist Aki

In many forms of martial arts, the fan has been used as a weapon. It is, therefore, very effective because it's so deceptive. Who expects to be attacked with a woman's fan?

Princess Aki

It doesn't matter the country or culture—many girls grow up dreaming of being one of these.

Sci-Fi Fighter Aki

A few good zaps from a ray gun ought to stop any gooey green thing from attempting to eat Earth.

Chibi-Style Magical Girls

Chibi means *small* in Japanese. Chibi characters appear throughout the manga genres. In the magical girl genre, they appear as supersmall magical girl characters and are some of the cutest gals in the comics world. As with other types of chibi, they're tiny with huge emotions and attitudes. Combine that with magical costumes and magical powers, and you've got the potential for lots of humor—in a teeny, combustible personality.

Chibi are "way out in front" with their expressions. If they feel it, you're going to know about it. And that's funny, because if your chibi is dressed as a princess and she's a little sad, then instead of welling up with a soulful tear, she will bawl uncontrollably. It's a funny look. Check out these over-the-top demonstrations of uninhibited attitude.

Bwaaaa!

Huge teardrops fly off her face. Streams pour down her cheeks. There's no consoling the poor dear. If you try to give her a hug, she'll probably slug you. The outfit is based on the popular sailor suit, which is a typical school uniform in Japanese public schools.

Omigosh!

The whole body pulls into itself, knees and arms included. If the eyes opened any wider they'd roll right out of her head. Open the mouth, but don't show any teeth.

Just Try It!

Tight mouth, tight arms, both feet planted firmly on the ground. Save your breath. She's not moving.

Zzzzzzz

The drool from the side of the mouth is the finishing touch in this pose. Better wash that bear!

You're Mince-meat Now!

The wide stance means she's ready to give some poor soul a bruisin'. The sharp eyetooth is a device used in manga to show anger or aggression. Try it on fiery expressions.

He Noticed Me???

The pink blush marks say it all. She holds her head in her hands, otherwise she might just keel over and faint!

Ha Ha Ha!

Laughing eyes always curve down.

Gulp!

Caught in the act. The little down-turned mouth, wide eyes, and eyebrows that turn up in the middle let us know that her mind just drew a blank. Someone, quick, toss her an excuse!

Magical Boys

The magical boy is a popular character type. He, too, possesses special powers. He may be a classmate of the magical girl. Or perhaps he's someone who lives in the other, magical world and requires the magical girl's help against the demons who are trying to destroy his people—and as such, he has been sent to Earth to bring her back to lead them. They will fight together, and maybe share a secret love from afar.

The Magical Boy Face

Like the magical girl, the magical boy is also about 14 to 16 years of age, but he can sometimes appear even a bit older if his features are longer and more elegant (a type of character known as a bishounen, or bishie for short, which in Japanese stands for *pretty boy* and is a standard character type pervasive in many styles of manga).

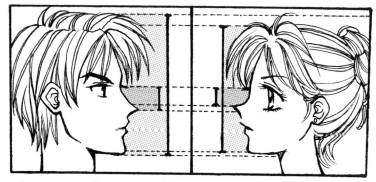

Male vs. Female Facial Proportions

On male characters, there's a higher forehead, more length from the top of the eye to the tip of the nose, and more mass at the bottom of the jaw.

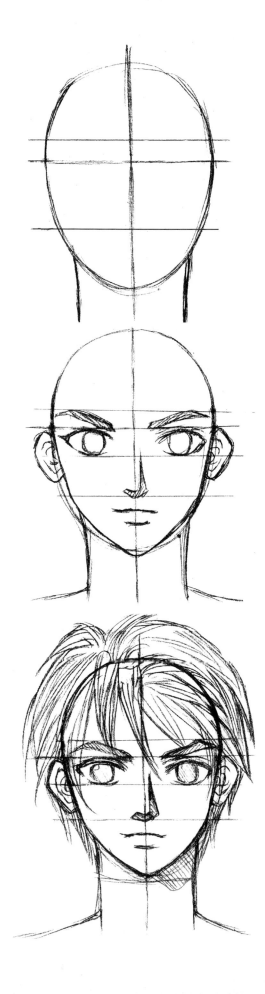

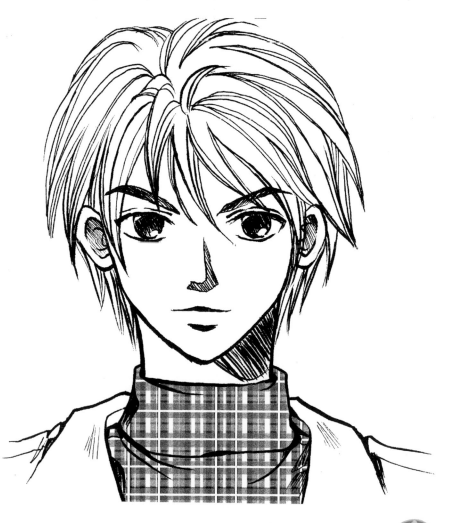

Profile

As you can see from the character design, the magical boy isn't a rugged type—no jock is he. He's earnest, determined, and true. And that's what you want in the magical fighting genre: teens with amazing powers, who nonetheless look vulnerable and outclassed by the enemy. If they looked invincible, there would be no drama. So the magical boy still looks a little on the soft side, but he's got a tiger's fighting spirit in him. And yes, he can be sarcastic and also crack stupid jokes. Hey, what did you expect? He's a boy?

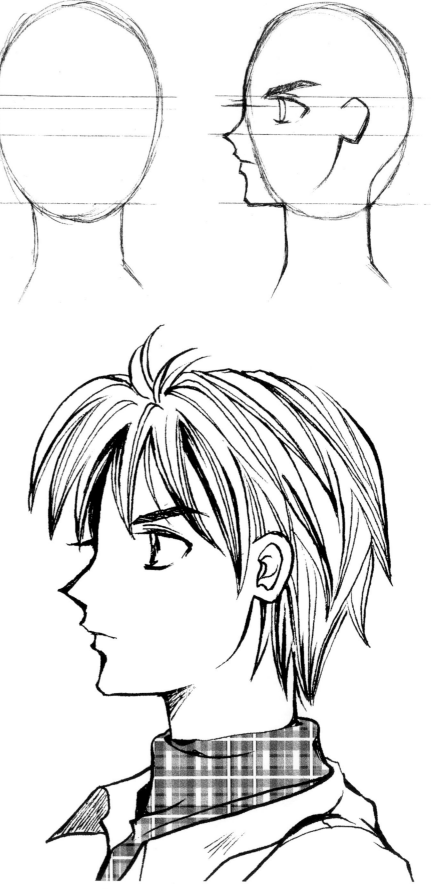

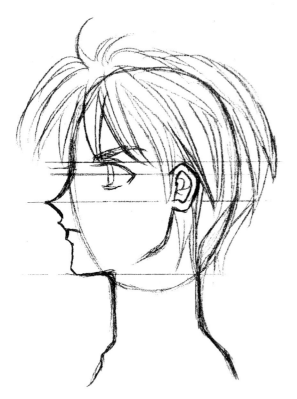

Costume Possibilities

Here's the same character dressed three different ways to create three different magical boys around whom you could build a story. Remember, the origins of the magical boy are important: i.e., where he comes from, what went wrong with his world, and how the magical girl can help save his people from destruction.

Crystal Moon Commander

High collars and squared off shoulder pads create a commanding appearance.

Young Galaxy Prince

A crown and ascot offer a pampered, regal look.

Dark Warlock's Son

A cloak and hood conjure up dark magic.

The Magical Boy Body

To start, draw a magical boy as a regular teen, before he transforms into a super version of himself. This chart gives some basic pointers on proportions. When artists think about body proportions, they don't get out the tape measure. Instead, they think in terms of "head lengths." In other words, how many "heads tall" is the character, or how many head lengths is the entire figure? Similiarly, they consider how many heads wide the character is from shoulder to shoulder. And they break down the character into

smaller sections, considering how many heads tall just the hip area is (on this diagram, it's three-quarters of a head). Doing this helps the artist keep the character looking the same in a variety of poses because even though the pose changes, the proportions don't.

All people are built differently. So these are *average* proportions. With shorter people, the proportions may be truncated; on lankier characters, they might be elongated. But these proportions make a good guide that fits into the normal range.

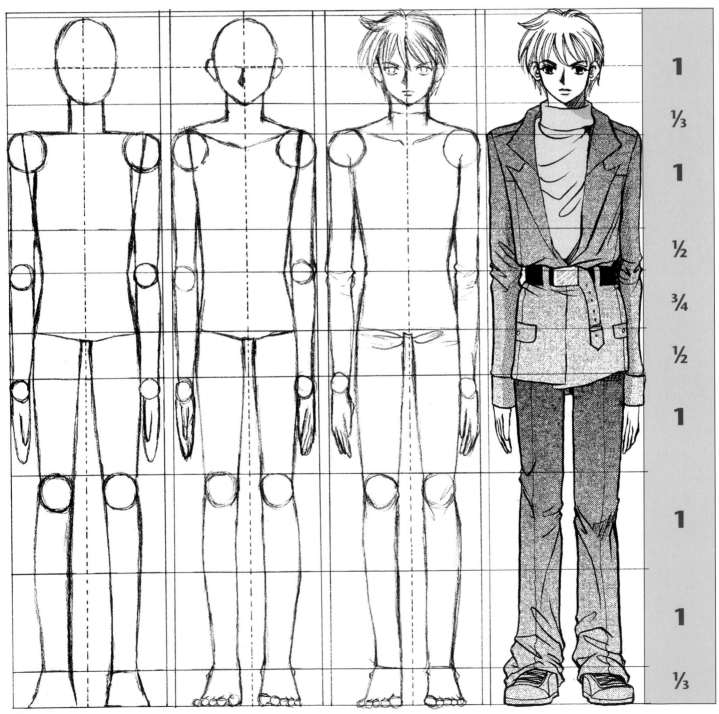

1
⅓
1
½
¾
½
1
1
1
⅓

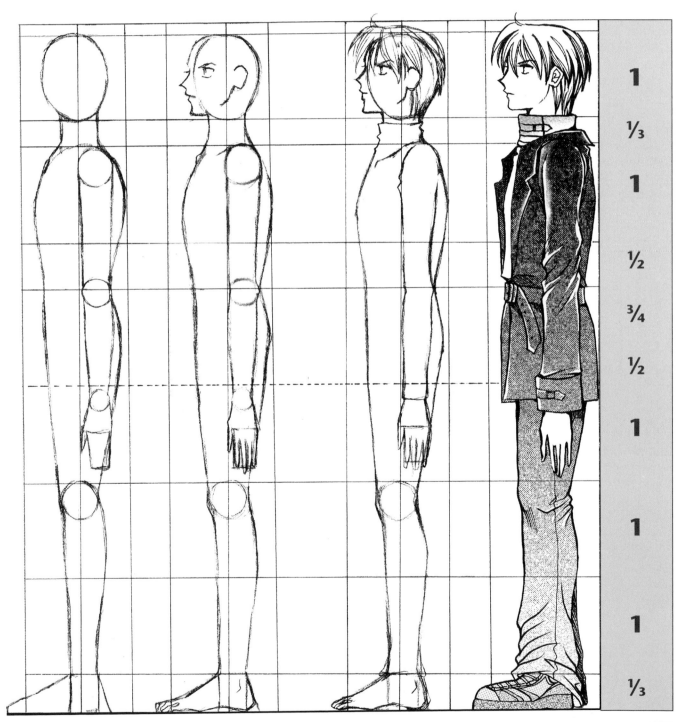

1

⅓

1

½

¾

½

1

1

1

⅓

Magical Boy Types

Just as there are different types of magical girls, there are also different types of magical boys. The figures here and on the next few pages provide some of the many possibilities.

Human (Left)

He's your average high school sophomore who's just been whisked from his bicycle and suddenly transported to another dimension where he has been hailed as the leader. He has been chosen to lead the fight against the legions of darkness that have invaded a peace-loving alien world. His new uniform shows that he is a commander of the highest order. He may not have any idea what he's doing—or what he's up against. Even worse, his new, all-powerful, wicked enemies now view him as the main obstacle to their ultimate domination of the universe. Makes you kinda wish you had a final exam to go to instead.

Elfin (Right)

He's the kind of magical boy who travels from the alien world to Earth to bring back a magical girl to save his people. His elfin ears, sharp nose, pointed eyebrows, and long hair all conspire to give him a faerielike quality. He may travel between the two worlds, but he cannot stay on Earth, even if he falls in love with an Earth girl. His home is somewhere else.

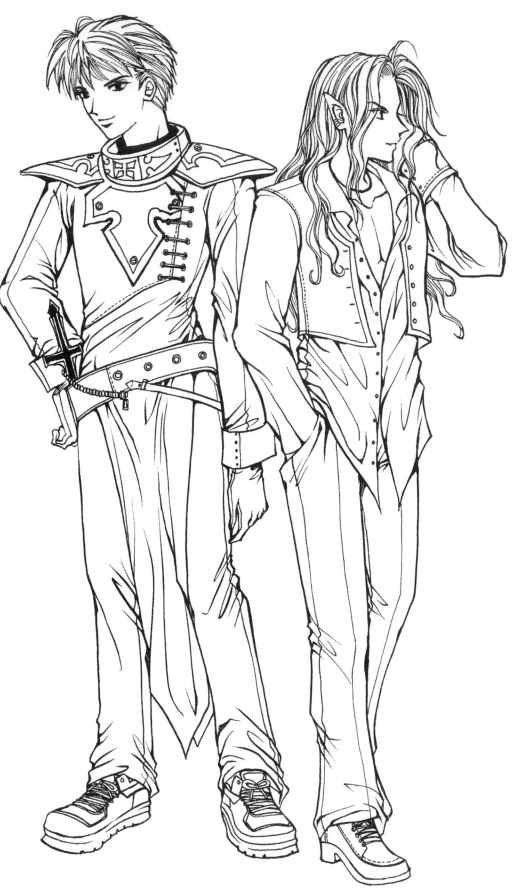

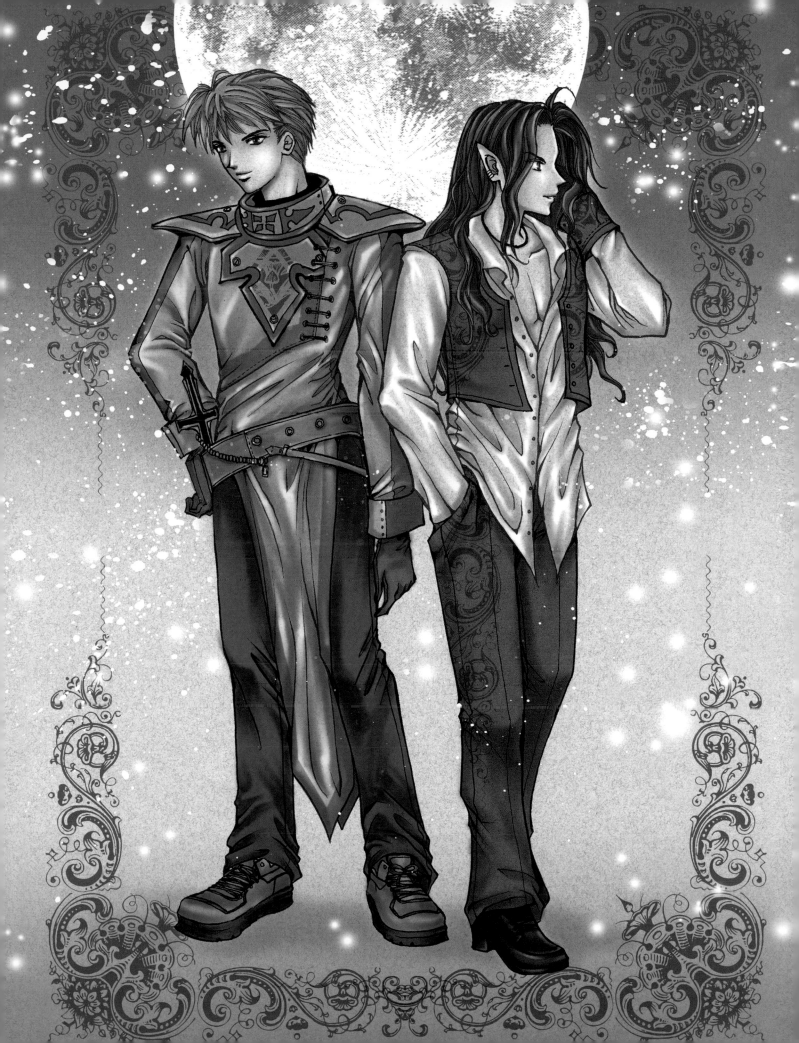

Sword Fighter (Left)

Magical boys can also be fighters of the sword, defenders of the realm, sort of "fantasy knights."

Anthro (Right)

Magical boys can be even more fanciful figures, as well, like *anthros*. *Anthro* is slang for *anthropomorphic*, which describes animals drawn with human attributes (walking upright, for instance). In manga, the term *anthro* refers to humans with animal traits, such as the cat-boy on the right. Anthros are popular enough to warrant their own subcategory in manga. These mysterious creatures can also possess mysterious powers and be part of the magical boy or girl genre.

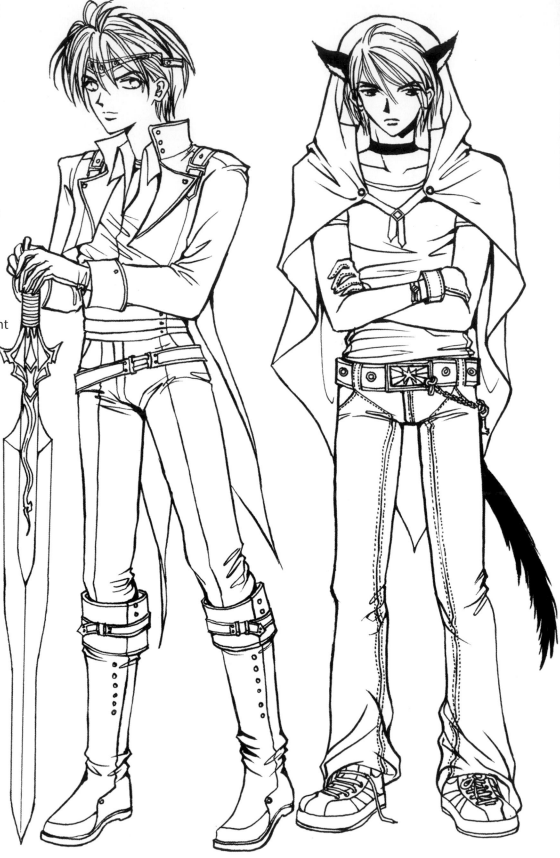

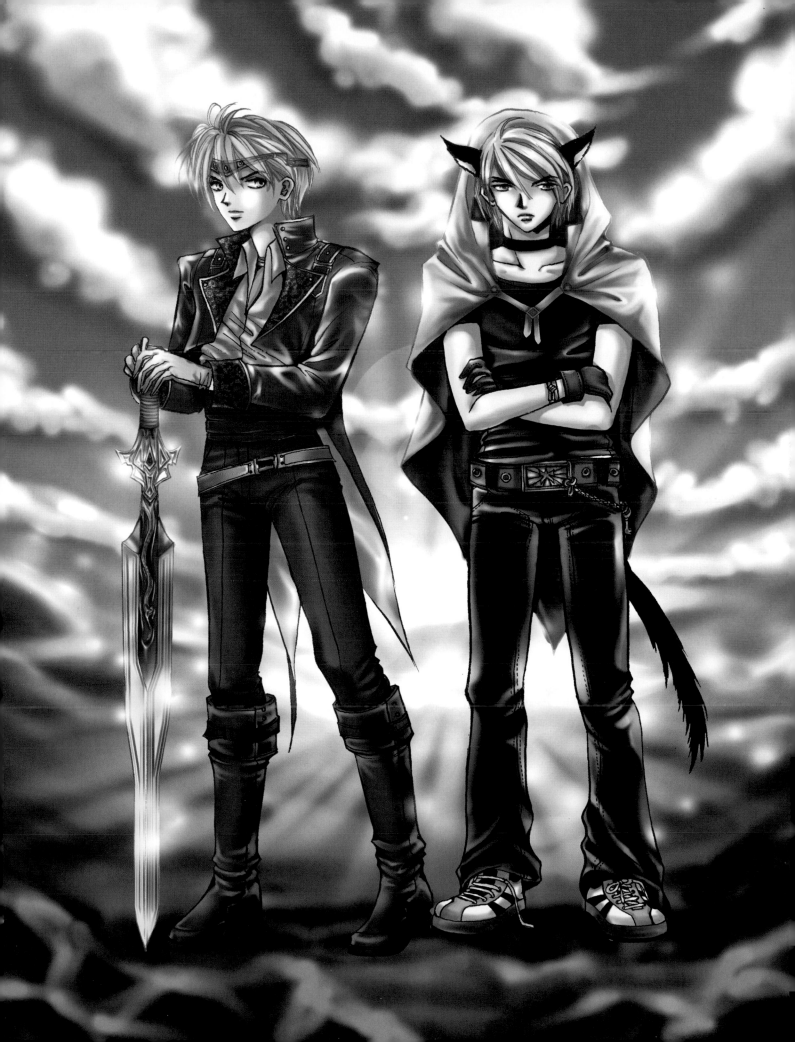

The Power Poses

Here they go—into action to help the magical girl defeat the forces of evil and bring justice to the world. The enemy—whether it be a monster, a giant robot, or a powerful wizard—is always larger in stature than the magical boy, which stacks the odds against our hero. That creates the nail-biting experience the reader secretly desires. It also means that the enemy is going to posses more brute force and generate more special effects. As a result, the magical boy is going to have to use mobility and speed to his advantage. So use lots of action and body movement in his poses.

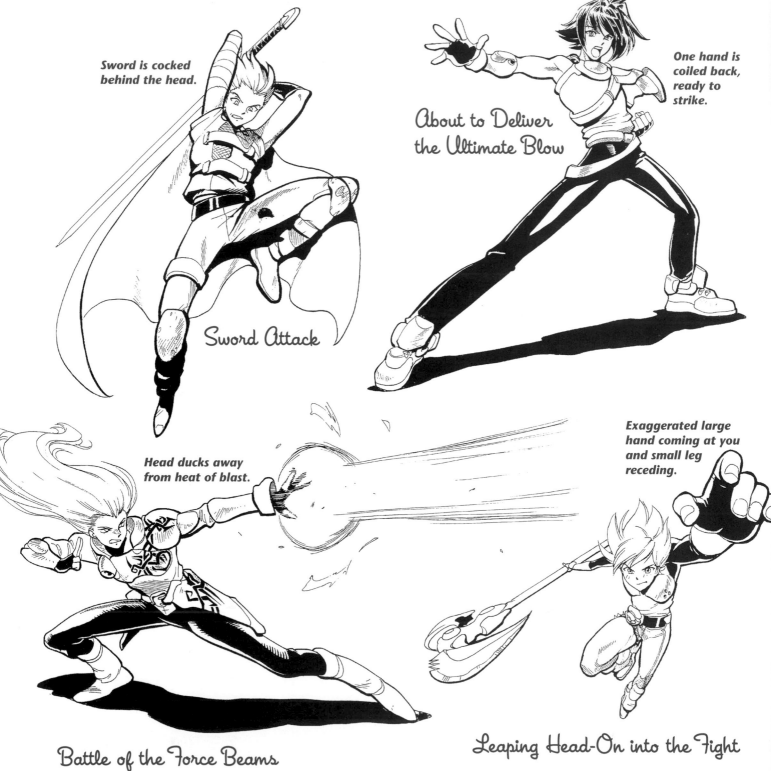

Sword is cocked behind the head.

Sword Attack

One hand is coiled back, ready to strike.

About to Deliver the Ultimate Blow

Head ducks away from heat of blast.

Exaggerated large hand coming at you and small leg receding.

Battle of the Force Beams

Leaping Head-On into the Fight

Impact

Strike with the toes, not the heel.

Raised arm locks at elbow.

Calling His People to Fight

High, roundhouse kicks are always flashier.

Leaping Kick

Lower foot rises off the ground.

Legs are wide apart.

Hair floats up, as if pulled magically.

Summoning Supernatural Powers

Cape floats.

Underside of arm increases in size as it comes toward you.

Confronting the Enemy

Feet begin to lift off the ground.

So, just who are these evil people that magical girls (and boys) are fighting? First of all, they're just no good. Take my word for that. You can't reason with them. But way, way down . . . deep inside, where their heart is . . . nope, can't reach them there either. I know they had bad childhoods, but, sorry, you still gotta destroy them. No choice. Don't be a Girl Scout. Just wipe 'em out before they wipe you out and enslave the entire known universe. We are talking bad!

The Villains

Elegant Evil

The evil ones in the magical girl genre are not giant, ugly, creepy crawly, slimy monsters. Far from it. They're elegant, sophisticated, handsome (if they're male), beautiful (if they're female), wicked beings who love their work: making humans suffer. You've seen them not only in manga, but all over popular anime on TV and in film. You hate them for their villainy and treachery.

And strange as it may seem, you can't look at them through the eyes of a manga fan. A manga fan might root against them. Who wouldn't? But as an artist, it's essential that you find a way to actually *like*, even *admire* these hateful personalities. You can't draw characters you despise. That doesn't mean you have to admire them, but you have to give them a dark, appealing charisma. Don't worry. You can do it. Actors do it all the time. They love to play bad guys. It's fun to be bad. Just as it's fun to draw wicked characters. Make them really evil, but—and this is a very important caveat—*they must be charming*!

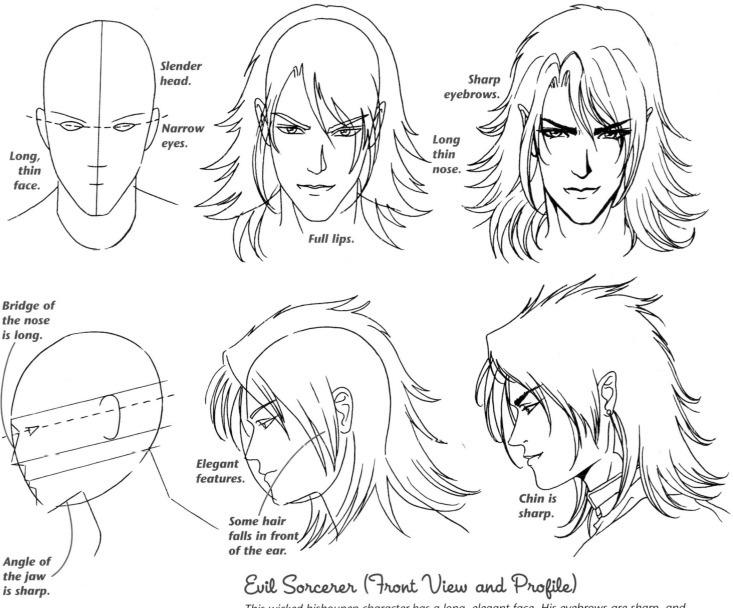

Slender head.

Narrow eyes.

Long, thin face.

Full lips.

Sharp eyebrows.

Long thin nose.

Bridge of the nose is long.

Elegant features.

Some hair falls in front of the ear.

Chin is sharp.

Angle of the jaw is sharp.

Evil Sorcerer (Front View and Profile)

This wicked bishounen character has a long, elegant face. His eyebrows are sharp, and importantly, they rest right on top of the eyes. The hair doesn't spike up as it does on many manga characters, but gently cascades down around his shoulders.

Unlike the magical girls (and boys), the bishounen-style character does not have such a round head. He's clearly older, more mature, more angular. For the profile, it's still easiest to start with an egg shape, but then you've got to go in for some sculpting, chipping away at the front of the face and making sure that the angle underneath the jaw is sharp enough.

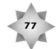

Evil Cuts a Dashing Figure

The bishounen evil guy is semigothic, which becomes more apparent when you see his entire body, complete with outfit. He dresses as if he's a dark prince from some faraway kingdom. Let's face it, the guy is vain. He can't pass up a sale at the designer cape shop. It's gotta take him the better part of two hours to get dressed and out of the castle each day. He's almost as pretty as the wicked sorceress (page 82). No wonder she's always ticked off!

His proportions are more realistic than the other characters in the magical girl genre. The villains seem like real adults. And there's a subtle message there: It's the teenagers vs. the adults. Us vs. them. The rebels vs. the authority. It places the reader in the mind-set of the teen characters—a clear vantage point. It's always best, when writing a story, to give your reader a "window" from which to view the world.

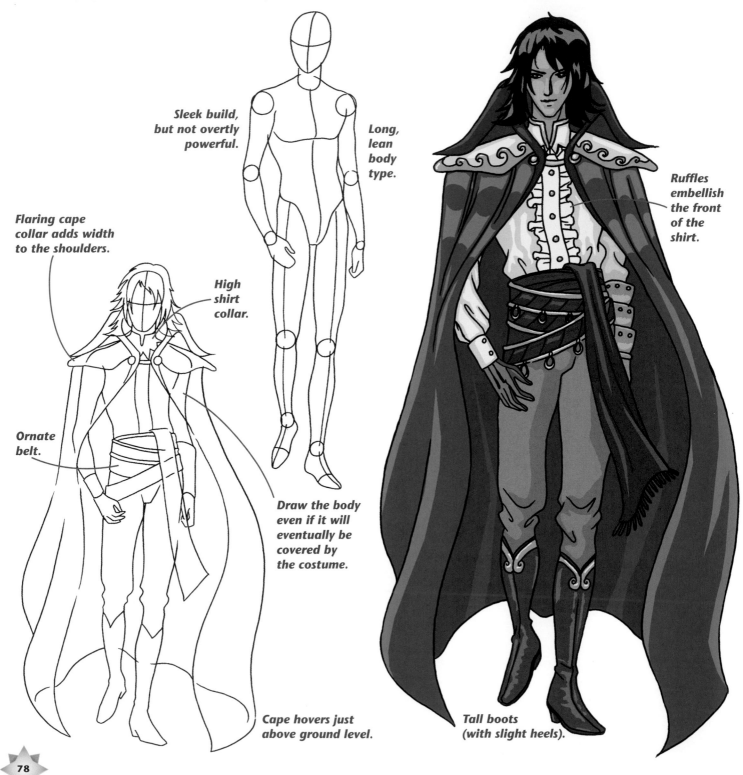

Sleek build, but not overtly powerful.

Long, lean body type.

Flaring cape collar adds width to the shoulders.

High shirt collar.

Ruffles embellish the front of the shirt.

Ornate belt.

Draw the body even if it will eventually be covered by the costume.

Cape hovers just above ground level.

Tall boots (with slight heels).

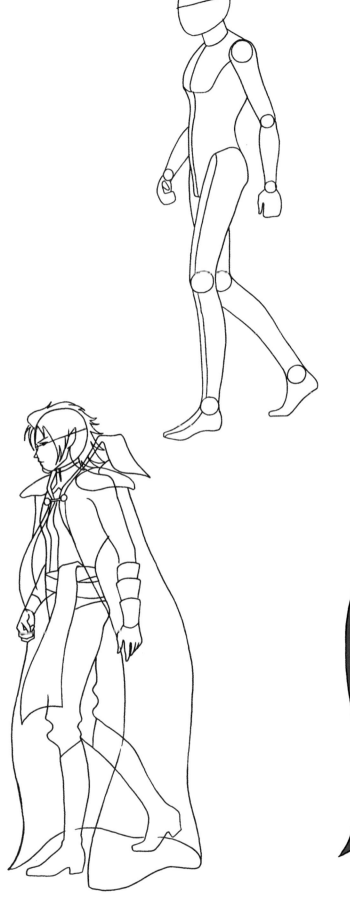

In the magical girl genre, the male villain is evilly seductive. He's an idealized, romantic figure akin to an androgynous vampire, in similar gothic attire.

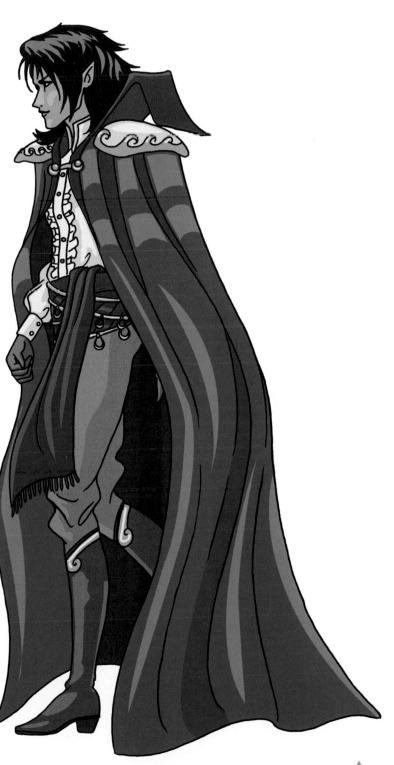

Wicked Enchantress

And you thought the sorcerer was bad? She's the one who's been coaching him! She doesn't even make a pretense of being "on your side." Impatient, cruel, gleefully bad—and those are her good qualities! Any character with black lipstick is up to no good, you can take my word on this one. The extra-heavy eyeliner is also a clue. Her features, though small, are sharp and pointed. Her hairstyle is a little nightmarish, like an apparition in the woods whose clothing and hairdo are continuously rolling in the breeze. You would *not* want to put her in charge of your living trust.

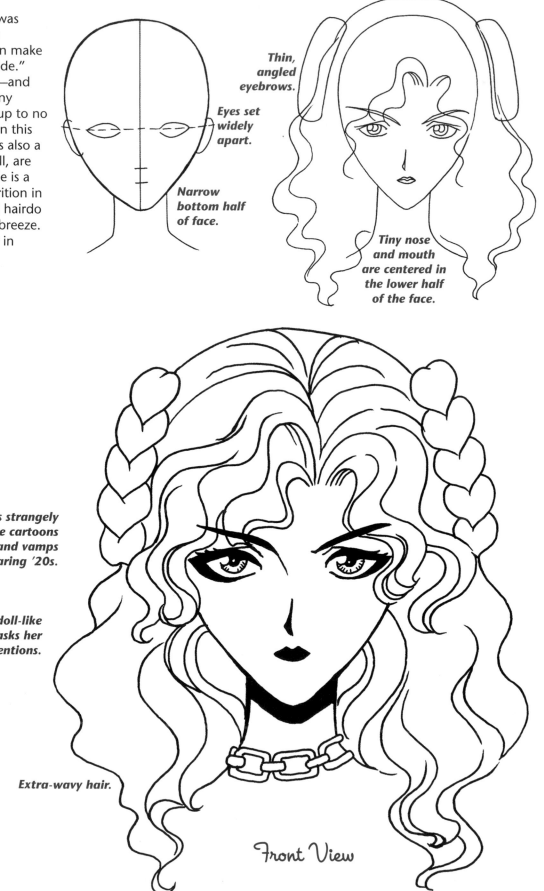

Thin, angled eyebrows.

Eyes set widely apart.

Narrow bottom half of face.

Tiny nose and mouth are centered in the lower half of the face.

The eyelash is strangely reminiscent of the cartoons of the flappers and vamps of the roaring '20s.

Her little, doll-like face thinly masks her cruel intentions.

Extra-wavy hair.

Front View

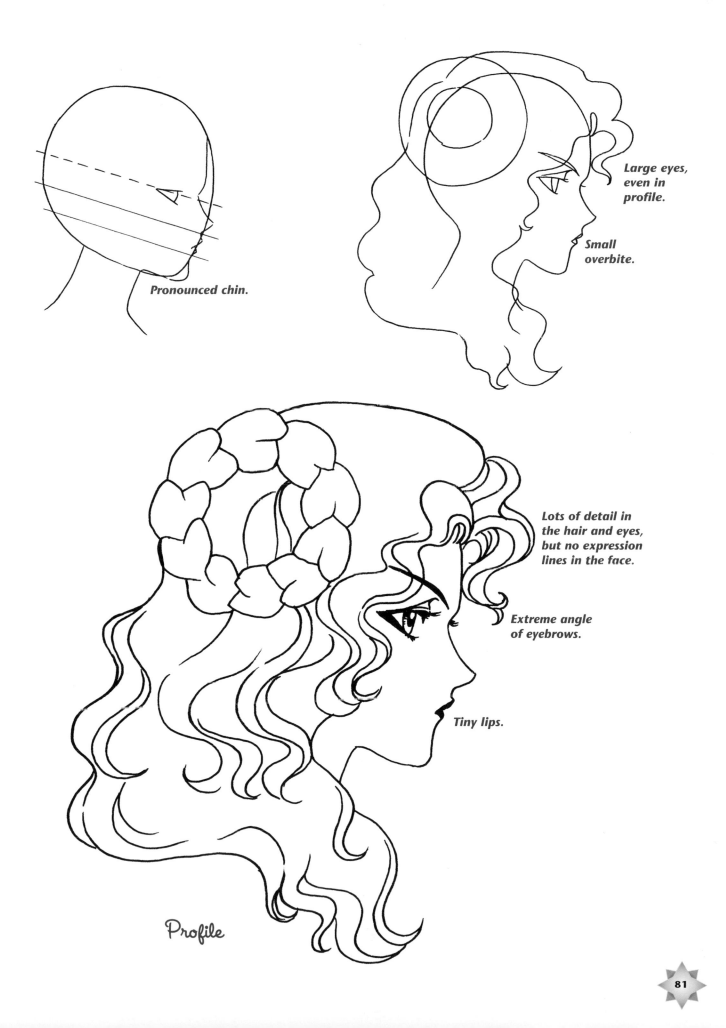

Pronounced chin.

Large eyes, even in profile.

Small overbite.

Lots of detail in the hair and eyes, but no expression lines in the face.

Extreme angle of eyebrows.

Tiny lips.

Profile

Evil Never Looked So Good

Her pose says it all: *I'm here. Prepare to die.* Okay, so it's not the cheeriest greeting in the world, but it does get the point across. I'm sure you noticed right away, unless you're going in for cataract surgery, that this character is extremely curvaceous. She's not planning to fight with her fists. Not now, not ever. In fact, she's not going to get one hair out of place. Not so much as a smudge in her lipstick. It's all in her magical powers—powers that rival those of the magical girl. In fact, the story is a lead-up to the climax, when we get to see whose powers are greater. It's a grand duel, a galactic spectacular, a titanic battle of fireworks between good and evil.

Outward curve.

Narrow, inward curve.

Outward curve.

Tall, pointy collar is effective on evil characters.

Low-cut dress is excellent for seductive, nefarious females.

Back of hand on hip conveys a disdainful attitude.

One leg crossing in front of the other in a relaxed manner tells readers, "I can beat you with my hands tied behind my back."

Feet arch down as the high heels push the heel up.

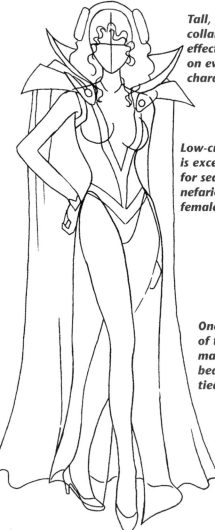

From the Side

From the side you can see that the slightly backward bend of her torso gives her that slinky look; it's a typical posture for villains. Her bare leg gives her some sensuality. Villains are like that. Sure, they want to kill you, but they can't resist flirting while they do it. Good guys are much more forthright in their posture, with the chest held high.

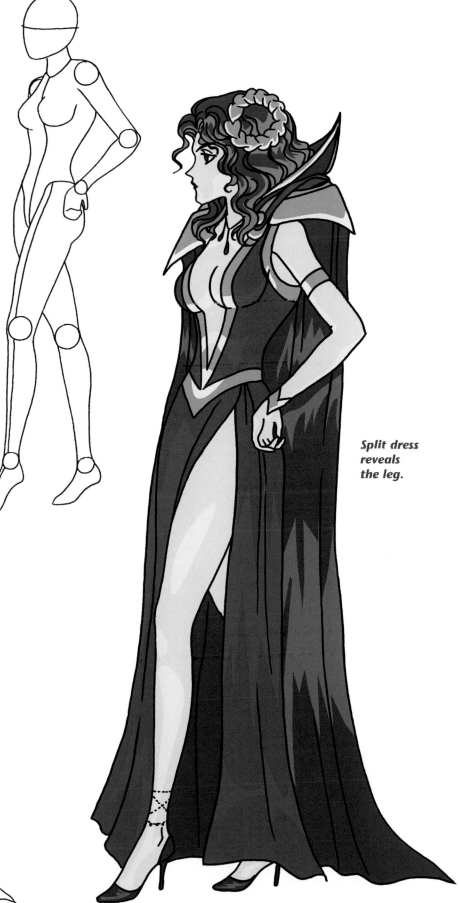

Split dress reveals the leg.

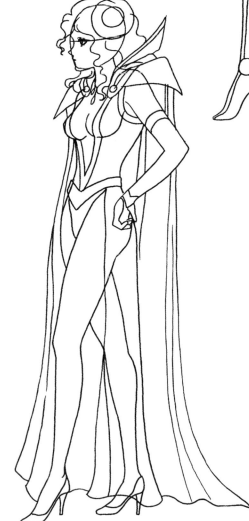

Evil Lord in Armor

The difference between a sorcerer and an evil lord is primarily the armor. When you add armor onto the sorcerer's outfit, he becomes an evil lord. It's not an authentic medieval suit of armor, but a fantasy/armor combo. The medieval and gothic plates, the spikes, and the sword bestow a dark leadership quality on this figure. The evil lord directs an army of sword-swinging followers who obey his every command. It is he who declares war and conquers entire civilizations. And, when he's not fighting on the front lines, he's meeting in a tent behind the scenes with his generals, plotting, planning, and kidnapping whoever can be used as a bargaining chip. He's a schemer and a plotter—and a betrayer.

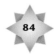

Head gear of a high rank.

Headband adds a fantasy quality to the outfit.

Spikes on protective shoulder guards for a gothic look.

Chest protector.

Powerful jewel amulet.

Arm plates.

Midlength gloves.

Long sword.

Tall boots with cuffs.

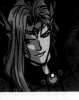

Female Warlord

Yes, my friends, she's a gothic warlord and not a happy camper. What will it take to make her smile? Her team winning the World Series? Shoes from Prada? Losing five pounds without even trying? The annihilation of Earth?

When we're talking about outfitting a female warlord, we're not talking about the kind of costume that would allow her to safely mount a horse and enter a joust. We're talking about making her look so gothic that she could adopt one of the gargoyles perched atop the cathedral at Notre Dame in Paris as a pet. She should move away from the conjuring-spells look, toward the I'm-going-to-set-fire-to-your-village look. Think gloves, boots, and shoulder and knee guards, all of which are protective in battle. Medieval warriors wore hip guards, as well. And yes, sharp wings help. Anything to make her less warm and fuzzy.

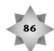

Extreme
headpiece.

Double-flared
shoulder guards.

Arm guards.

Wrist guards.

Impressive,
jeweled belt.

Wings. (These are
more decorative
than functional.)

Wraparound
leg guards.

Knee guards.

Cape.

Lord of the Beasts

The ability to hypnotize—and cast a spell over—vicious, predatory animals is a motif that has been around since the times of the earliest fables. This conceit conveys a message about the power of the character who holds dominion over such fierce beasts. I, personally, can only hypnotize a bichon frise, but it's an extremely aggressive bichon frise. I'm currently working my way up to poodles.

Lions, tigers, wolves, leopards, snakes—any dangerous carnivore makes a good pet for a villain... although, they can be tough to housebreak. Who's going to reprimand a leopard if it has an accident on the carpet? Not me, I can promise you that.

In many manga stories, these beasts are not really animals but humans who have been turned into animals by way of an evil spell. Others are demons in animal form. You can make up your own history for your beast. Either way, these beasts can still "speak" their thoughts to humans of their choice, without anyone else hearing them. A magical girl who faces down these evil foes will sometimes be drowned out by the noise of the inner dialogue going on between the beast and its master as they cackle and plot. The voices can become loud and overwhelming.

Human stands in front, as the leader.

Beasts are ready to attack on command. They are submissive only to their master.

Essential Supporting Characters

Fantasy requires very clear rules and boundaries. Without them, the story becomes a mishmash and meanders aimlessly. The way to "ground" a fantasy, such as the magical girl genre, is to firmly establish the world in which the magical girl, as a schoolgirl, lives. The supporting characters, therefore, become the canvas of her life. They're her world, the background. They're where she comes from. They give the story the stability it needs.

Best Friends and Confidantes

Everyone has to have a pal, a true-blue friend who can keep a secret, chat endlessly on the phone, and never let you down. When it seems like the whole world is against you and you just can't confide in your parents, you've got to have a best friend you can talk to. This is an essential tool in visual storytelling. Without the best friend, how would the magical girl express her thoughts? If she were to only "speak" in thought balloons, her world would become too insular and self-enclosed. She needs someone to share her secrets with and to challenge her.

The best friend character is typically perky and cute, but doesn't compete with the magical girl in personality.

There may be a really popular girl in their clique, but she won't be the magical girl's best friend. The magical girl will only confide in someone who is down-to-earth like her. In fact, a magical girl's group of friends are all unassuming, fun-loving girls who can share their hopes, dreams, and problems with one another.

And one more thing to keep in mind: Sometimes, when the transforming magic strikes a girl, it will also strike her entire group of girl friends (usually three girls) all at once, turning all three into a *team* of magical girls. So a best friend might just end up being a magical girl fighter, too!

The Japanese School Uniform

These are examples of authentic Japanese school uniforms. You can mix and match any of these sweaters, jackets, skirts, ribbons, and leggings to create new outfits. You can also change the colors and patterns. For example, instead of a plaid skirt, you could use a checkered pattern or zigzag lines and so on. You're the designer.

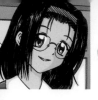

Classic Japanese Schoolgirl Uniform

Of course, you're going to have to draw a variety of schoolgirl outfits for the magical schoolgirl's group of friends, as seen on the previous page. But this is the classic schoolgirl uniform. You don't have to reinvent the wheel in order to come up with your own variations. Try adding different patterns to the skirt. Add oversized buttons and pockets to the sweater. Tight knee-high socks might replace leggings. A series of small changes can add up to a whole new look.

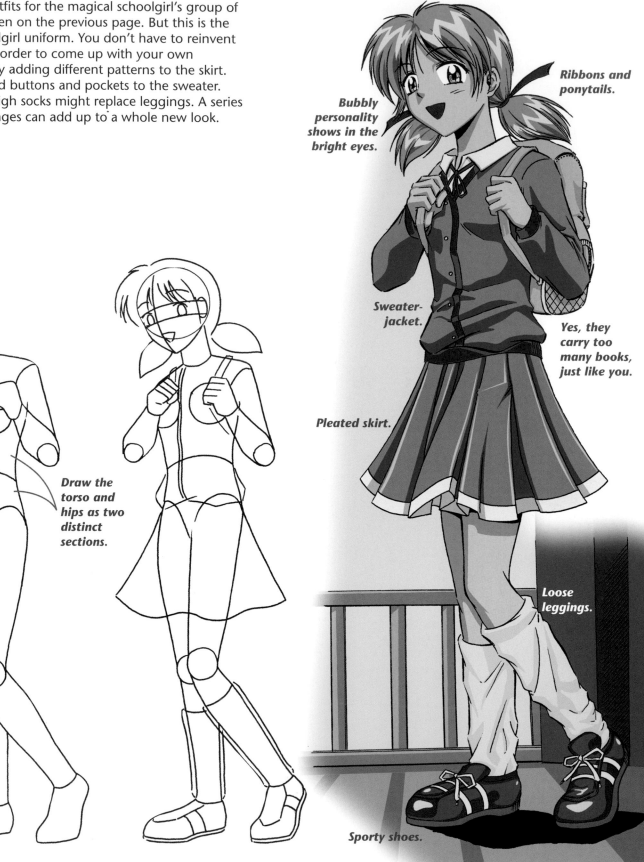

Draw the torso and hips as two distinct sections.

Bubbly personality shows in the bright eyes.

Ribbons and ponytails.

Sweater-jacket.

Yes, they carry too many books, just like you.

Pleated skirt.

Loose leggings.

Sporty shoes.

He's the one who can make the magical schoolgirl blush and forget what she was going to say. She's sure he likes someone else. And why shouldn't he? Every time he sees her, she trips, falls, or spills something on herself due to a case of nerves. When he stops to help her clean it up, she practically bursts into tears of embarrassment. And he can't understand why she never wants to talk to him!

He's a good guy, probably dating the rich snob at the school (see page 94), but only because our magical schoolgirl won't give him a chance. (Humans! It's amazing we've survived this long!) Even though he's a nice-looking character, he's not a bishounen. That's because he has a young teenager's face, not the long, thin, angular face of the more elegant, androgynous, mature bishounen. This character is typically 14 to 16 years of age.

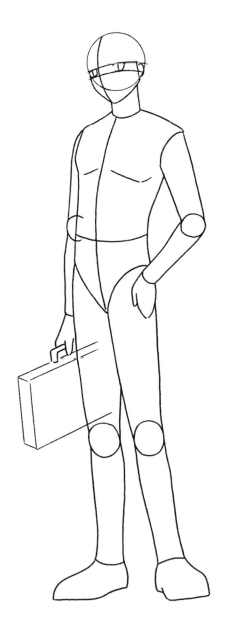
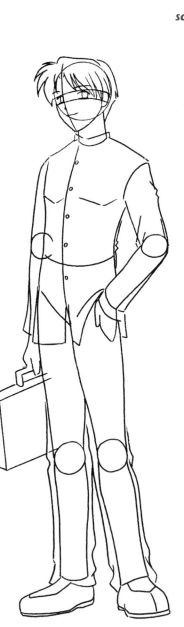
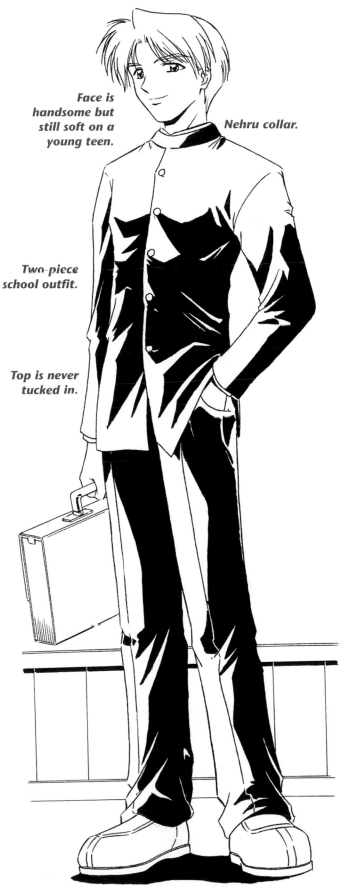

Face is handsome but still soft on a young teen.

Nehru collar.

Two-piece school outfit.

Top is never tucked in.

The Rich Snob

Okay, so she's pretty, but does she have to be so obvious about it? And the way she spends her daddy's money on clothes, you'd think she had no other hobbies, except criticizing the mismatched outfits other girls wear. But don't try to stand up to her. She has a razor-sharp tongue, and she's not afraid to use it. She's tight with a few other chic females who make up a closed clique that draws admiring looks from all the boys—and major-league resentment from all the other girls.

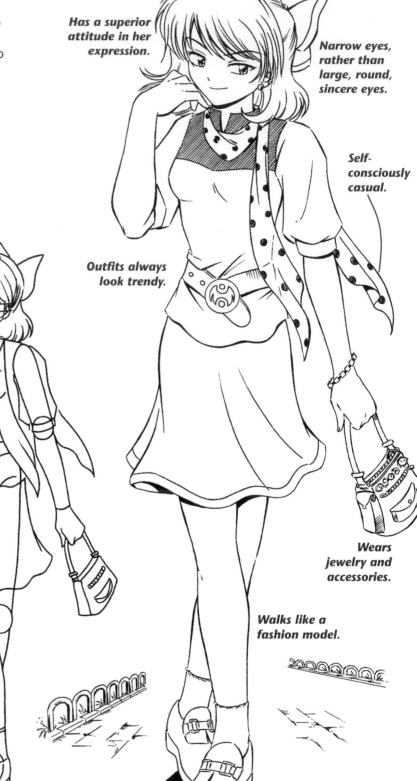

Has a superior attitude in her expression.

Narrow eyes, rather than large, round, sincere eyes.

Self-consciously casual.

Outfits always look trendy.

Wears jewelry and accessories.

Walks like a fashion model.

Magical Girl's Kid Brother

Family is always an important backdrop in magical girl stories. And the humorous sidekick in the family is often the kid brother. He's the little daredevil of the family, getting into trouble, taking the pratfalls. He might snoop around, suspecting that something's not quite right about his big sister, getting close to finding out what her secret is but always falling on his face as he tails her on his skateboard. He's short in stature and a bit of a string bean.

Long floppy hairstyle.

Mischievous demeanor.

Casual sports clothes.

Shorts or jeans.

Skateboard is at least half his height.

Sneakers or athletic shoes.

Dad

Just as the *Father Knows Best* 1950s-style sitcom dad was always cheerful on his way to work each morning, so too is the magical girl's father. He's Mr. Oblivious, never even remotely aware that his teenage daughter has to deal with real-life problems or that the teenage years might pose particular difficulties or that, as a girl suddenly given immense powers and the responsibility to save the world, his daughter might be a little . . . um . . . stressed. Of course, she's keeping all of this a secret from her family, but still, she's got a lot going on. However, there's nothing that a brownie and a cold glass of milk won't fix, according to dad.

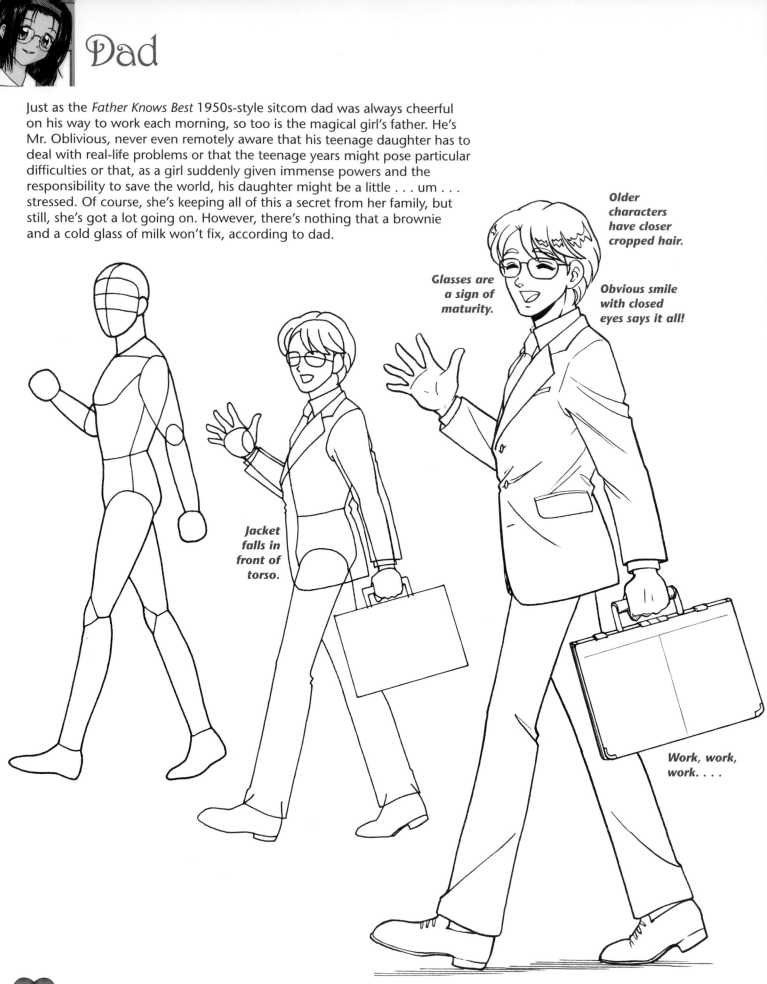

Older characters have closer cropped hair.

Glasses are a sign of maturity.

Obvious smile with closed eyes says it all!

Jacket falls in front of torso.

Work, work, work. . . .

Mom

Mom has never heard of the women's movement. To her, Betty Crocker is a feminist. She is always busy around the house. All this commotion leaves the magical girl feeling alone in the midst of her family. And that's on purpose. It's a situation that the average teen can relate to. You've got your entire family around you, but no one understands. The only ones who "get you" are your friends. And even still, sometimes, you feel alone. That's the plight of the magical girl. And that's why she's such a popular icon. All teens can relate to her.

The Mean Teacher

Are there any nice teachers? Sorry, but I speak from a boy's perspective. In my experience, teachers do not like boys. Boys have too much energy. They don't like to sit for long stretches at a time. They like to crack jokes and mouth off. Well, what did teachers expect when they got into the profession? We're boys! This is what we do! We can't help it. It's a chromosome thing.

But the same kind of teacher is generally fond of girls, who get their homework in on time and like to be called on in class. Unfortunately, battling demons in other dimensions doesn't leave a magical girl with lots of time for algebra assignments. So the magical girl may have her chance to see a side of the teacher that the boys have to face every day.

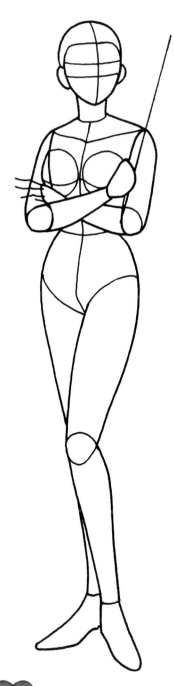

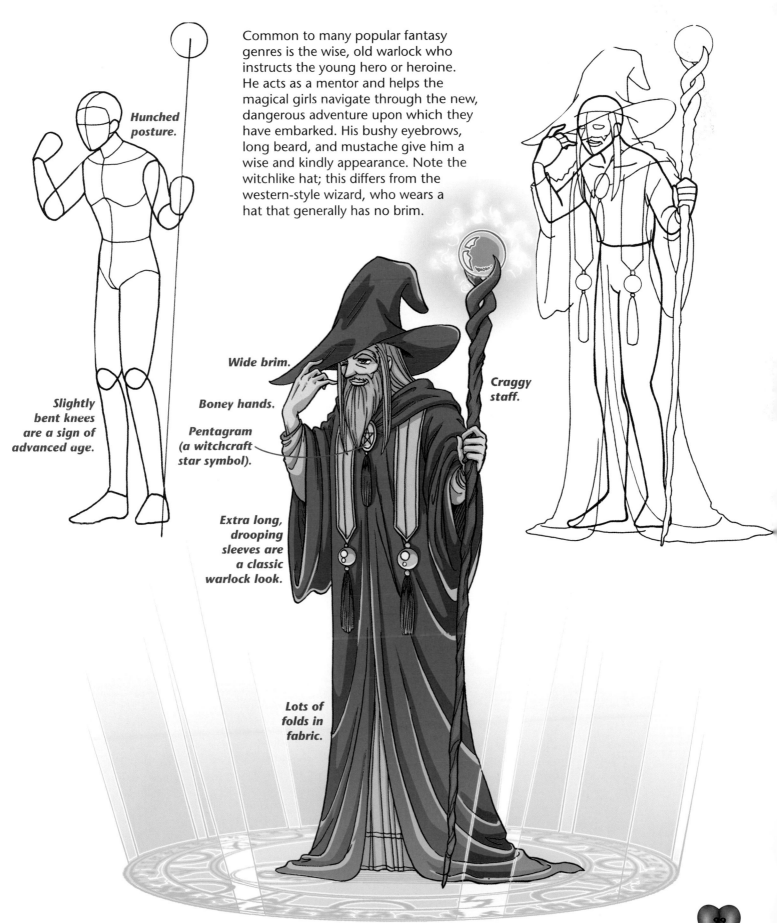

Common to many popular fantasy genres is the wise, old warlock who instructs the young hero or heroine. He acts as a mentor and helps the magical girls navigate through the new, dangerous adventure upon which they have embarked. His bushy eyebrows, long beard, and mustache give him a wise and kindly appearance. Note the witchlike hat; this differs from the western-style wizard, who wears a hat that generally has no brim.

Hunched posture.

Slightly bent knees are a sign of advanced age.

Wide brim.

Boney hands.

Pentagram (a witchcraft star symbol).

Extra long, drooping sleeves are a classic warlock look.

Craggy staff.

Lots of folds in fabric.

99

Magical Mascots

These cuddly little fantasy monsters, rascals really, are pals of the magical girl. They're mascots, buddies, magical friends. They hop along for the ride. Magical girls usually encounter them once they enter the "other world" where they have been sent to save the people from the evil lord. These chipper little critters are not afraid of going to dangerous places with her. In fact, they'll even throw themselves into harms way to protect her. Yes, they've even been known to give their lives for their magical friends. A tear or two has been shed over the loss of these brave little companions. There is no finer friend than a tiny manga monster.

Designing Your Own Manga Mascots

Real Bunny Starting Point

They're irresistibly cute, there's no denying that. But can you teach someone to draw something irresistible? Is there a class in drawing *irresistibility*? Well, believe it or not, you *can* learn how to make something irresistible. The secret is twofold. So, we'll start with the first element—the basis for all of these little manga monsters: animals. That's right, cute little animals. And if you want to make them extra cute: baby animals. By using baby animals as your starting point, you can easily build a manga monster that tugs on the heartstrings of the reader. All you have to do is create a cartoon of the animal with some manga features and styling.

Cute Manga Bunny Critter #1
The entire body is one shape, just a little puffball.

Cute Manga Bunny Critter #2
The head and body are two different sections, but of equal size. Note the nice manga eyes, with shines.

When Mascots Cross Worlds
Although these fun-loving, courageous, hyper rascals live in the "other dimension," they do sometimes pop back into the magical girl's "real world"—with hilarious results. For example, it's very difficult to explain to your science teacher what a flying ball of blue fluff is doing hovering next to your desk, eating all of your Cheese Crunchies out of your backpack. So these manga monsters are humorous characters who, nonetheless, are prepared to fight to the death to protect their friends.

Real Cat Starting Point

Cute Manga Cat Creature

Notice that the manga version is a kitten. Baby animals are much cuter. Add a fantasy swirl off the forehead and a fantasy tail, as well as markings on the cheeks. You don't have to destroy the form in order to turn it into a creature. You only have to make it seem like it belongs just this side of the fantasy realm.

Real Puppy Starting Point

Cute Manga Puppy Creature

The face has become rounder and younger-looking, with manga eyes. And the entire form is now ultrasimplified. That star marking on the forehead tells us that this is a fantasy creature. The body has been changed so that it no longer looks like a regular dog (note the weird leg formation).

Real Turtle Starting Point

Cute Manga Turtle Creature

Add a silly touch!

Ever see a turtle walk on two legs? Or have eyelashes? Me neither. Walking on two legs gives the turtle-creature extraordinary speed. Does the mile in just under a week and a half.

Real Mouse Starting Point

How did that happen???

Cute Manga Mouse Creature

Who wants to go three rounds with Squeaky the Tornado? Winner gets a week's supply of cheddar.

103

Ordinary vs. Superfantasy

Using animals as the basis for your cute manga mascots is only the first step. You can, as you progress, use anything you want as your starting point. Although animal-based monsters are the surest way to achieve a cuddly looking character, there have been many funny monsters based on plants and even inanimate objects. You can also make up shapes from your imagination.

But whatever you start with, your finished drawing must be in the realm of the fantasy kingdom. And that's where the second element to designing magical mascots comes in. They've got to be part of the magical world of magical girls. We've got to believe that the mascot can zip in and out of different dimensions. If there's too little in the way of a fantasy style, your mascot's just going to look like a very weird pet. It needs to have an *enchanting*

charm. Remember that term. It's important that you aim for that in your drawings.

Let's take a look at a bunch of manga mascots drawn two ways to show the contrast. The first versions show how a beginner might attempt them. Nothing wrong with that. In fact, they are pretty good first tries. But they're not the types of characters that are ever going to be memorable or be favorites among readers. They just don't have enough magic, enough sparkle, enough *enchanting charm*. The second examples show the same characters drawn with classic, fantasy-based motifs and styling. The characters are also adjusted to better fit the genre. Sometimes, all it takes is a simple adjustment of the posture. Other times, more fantasy decorations are included, or costumes are added.

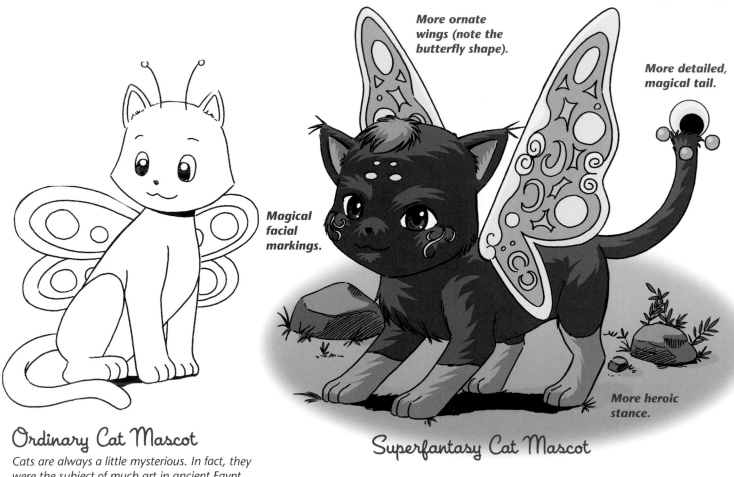

More ornate wings (note the butterfly shape).

More detailed, magical tail.

Magical facial markings.

More heroic stance.

Ordinary Cat Mascot

Cats are always a little mysterious. In fact, they were the subject of much art in ancient Egypt, where they were considered sacred animals.

Superfantasy Cat Mascot

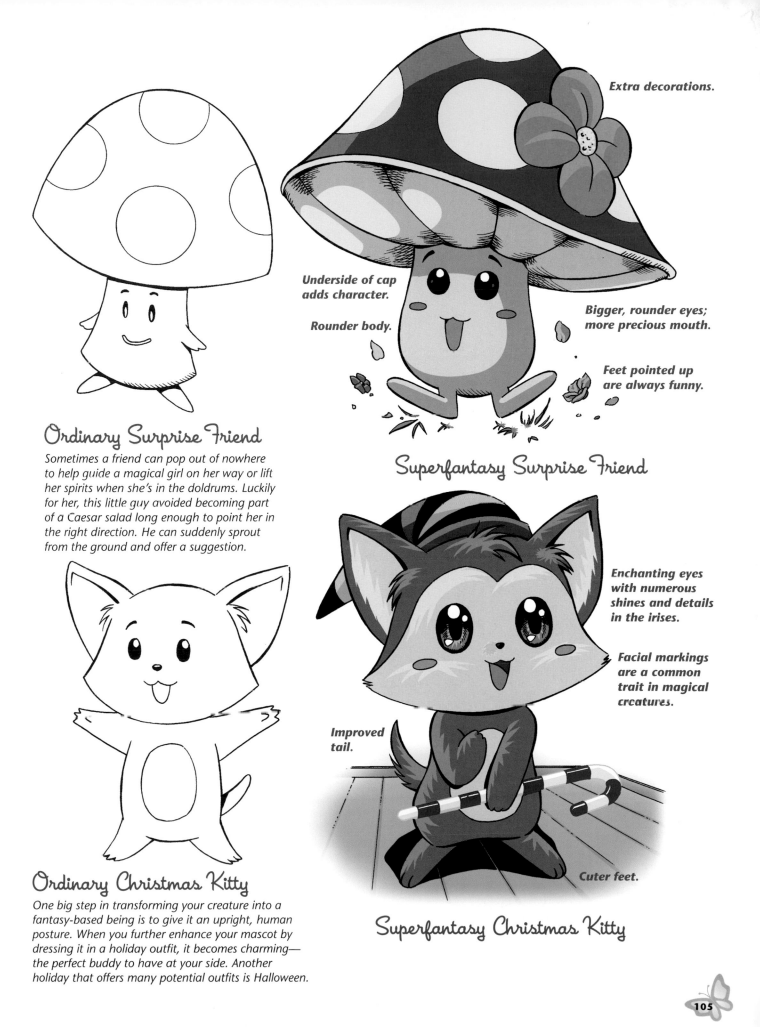

Extra decorations.

Underside of cap adds character.

Rounder body.

Bigger, rounder eyes; more precious mouth.

Feet pointed up are always funny.

Ordinary Surprise Friend

Sometimes a friend can pop out of nowhere to help guide a magical girl on her way or lift her spirits when she's in the doldrums. Luckily for her, this little guy avoided becoming part of a Caesar salad long enough to point her in the right direction. He can suddenly sprout from the ground and offer a suggestion.

Superfantasy Surprise Friend

Enchanting eyes with numerous shines and details in the irises.

Facial markings are a common trait in magical creatures.

Improved tail.

Ordinary Christmas Kitty

One big step in transforming your creature into a fantasy-based being is to give it an upright, human posture. When you further enhance your mascot by dressing it in a holiday outfit, it becomes charming— the perfect buddy to have at your side. Another holiday that offers many potential outfits is Halloween.

Cuter feet.

Superfantasy Christmas Kitty

Ordinary Rabbit Helper

This little forest helper can scamper about, tell the magical girl a secret that will aid her quest, and hop away just as quickly as it appeared. The challenge with all of these creations is in designing them to look like the original animal—but yet different enough so that it will look bewitched. You only need a few well-placed elements to convey the idea that it's not a real rabbit. However, if given a choice between having too many fantasy "bells and whistles" or having it look too much like a rabbit, I would err on the side of having it look too much like a rabbit. The reason is simply because the "cute" factor of the rabbit is too appealing to tamper with. And by choosing a fantasy-based color—for example, making the rabbit pink or blue—you're already taking it out of the realm of realism.

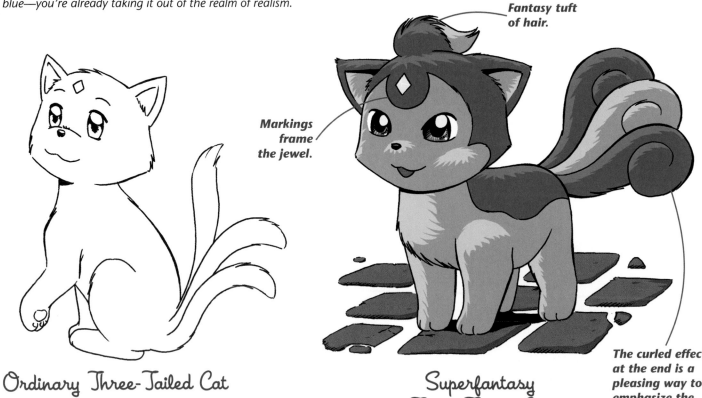

Unusual markings will be noticed by the reader.

Small, well-placed ornaments—like jewels, tiaras, and earpieces—are especially effective.

Cheek area is accentuated for cuteness.

Accentuated fur detail running down the back.

Tail marking.

Superfantasy Rabbit Helper

Fantasy tuft of hair.

Markings frame the jewel.

Ordinary Three-Tailed Cat

You can often repeat a feature on an animal to create the fantasy idea. On this little hairball, it's the tail, but you could invent a character with extra ears, noses, or even eyes.

Superfantasy Three-Tailed Cat

The curled effect at the end is a pleasing way to emphasize the novel tail.

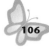

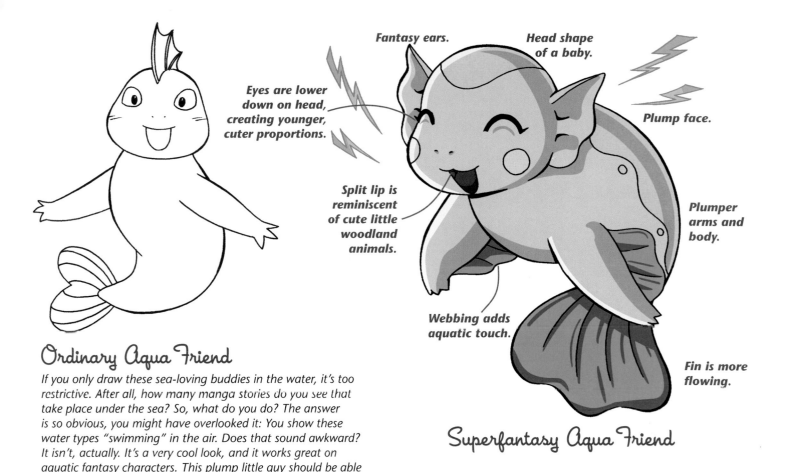

Fantasy ears.

Head shape of a baby.

Eyes are lower down on head, creating younger, cuter proportions.

Plump face.

Split lip is reminiscent of cute little woodland animals.

Plumper arms and body.

Webbing adds aquatic touch.

Fin is more flowing.

Ordinary Aqua Friend

If you only draw these sea-loving buddies in the water, it's too restrictive. After all, how many manga stories do you see that take place under the sea? So, what do you do? The answer is so obvious, you might have overlooked it: You show these water types "swimming" in the air. Does that sound awkward? It isn't, actually. It's a very cool look, and it works great on aquatic fantasy characters. This plump little guy should be able to throw lightning bolts as his special power. But I'm spilling the beans prematurely. We're going to get into the special powers of manga mascots in a couple of pages.

Superfantasy Aqua Friend

Folded ears look friendly.

Third "eye" emblem design.

Fantasy feather design; not realistic.

Clouds act as the ground.

Foxlike tail.

Ordinary Flying Pup

Better have a very long leash, because when he sees an airplane fly past, he loves to chase after it! Wings are always a good, solid standby when you're trying to come up with a fantasy characteristic to tack onto an animal. But one word of caution: Don't make the wings the typical, realistic, feathered angel wings that you would see in a Rubens painting. That would make the dog look like an angel dog—in other words, to be blunt, a dead dog. Don't want that. Give the pup fantasy wings, with curls and exaggerated feathery shapes.

Superfantasy Flying Pup

Ordinary Wolf Pup

It doesn't really matter what type of animal you start with, even if it is, potentially, a threatening type, like a wolf. Just turn it into a baby with big eyes and a tiny nose. Who can resist that? Baby lions and baby grizzly bears are incredibly adorable, even if their parents send shivers down your spine.

Moon motif is from the world of wizards and witches.

Special effects magic.

Rings "float" mysteriously around the tail without touching it.

Superfantasy Wolf Pup

Ordinary Goofy Cat-A-Roo

Yes, you can have a sidekick whose main attribute is that he's just plain silly. Although he tries hard to help, the only thing he manages to do is to slow down the magical girl in her quest to save the day. But he's so darn earnest, you gotta love him. This guy is usually a little hyper: Wind him up and watch him go! Yes, he's aware that he's only made things worse by his efforts. But he promises that he'll redouble his efforts next time, which is exactly *what* you want him *not* to do!

Droopy ears.

Slightly crossed eyes.

Thin neck.

Funny little pouch.

Skinny legs.

Long, thin feet.

Superfantasy Goofy Cat-A-Roo

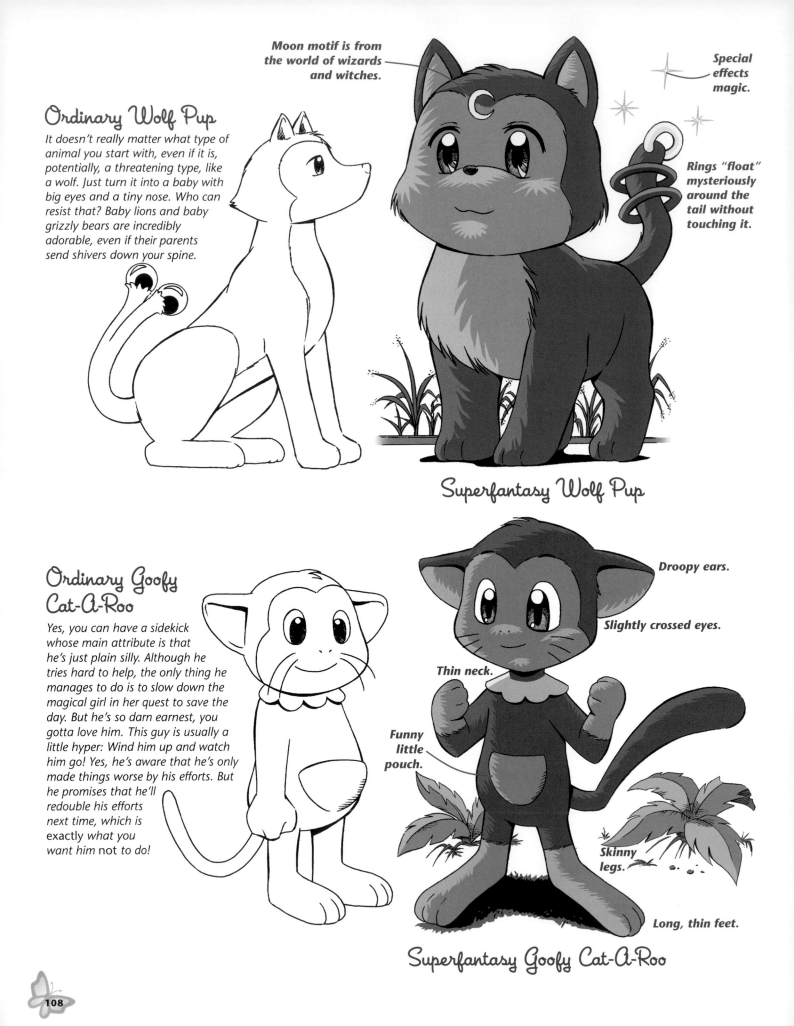

Ordinary Water-Thudder

It's tempting, when you draw a character that has a naturally round outline, like a whale, to just leave it at that. Just draw a simple football or blimp, and start working on the cute features of the face. Well sure, that's okay, and you can invent some good characters like that. But if you want to bring out the cuteness of the character and make it so adorable that your friends will compliment you and your enemies will be so jealous that they'll wish they were never born, then I'd suggest doing a little extra work on the *far* side of the outline of the face. Make sure that the orbit of the eye curves *in* slightly and the cheek area below it curves *out* slightly. Also, the horizontal marking across the face gives the subtle suggestion of a nose, without the need for nostrils or any added definition.

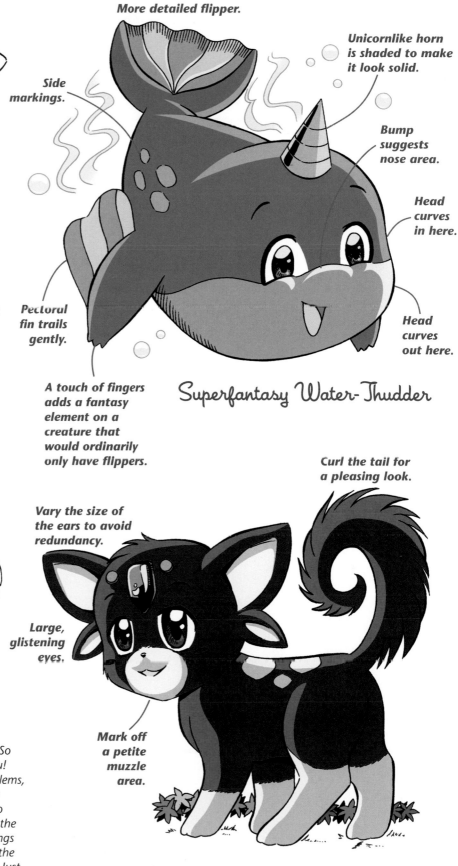

More detailed flipper.

Side markings.

Unicornlike horn is shaded to make it look solid.

Bump suggests nose area.

Head curves in here.

Pectoral fin trails gently.

Head curves out here.

A touch of fingers adds a fantasy element on a creature that would ordinarily only have flippers.

Superfantasy Water-Thudder

Ordinary Enchanted Fox

It's not every day that you see a fox with four ears. So no whispering behind his back, 'cause he'll hear you! The head is always a good place to put jewels, emblems, markings, or horns. You can do it very economically because the reader can't avoid noticing them due to the fact that the reader is almost always looking at the character's head. If you were to place special markings somewhere else on the character—for example, on the stomach—then you wouldn't see them in this pose. Just don't add too many, or you'll clutter up the face.

Curl the tail for a pleasing look.

Vary the size of the ears to avoid redundancy.

Large, glistening eyes.

Mark off a petite muzzle area.

Superfantasy Enchanted Fox

Special Mascot Powers

As we've seen, these little creatures are more than just buddies; they're humorous sidekicks. One of the principles of humor is placing two incongruous things together. And that's what happens with the special powers: We give these tiny, harmless-looking creatures oversized powers. It's always a visual surprise to see such explosive force coming from such tiny containers!

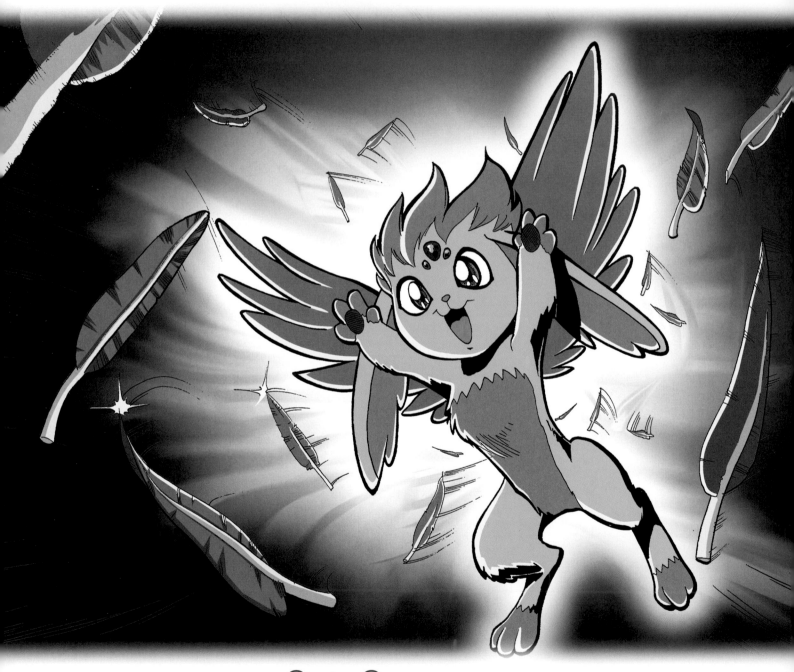

Blinding Burst

Too bright to see. This mascot temporarily blinds the magical girl's enemies.

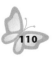

Blowing Streams of Energy

Note the burst around the origin of the energy stream, which adds to the effect and makes it more brilliant.

Burst effect.

Supersight

This is the ability to see up to twenty miles away. You don't have to stay with familiar powers, like superstrength or the ability to fly. You can invent very specific ones that give your manga mascots an advantage in unexpected ways.

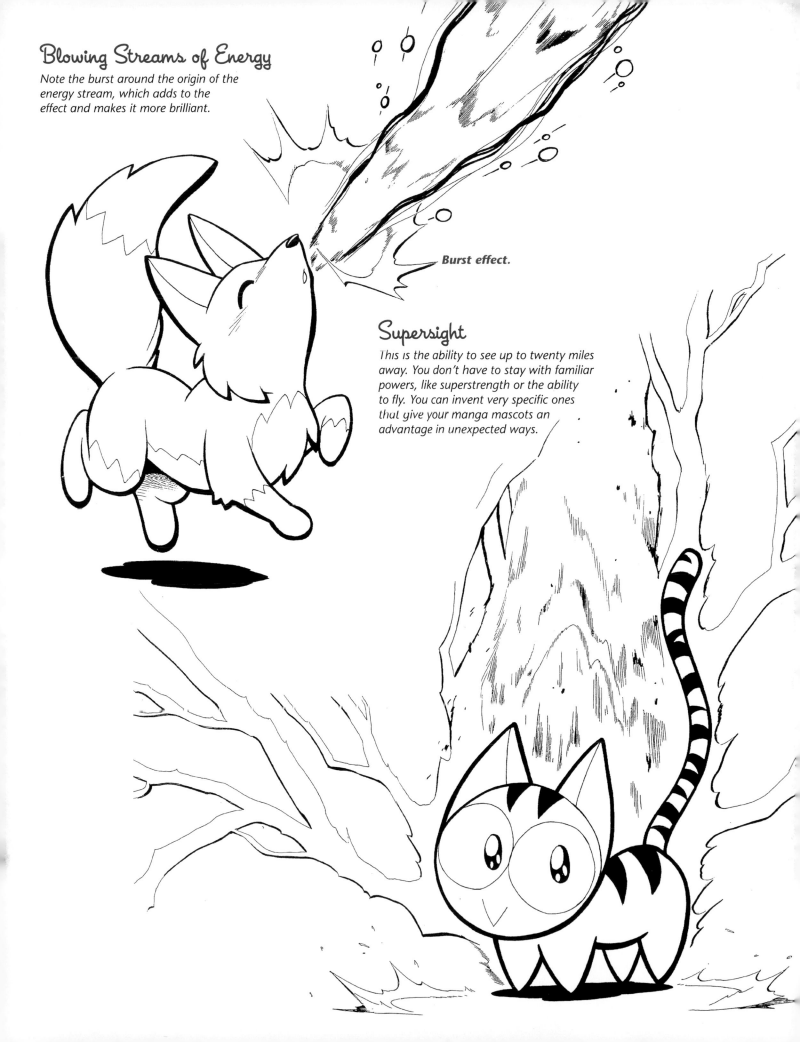

Speed Hopper

Now you see this sidekick, now you don't!

Keep the musical bars wavy to give the feeling of a lullaby.

Sings You to Sleep

No matter how hard you try to resist, the sweet voice makes your eyes so heavy, you can't keep them open. Kinda like being in geometry class only worse, if you can believe it.

Combining Mascot Powers

When you put several of these magical friends together in a single scene and let them loose with their impressive powers, watch out! It should look like a hurricane hit the page.

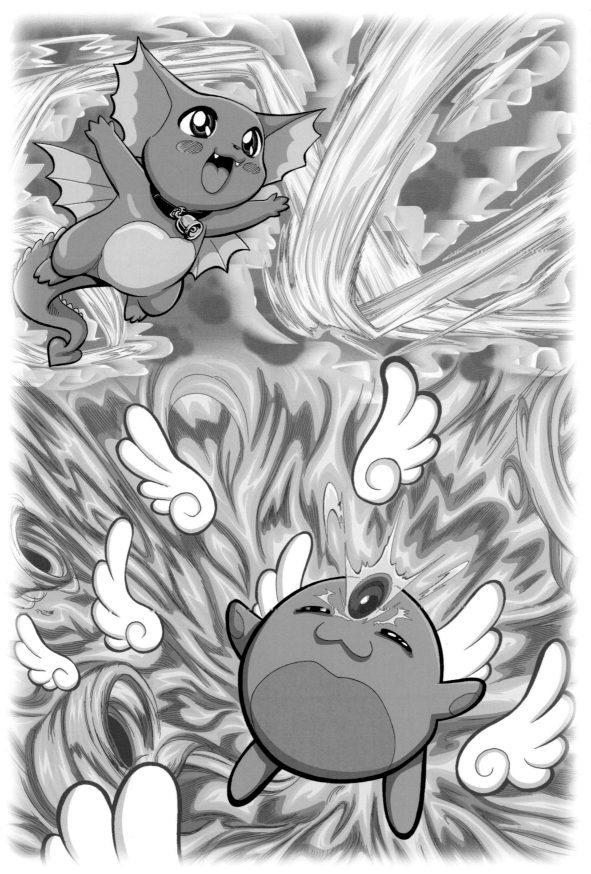

Magical Girls and Mascots Together!

Here they are, together where they belong—the magical girl and little monster friend. Sometimes, the monster friend will travel back to Earth with her. Maybe the magical girl will try to hide it in her school backpack, the way some grown-ups walk around with their Chihuahuas in their purses. But that won't work for long. Magical friends are mischievous. You might be sitting in class and decide to peer into your backpack to check on your monster friend, only to discover that it has disappeared! Where'd it go? It has magically transported to the school cafeteria and is eating everyone's dessert.

With her power-packed wand on one side and her flying buddy on the other, she has enough ammo to give any bad guy a fight. So who does what in the fight? You can stage it any way you like. But a tried-and-true method that audiences like is for the magical girl to fight the bad guy head on and sustain some setbacks while her little magical buddy buzzes him, distracting him long enough for her to regroup and launch a second attack that is, ultimately, successful. Believe it or not, it's the first failure—and near defeat—of the magical girl that makes her ultimate victory so compelling. Without her near loss, the reader would never be pulled emotionally into the scene.

Magical Fighter Teams

The magic that transforms the average schoolgirl often transforms more than just one person—it transforms her group of friends. This is, in a loose analogous way, the Japanese version of the American Team Action Fighters, all costumed, who fight on the side of justice. But these girls are more than just fighting for the same cause, they're also best friends.

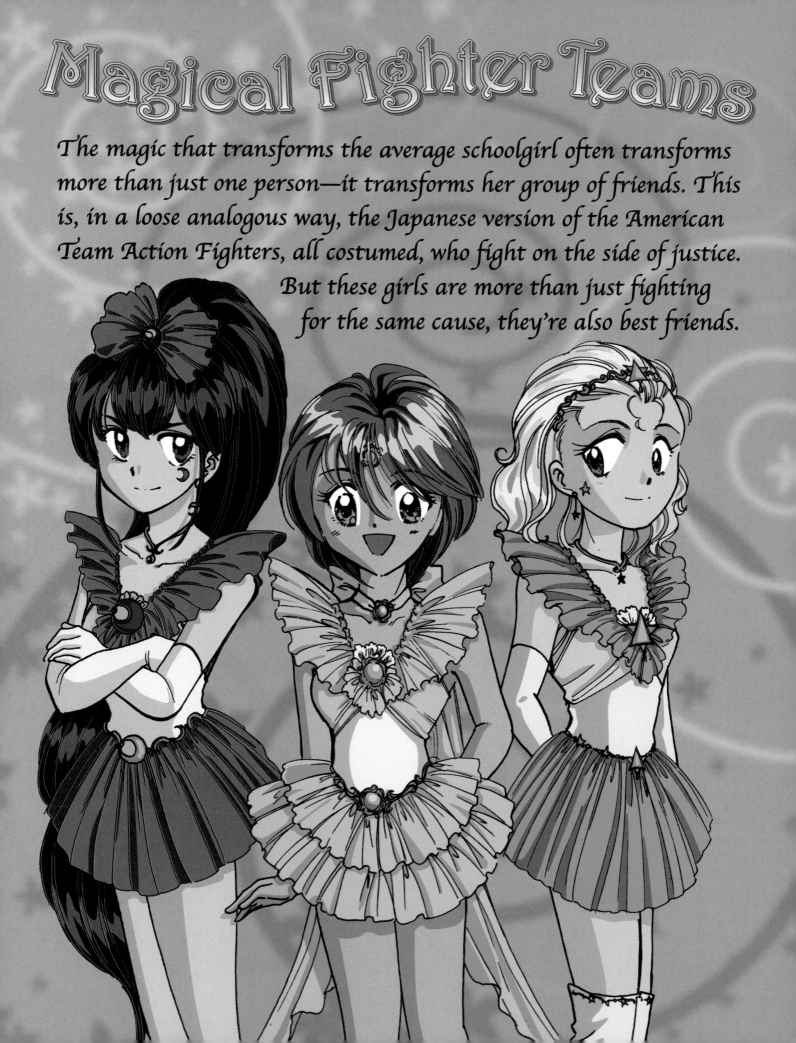

Varying the Height

When you're working with three girls, rather than one, it's important to create more than just a unifying visual theme, but *differences*, as well. You don't want them to blend together to such an extent that they lose their individual personalities.

One commonly overlooked way to do this that you should *always* employ when drawing a group of girls is by varying the height of the characters.

Varying the heights forces the eye to travel up and down while scanning the image, which makes the eye slow down and take more time to soak in the image. When the characters are all the same height, the eye tends to skim the image quickly, as one whole clump, without looking at each girl individually, which is a disadvantage for the artist, who has worked hard to draw each figure.

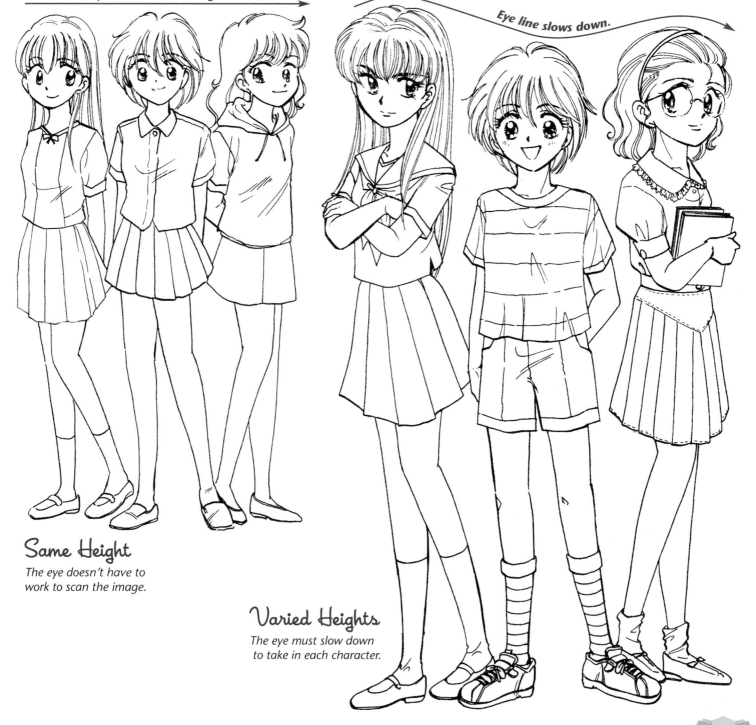

Eye line "skims" image.

Eye line slows down.

Same Height
The eye doesn't have to work to scan the image.

Varied Heights
The eye must slow down to take in each character.

Varying the Costumes

Of course, you'll give the magical girls outstanding costumes. But will you give them each different costumes? Well before you answer, let me present the issue in more detail. You need to give each girl her own, individual identity. If you give each character the same costume, they will all look like clones. But if the costumes look too different, the characters won't look like part of a team. So the answer is: No, you don't give them each totally different costumes. You give them all *similar* costumes—but with just enough differences to make them look like individuals. The differences in the design of the costumes may be subtle, but with the addition of color, you can highlight the differences one notch further.

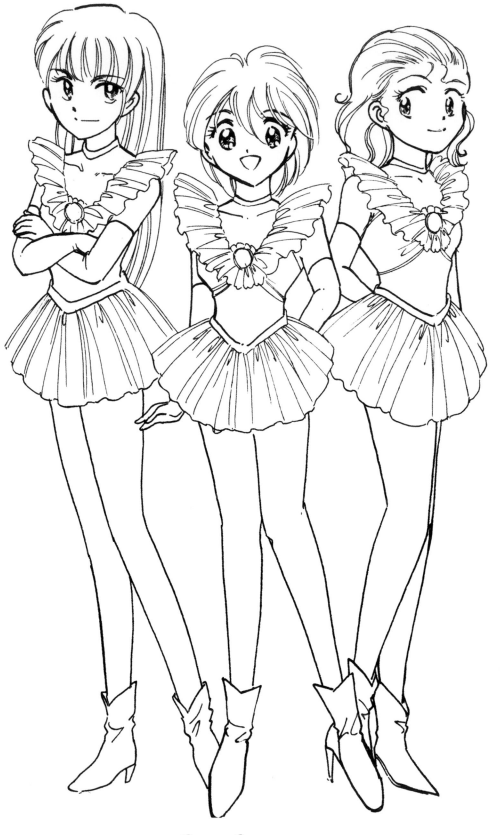

Same Costumes

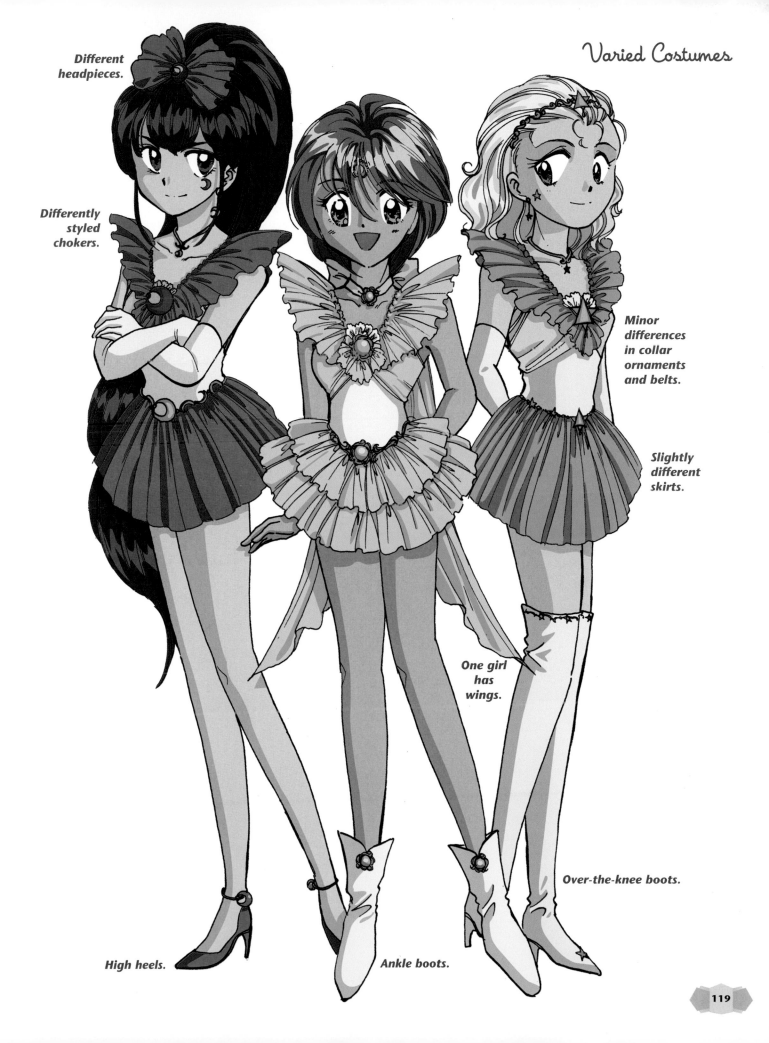

Different
headpieces.

Varied Costumes

Differently
styled
chokers.

Minor
differences
in collar
ornaments
and belts.

Slightly
different
skirts.

One girl
has
wings.

Over-the-knee boots.

High heels.

Ankle boots.

119

Staging Team Action Poses

The last step in creating a team is all about staging and matching each personality to a fighting style. You could show your magical girl team standing stiffly, or you could show your team in motion, ready to take on the bad guys. You don't want the team members standing in a single row, side by side. That's boring. It's more exciting if they look as if they're coming at you. But you have to be careful that the figures don't overlap one another too much. You want the reader to have a clear view of each character. Try arranging them with the highest figure as the one in the center and the other two below her and to the sides.

Just as there are different hairstyles for different personalities, so too are there different types of magical girl fighters. Choose the personality type that best fits the fighting style. For example, the bubbly personality is best suited to be the fighter with the special effects. The introverted personality is best as a fighter who possesses mysterious powers. And the leader of the group takes the fight to the bad guys.

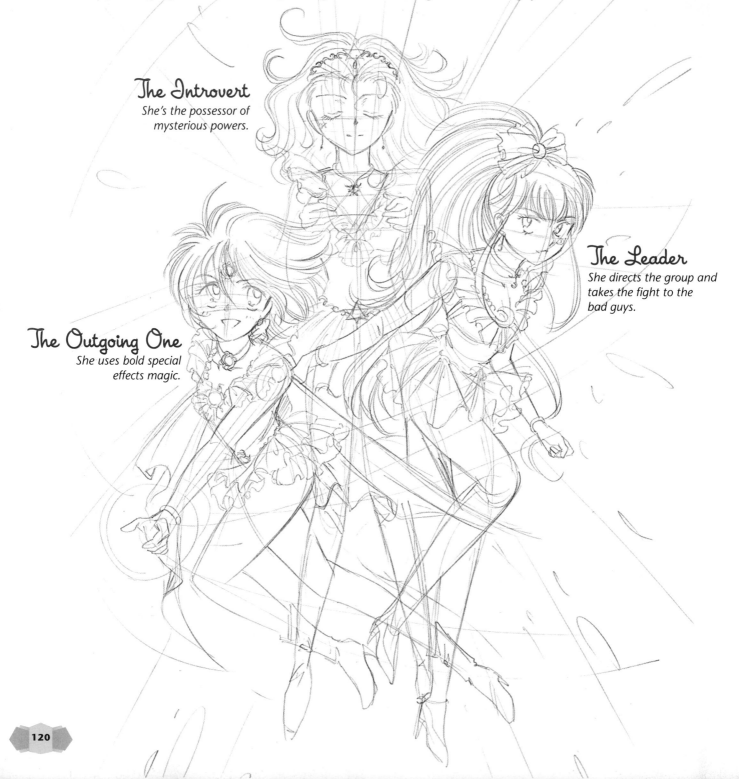

The Introvert
She's the possessor of mysterious powers.

The Leader
She directs the group and takes the fight to the bad guys.

The Outgoing One
She uses bold special effects magic.

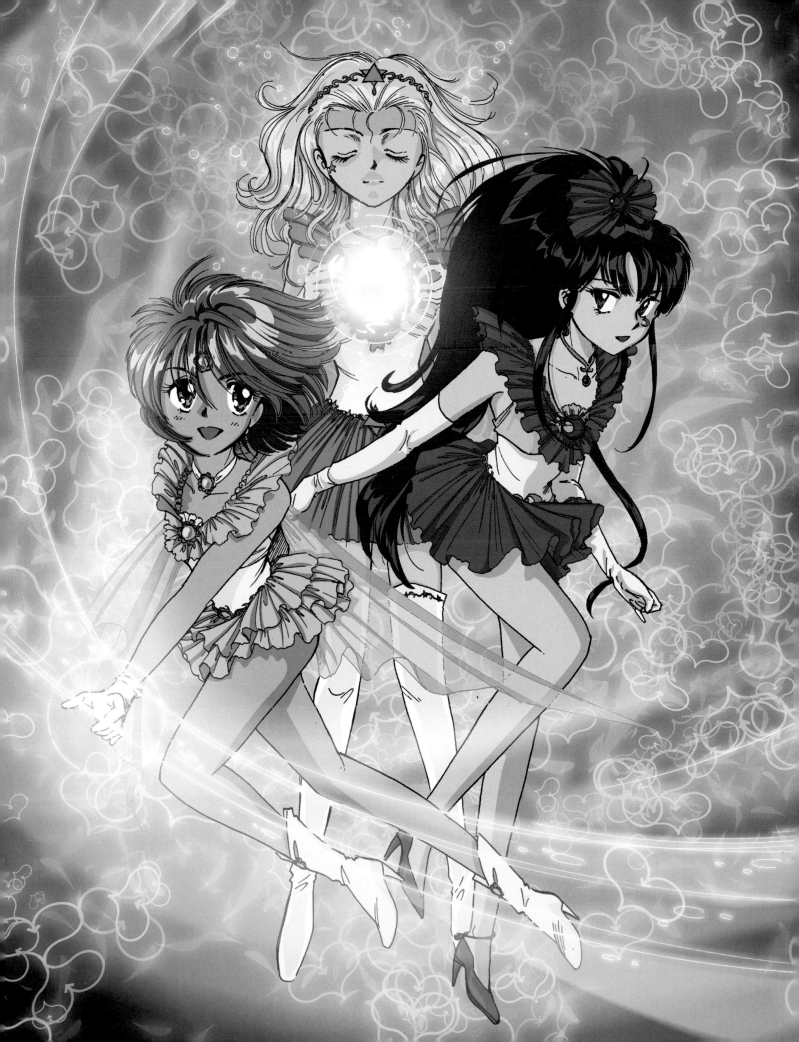

Choreographing Team Fight Scenes

What's the most important moment of an effective fight scene?

A. the attack
B. the group huddle
C. the special effects
D. the near defeat
E. the monster's expression

Time's up. What did you guess—A? That's what I would have guessed. That makes the most sense, naturally. I mean, you've got to have an attack, right? If you guessed A, get down and give me ten push-ups and a lap around the track. You're *wrong*! Same with all you readers who picked B, C, and E. The correct answer is D. Yep, that understated, lonely little answer hidden toward the bottom of the stack is the correct one. The near defeat is the key to a good fight scene.

The near defeat comes right after an attack that *should* work but doesn't. It's the "uh-oh" moment of the fight, when the girls realize that they might not have enough of what it takes to win. It's the *necessary* point in the scene when the audience goes, "Oh heck, *now* what do they do?" That's the point you've got to bring your reader to. Without that, you're just going in a straight line toward victory, and that spells B-O-R-I-N-G. With the setback, the reader suddenly wakes up and realizes, *Hey, these gals could actually lose!*

Let's follow the action the way a professional manga artist might lay it out in a scene between a band of magical girls and a fire monster.

Panel 1: The Face-Off

This is when they come face-to-face with their enemy. No blow is struck. It's just a confrontation at this point.

Panel 2: Lead Girl Takes Her Best Shot

The first magical girl throws her magical boomerang into the heart of the fiery beast. This is her most effective weapon, and it never fails—until now! This is a real setback! Gulp!

Panel 3: The Reaction Shot (the Huddle)

Again to underline the setback, we have a reaction shot, as the girls look to one another, bewildered. Hmmm, this could mean trouble. What are they going to do now?

Panel 4: Strike Again

This time, they combine forces and strike as a single group. Their power multiplied by three, the girls now overcome the fire monster, save the world and the universe, and still have time to complete their homework assignment before class tomorrow.

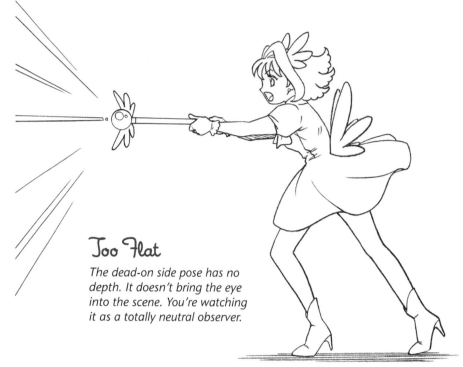

The Best Angle for an Action Shot

Before you start to draw your figure, do some very quick, rough sketches—I'm talking fifteen-second sketches—of your character in a variety of poses to decide which is the most dynamic position. Don't invest anything emotionally in any one, single pose. Add no detail. Don't get attached. This will help you make a totally dispassionate decision. If you don't like any of the choices you've made, toss 'em and start over. Once you find a pose that's promising, *then* start exploring its possibilities and work it up.

Here's a typical action that you'll no doubt have a reason to draw at some point in your magical girl comics. The magical girl has taken just about all the abuse she cares to take . . . now you've gone and ticked her off. Out comes the wand, and she lets you have it! Let's examine the three most likely ways a beginner might draw this pose. (None of them are wrong, per se, but there are reasons why they might not be your absolute best choice.) And then we'll see what we can do about it.

Too Flat

The dead-on side pose has no depth. It doesn't bring the eye into the scene. You're watching it as a totally neutral observer.

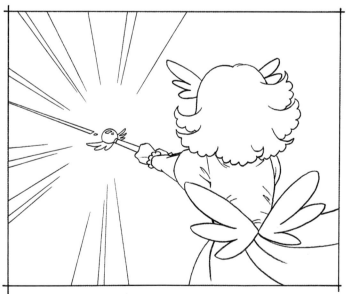

Reverse Angle

A reverse angle describes viewing the action from over the shoulder of the character. The drawback with this pose is that the biggest, most impressive object in the picture is the girl's back.

Bird's-Eye View (High Angle)

This is usually a nice angle for a change of pace. The problem here is that the action doesn't support the angle. The high angle doesn't underscore a sense of power, it detracts from it. Low angles underscore power.

Most Effective Angle

Why does this pose work so well? The first thing to notice is that the wand points toward the reader. There's no ducking out of the way! And to make an even bigger impact, exaggerated perspective is used; in other words, the wand increases greatly in size as it comes toward the reader, as do the energy lines and the feathers. The energy lines are, in actuality, vanishing lines that converge at the crystal atop the wand, drawing your eye to the power center right away. And the concentric circles of radiating energy lines orbiting the wand draw us, hypnotically, into the center of the picture. Everything about this page continually pulls us in, like a whirlpool.

Diving Out of Harm's Way

Here's another comparison of poses. Does this scene remind you of anything? How about the old Westerns when a gunfighter shoots at another guy, who dives behind some cover? Yes, the costumes and settings change, but the plot lines vary little. Instead of bullets, it's laser beams. But you still have to jump out of the way because you don't want to get hit by either of them! This is a "money shot" (Hollywood lingo translation: it's an audience favorite)—so use it! If you're doing a sequential fight scene, try to work it in.

Not Bad, but . . .

This works well. But there's something a little static about the scene. I mean, you've got your main character leaping out of the way of a blast, and yet there's still room to build it into more of a moment.

Long Shot, Looking Down

When you take a longer view of two characters, it's called an establishing shot. An establishing shot is very useful for two specific purposes: to set up the beginning of a story and to reestablish where you are in the middle of a scene (if you've had so many close-ups and action shots that the reader may have gotten a bit lost). However, to cut to an establishing shot in the middle of an action scene is deadly. It saps all the energy from the moment.
Can you feel it? The suspense is suddenly lost. This is where your reader puts the book down and goes to the fridge. Don't let that happen.

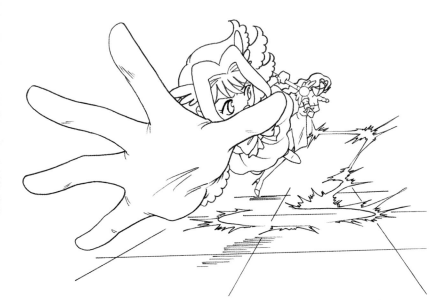

A Good Idea Taken Too Far

Okay, okay, I said to make a bigger moment out of it, but don't go nuts! Forced perspective is a great technique. But you've still got to be able to see what's going on. And unfortunately, here you can't.

Most Effective Angle

This is an improvement on the first example. It's bursting with energy. You can feel the urgency. So what did we change? For one, instead of darting out of the way of the laser beam, she is leaping as if her life depends on it—she's totally airborne. Also, look closely at the floor. It's drawn on a severe diagonal. That's right, we've actually tilted her entire world. The panel is tilted. A tilted panel is used during moments of extreme distress. It underscores severe emotional turmoil, as opposed to a horizontal panel, which conveys a calmer state of mind.

Clashing Weapons

Ah yes, the moment we've all been waiting for: It's a tense instant—at least, it should be—because she cannot hold it for long against her physically more powerful opponent. And readers know it, which adds the classic suspense elements of the ticking clock: How much longer can she keep it up?

Too Much Distance

This is a typical beginner's mistake. Concentrating on making the figures look correct at the expense of the action. Figures in fight scenes do not keep so much distance from each other. There's one exception to this: when you're showing a reaction shot in a fight scene. So for example, if someone is punched halfway across a room, you can show that person crashing into a wall twenty feet away. Otherwise, figures in fight scenes should be positioned in close to each other, to heighten the struggle.

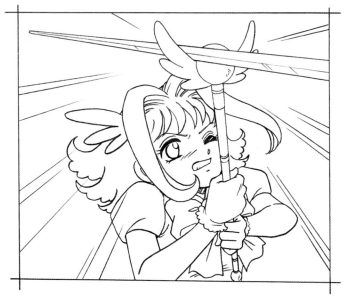

Great Shot, Bad Timing

This is a great shot to cut into *after you first show a two-shot (a shot with two people in it).*

Too Far Away

Nice angles, nice everything, but when you're drawing action scenes in comics, you've got to be in the reader's face. And this is not.

Most Effective Angle

Those special effects sure come in handy, don't they? You're beginning to see that special effects are not just "extra stuff." They're legitimate and essential tools of the manga artist, just like anatomy, foreshortening, and design. So, can you guess what the major design (or layout) dynamic is that makes this page work so well? It's the dominant/subordinate position of the characters. He is up high, descending upon her as if she were his prey. And she is low, looking up at him, defending herself. In addition, we're now close in on the girl, bypassing most of the man. The guy's cape and knee frame the image so that we focus entirely on the girl and nowhere else.

Magical Transformations

Here's the part you've all been waiting for. It's the most wondrous, enchanting phenomenon that occurs in the magical girl genre. It's the transformation scene: when a normal schoolgirl miraculously changes into a magical girl. It doesn't just happen with a snap of the fingers. It's a dreamy, surreal process that envelops the ordinary girl with all sorts of magical effects and glitter. It's beautiful and amazing. You don't want it to happen too quickly. The reader wants to take in the moment, like riding a rainbow.

Creating a Typical Transformation

Before we get to the actual technique of creating the transformation (in stages from beginning to middle to end), let's see how a transformation might occur in a typical manga story. Here, we come upon an ordinary schoolgirl on her way home one day. Suddenly, demons appear out of the sky. They seem, at first, to be frightening. Everyone is running from them, including the adults. Our schoolgirl tears down the block and then . . .

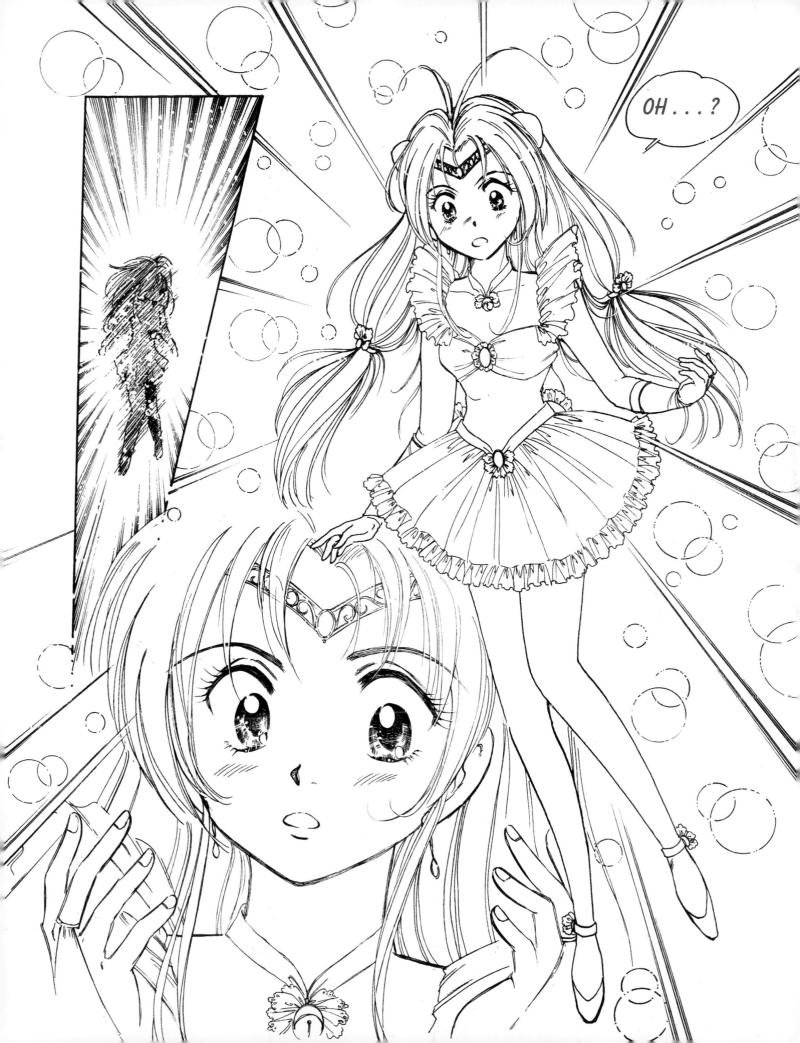

The Transformation Step by Step

The wand can ignite the transformation.

Now let's take a look at the actual basic steps involved in transforming from a regular girl into a magical girl. These steps may go in sequence, or they may be combined:

1. Magic begins to appear.
2. Costume begins to change.
3. Magical effects become a torrent of swirls.
4. New costume becomes elaborate.
5. Magical effects change shape as new costume solidifies.
6. Magical effects dissipate.

Magic sparkles are necessary. Without them the swirling effect would look like wind.

Character is posed to cover nudity. Swirls and flowing hair also conceal body.

Tyical schoolgirl outfit.

Step 1: Regular Schoolgirl

She calls on the magic to transform her. At this point, like a thunderstorm on its way, there's just the rumble of magic in the air.

Swirls orbit the character.

Step 2: The Transformation Begins

The magic becomes a tornado swirling around the character as the old "her" is swept away. It's common for the magical girl to become nude when the transformation occurs. So position the special effects and the character to cover up, in order to retain modesty.

134

Magical effect changes from swirls to lightning-style bolts.

Step 3: The Conversion

Violent special effects usher in the transition, which can be abrupt and difficult. The swirls move farther apart, revealing the new costume underneath.

The first good look at her new self.

A commanding "ready" pose.

Step 4: The Reawakening

She now awakens to find herself in her new role as a magical fighter. The difficulty and turmoil of the transformation is behind her.

Step 5: Ready to Fight

Now fully in command in her new role, she's ready to bring justice to those who are still chained in darkness!

135

Transforming Magical Helpers

Often, the little magical mascots or helpers are on an urgent mission to bring a magical girl back to their world to save them from a dark lord. These little helpers can be quite persistent. They, too, can transform. And their transformation is sometimes just as astonishing as that of the magical girl. What starts out as a sweet, faerielike mascot, for example, can turn into a more aggressive creature in another dimension.

Step 2:
The Magic
Begins to Take Hold

Magical girl is enraptured by the spirit. Her clothes begin to blow in the breeze.

Step 1:
Faerie Helpers
Lead Girl Toward
Transformation

Faeries dance their hypnotic spell. Magical effects trail below them.

Step 3:
Transformation and
Special Effects Begin

The magic catches hold. Faeries back up, making room for the transformation to take effect. Off with the old!

Step 4:
New Costume
Appears

Step 5:

Transformation Complete,
Faerie Mascots
Turn into Faerie
Dragons

Posing with Special Effects

In addition to creating cool transformations, you'll also want to combine fantastic magical effects with eye-catching poses. This really puts the icing on the cake. Start by sketching the outline of the body. Next, add the details of the face, as well as other details, like fingers and toes. Then, draw the costumes. The special effects always go last. (I know, I know . . . it's hard to wait to draw the fun stuff!) Although you may start off drawing the figure tentatively, once you've got your basic construction the way you want it, you should strive to finish your drawing with bold, confident strokes.

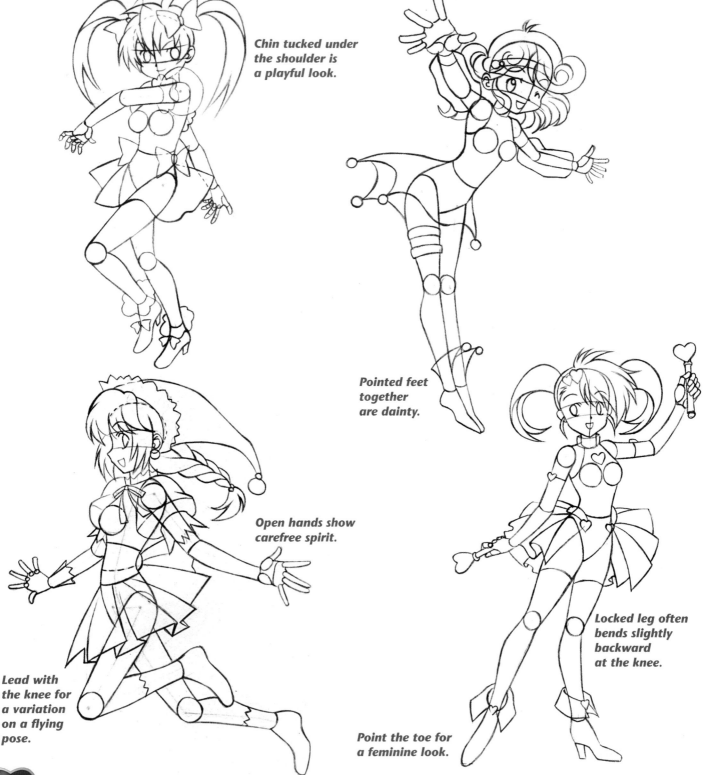

Chin tucked under the shoulder is a playful look.

Pointed feet together are dainty.

Open hands show carefree spirit.

Lead with the knee for a variation on a flying pose.

Locked leg often bends slightly backward at the knee.

Point the toe for a feminine look.

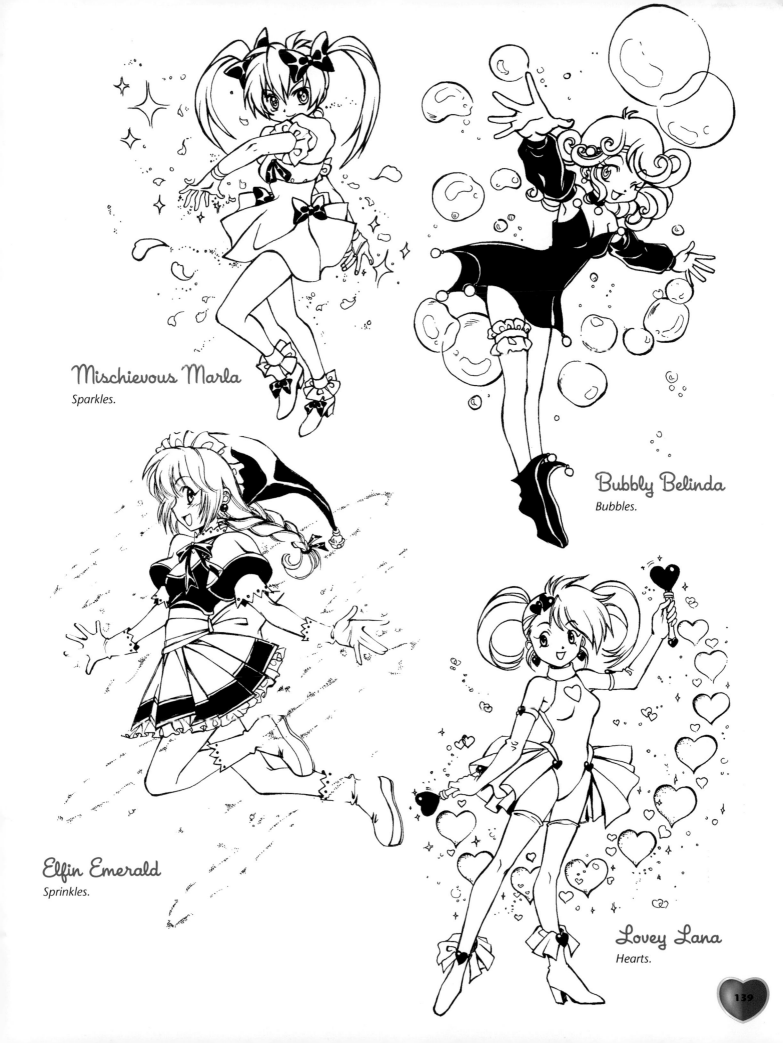

Mischievous Marla

Sparkles.

Bubbly Belinda

Bubbles.

Elfin Emerald

Sprinkles.

Lovey Lana

Hearts.

139

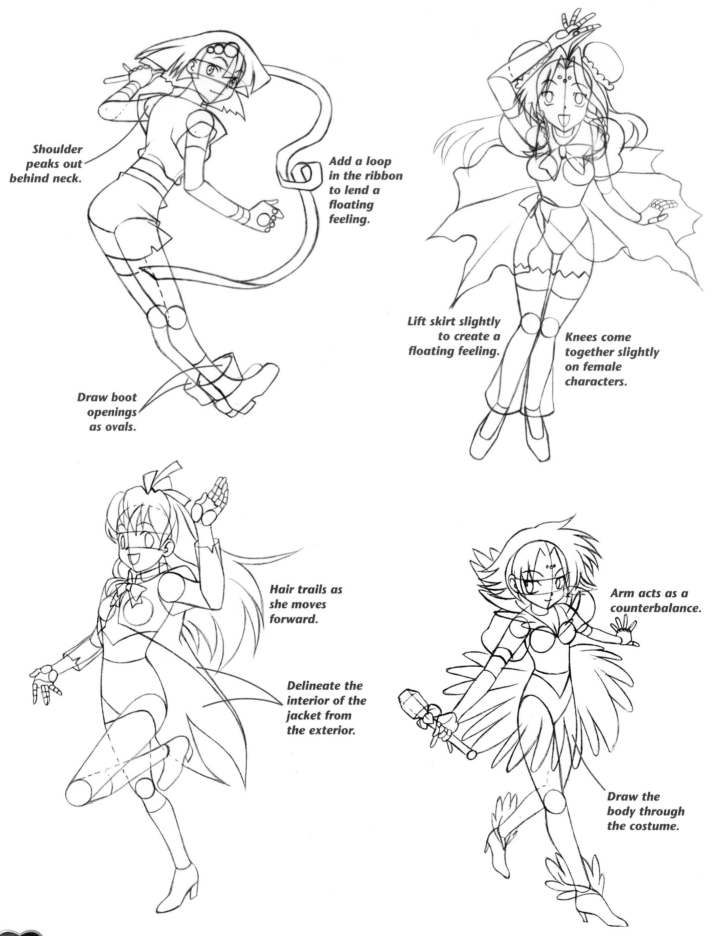

Shoulder peaks out behind neck.

Add a loop in the ribbon to lend a floating feeling.

Draw boot openings as ovals.

Lift skirt slightly to create a floating feeling.

Knees come together slightly on female characters.

Hair trails as she moves forward.

Delineate the interior of the jacket from the exterior.

Arm acts as a counterbalance.

Draw the body through the costume.

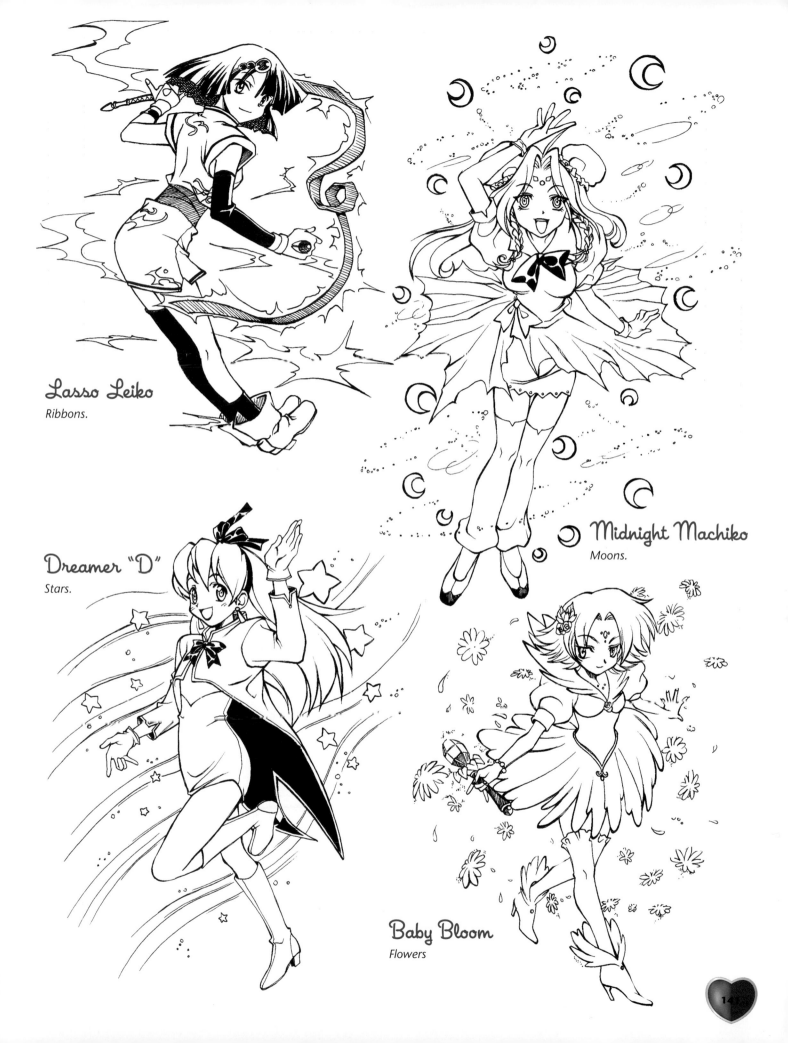

Lasso Leiko
Ribbons.

Midnight Machiko
Moons.

Dreamer "D"
Stars.

Baby Bloom
Flowers

14

Special Effects in Panels

By filling a graphic novel panel with special effects, you can see how magical girls command a scene. It's important to note several design techniques:

First, special effects don't always stop before they reach the panel's edge. Sometimes they bleed to the edge, where they're cut off. This makes the special effect look as if it's growing in size and strength.

Next, the magical girl doesn't have to be the biggest object in the panel. Often, she's outsized by the special powers she wields. But since her powers lead directly back to her, she's the nexus and, therefore, the focus of the panel.

Also, you can place the magical girl anywhere in the panel. She can be in full figure, cut off, floating, or standing.

In addition, the special effects can illuminate a dark background or can add a different hue to an already colorful background. They can serve as foreground or background, or they can surround her.

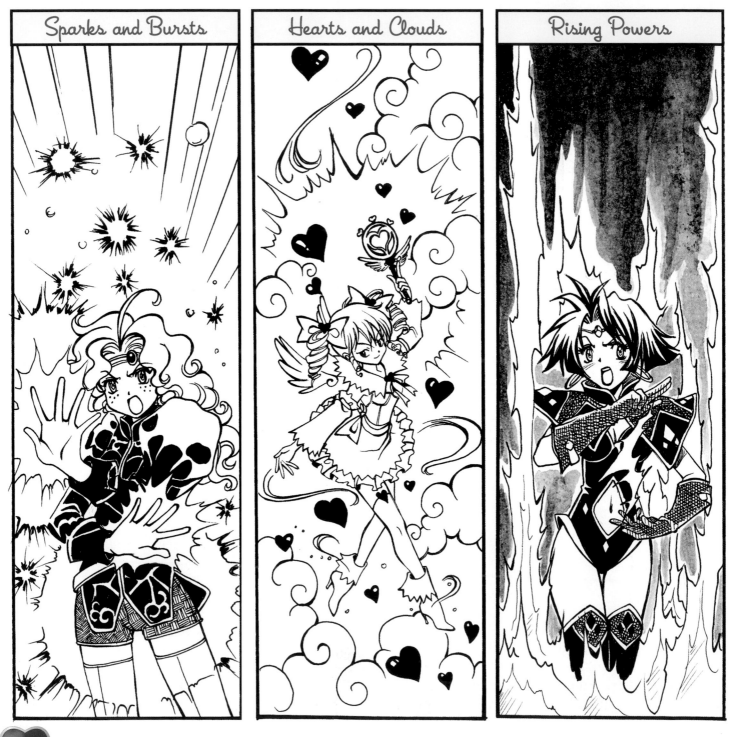

Sparks and Bursts

Hearts and Clouds

Rising Powers

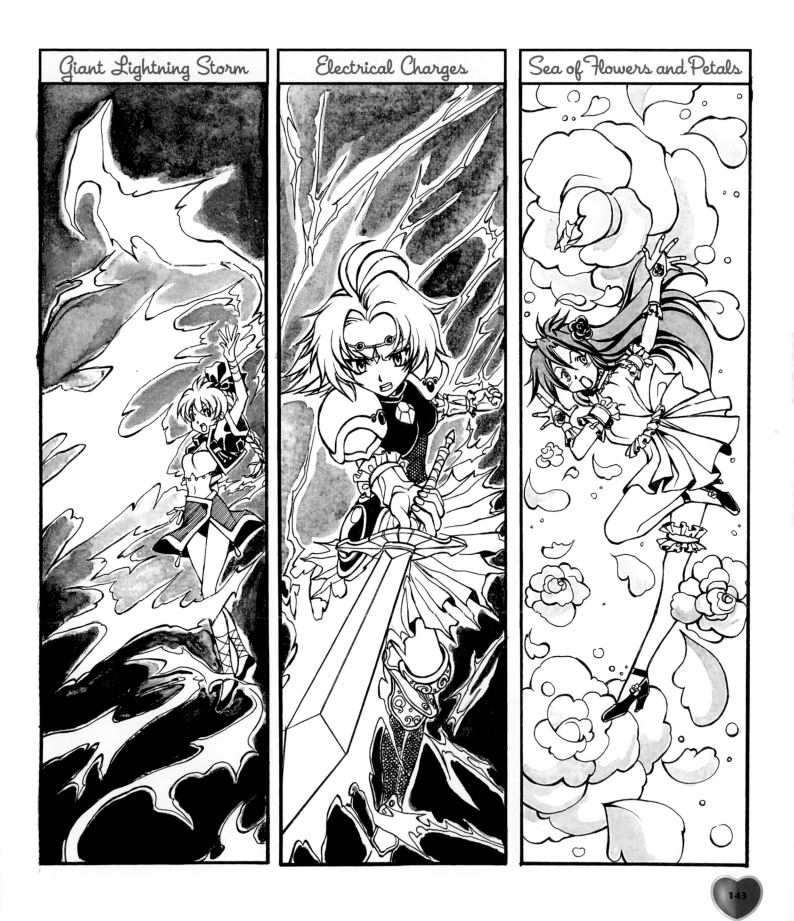

Giant Lightning Storm

Electrical Charges

Sea of Flowers and Petals

143

Index